700.904 A.501
Auping
30 Yea
and Ou

D0498979

DISCARDED

HAY LIBRARY
WESTERN WYOMING COMMUNITY COLLEGE

MICHAEL AUPING

30 YEARS INTERVIEWS AND OUTTAKES

MODERN ART MUSEUM OF FORT WORTH
IN ASSOCIATION WITH PRESTEL

For Pat, Alicia, and Jonathan,
who have known most of them,
and lived through all of it.

PREFACE
ACKNOWLEDGMENTS

This book contains excerpts of interviews I have conducted with artists over the past thirty or so years. These interviews began when I was a graduate art history student and would-be curator in southern California. I didn't have an original idea about art. Doing interviews with artists seemed like a good way to find one. Not that much has changed. The most recent interview was conducted this year.

I'm not sure how to describe this book. It's about art, but it's about a lot of other things, too. These dialogues run a gamut from political argument to naïve questions with patient answers to interview as performance piece. In some cases, these are outtakes of interviews originally conducted in preparation for an exhibition and its accompanying catalogue/book. What is presented here are the parts of the interview that were thrown out because they didn't seem "quotable" in the context of what I wanted to say at that time. I know a little more now and am a bit more attuned to the oblique nature of content. Sometimes art is best approached from the side.

This book would not be possible without the encouragement and support of the following: Emerick Yoshimoto; the Oral History Department at the University of California, Los Angeles; Marla Price, Susan Colegrove, and Pam Hatley at the Modern Art Museum of Fort Worth; my former colleagues at the John and Mable Ringling Museum of Art and the Albright-Knox Art Gallery; and Anthony d'Offay, who suggested early on that these interviews be published. A very special thanks goes to Peter Willberg for donating his time and skills to this project, and for his friendship.

From Los Angeles to Berkeley to Sarasota to Buffalo to Fort Worth, I have spent a lot of time in artists' studios, and have always felt very lucky to be invited. Many of these artists were and are friends and mentors. If one believes that art is, and has always been, a significant and vital part of the formation of an individual and society, then there is no greater privilege than to be able to speak with the artists of our time. It is to them that I am most grateful.

MA

TADAO ANDO

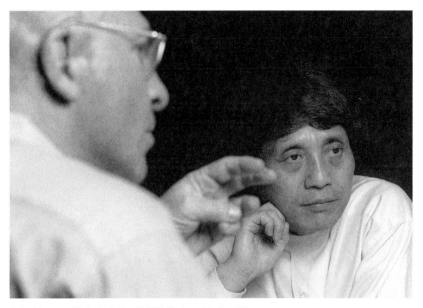

Michael Auping and Tadao Ando, May 16, 2001. Photograph by David Woo.

THE BOXER

May 13, 1998
Fort Worth, Texas

Michael Auping: Were you interested in buildings when you were young?

Tadao Ando: As a child, I used to go looking at the construction sites near my home in Osaka. I always thought the carpenters were important people. They looked so great for me, a young boy with so much interest toward making things by my own hands. They would put the frames up before the siding was put on, and they were so confident and proud that the house they were building would stand for one hundred years. I was very impressed by that as a child. They would tell me that a building must be built with confidence and pride— materials alone do not make a building great or strong. Becoming an architect, or any profession, is usually gradual. You don't know exactly when you become that person who is an architect, but I think that maybe it was that moment for me that I could imagine myself as a builder. The combined effect of beginning to understand a carpenter's confidence, and the pride of a craftsman, made me think that this could be a way for me to contribute to society in some way.

MA: What type of a house did you grow up in?

TA: We all have had certain experiences in our childhood that have stayed with us for our entire lives. The house that I grew up in was very important for me. It is an old Japanese small wooden house partitioned into several units— a Nagaya row house. It is very long, and when you come in from the street you walk through a corridor and then into a small courtyard and then another long space that takes you deeper into the house. The courtyard is very important because the house is very long and the amount of light is very limited. Light is very precious. When you live in a space like that you realize how important light is to interior space. Living in a space like that, where light and darkness are constantly interacting, was a critical experience for me.

MA: You can see that in your buildings, in the sense that you pass through various intensities of light that create different moods in each space. You also create long walls that catch light, natural light, and that change throughout the day. Do you think these characteristics refer back to that house?

TA: Yes, but it's unconscious and very natural for me. The memory of that house has always stayed with me, the ways the rooms seemed to be painted in shadow and light. That is how I experience space. When I was fifteen years old I took part in renovating that house. I knew the house so well, and the workers and craftsmen let me join them. It was a very important learning experience. I was very proud that I could contribute because I knew the house very well. By working with them side by side, I developed an intimacy with that project that was very important for me.

MA: Was it a well-built house?

TA: It was a very common, typical house that was built about ten to fifteen years before the second World War. The house was sixty-five to seventy years old at the time when we renovated it. There are many houses like it in Japan. So in that sense there wouldn't appear to be anything special about the house. It was in a working-class neighborhood. Across the street was a craftsman's small factory that did a lot of wood works and next door was a shop that did a lot of small stone works, especially used for the Japanese chess games. So I grew up in this neighborhood watching all these people working with their hands. It made me very conscious of how things were made and built, and the joy that could come from making something with your hands. I was very lucky to have that. At the same time, I also remember the strange fact that you had to sell what you made because it is your occupation. I remember seeing that as a very difficult moment for the craftsmen, that they had created something and they didn't want to let it go, but of course they had to. What they had left was the sense of pride that this thing could go out into the world and maybe affect it in some small way. I certainly understand those feelings now. The house and neighborhood where I grew up shaped how I see things. Those craftsmen in my neighborhood shaped how I feel about making things. I always felt that neighborhood shaped my eyes and my heart. They are the kind of people who are so busy living and building that they made building a joyful thing. Building something was not a problem for them but a life itself.

MA: It seems those childhood experiences precede and form how we educate ourselves, because education is not a set experience for everyone. Certainly you have taken an unusual course in being essentially self-taught, rather than following a typical university training.

TA: I'm sure every architect has a story to tell and that story is the beginning of one's path. For example, Mies van der Rohe's father was a stonemason and his experience of seeing his father work at a very young age affected his approach to life and his profession. Louis Kahn's parents were artists; his father a musician and his mother a painter. Le Corbusier's father was a watchmaker and his first teacher was a painter. So he learned to use his hands and eyes in a certain way. It's this kind of learning that leads you into a profession naturally.

MA: It's experimental rather than theoretical.

TA: Yes. That is how it works for me.

MA: Do you remember any other buildings as a child?

TA: I also have a very strong image from my childhood of the farmhouses. The Japanese farmhouse is very unpretentious. There is something so honest about how they look with their over-protecting roof and how they function as a place of protection. The way they withstand the weather and stand so strongly in the landscape—I think they have a very powerful presence. And the way the engawa is employed in those buildings is very strong.[1] When you talked a while ago about how much you appreciate the experience of Ryoanji, the rock garden, I was thinking to myself that the most interesting part of experiencing Ryoanji for me is the building that faces the garden, and particularly the floor of the engawa that faces the garden, the way the light falls down onto the floor of that transitional space, that engawa. It engages the space of the rocks without intruding on it. It sets the stage for seeing the rocks.

MA: That's an important boundary, and one that obviously comes into play in the design of a museum.

TA: Architecture has always been about boundaries; building boundaries for protection and then opening them up for movement.

MA: As a young man when you began traveling to look at architecture as a means of self-training, what were some of the first buildings that impressed you?

TA: In my early twenties I traveled all around Japan. In Hiroshima, I saw Kenzo Tange's Peace Center.[2] It is a concrete building supported by *pilotis*. That left me with a very strong image. I think that was partly because it was in Hiroshima. It was something about the strength of the building and the history of the place. The place talks about the possibilities of humankind, and the strength of people to survive. The architecture also spoke of that kind of strength. I think I felt at the time that architecture should have a responsibility to speak to the strengths of humankind in the same way that men should have a responsibility to other men. In this way, architecture plays a moral role in our life. It is an inspiration; at the same time it is a protection.

MA: Then you traveled outside of Japan to see the Pantheon and the Parthenon.

TA: It was very important for me to travel to those buildings, not to study them in an academic sense but to see them, be in them, experience them as a form. In Japan, when you study architecture, you are basically studying Western architecture. With that in mind, I felt I needed to go to the source of Western architecture, which is Greek and Roman architecture. So when I started my journey, I visited the Pantheon and the Parthenon. I still believe those buildings to be a great source for the architecture that followed them. When I design a building, those images are always with me. I design according to function and the site that is presented to me, but within that I always go back to thinking about those buildings and their effect as a built structure.

MA: You also went to Africa.

TA: In Morocco, I went to see Caspar. I remember thinking when I saw it from afar that it looked like this very chaotic, out-of-order settlement. But when you actually enter, you realize the sense of order in that place. What creates that order is the lifestyle of the people, the social order that has developed based on the geography they inhabit. I was very interested in the cliff dwellings that were set within this fairly drastic topography. The cave is such a basic form of protection, and that is a basic priority of architecture, and related to social order.

MA: Le Corbusier said that architecture is "civilization itself"; in other words, the ultimate form of social sculpture.

TA: I agree with that. Architectural form reflects and directs how we relate to ourselves, to each other, to nature, to materials. Look at the small island of Japan and the spaces that are created there with wood and paper, and compare that to the United States or Germany. All of these architectures reflect the place and the cultures that have learned to inhabit the specific requirements of their land. The challenge that they all have in common is protecting the individual as well as society, and then creating an environment that brings them together as a society.

MA: It must be intimidating to think of what a broad discipline architecture is.

TA: For me it is a way of participating in society.

MA: You are an unusual case in that you are self-educated, with no university education. How did you actually enter the field of architecture?

TA: I began as a craftsman and a builder, working with my hands. I still miss that now. Working with your hands and muscles is important. It is very important, very important to understand scale and weight, and the voice of materials. I don't want to design impractical things that a human being cannot build. Working with your hands teaches you very basic concepts of beauty. For example, I like concrete because it is handmade compared to some other types of modern building methods.

MA: Is there a point when you recognize that you are going from being a builder to being an architect? Do you remember acknowledging that stage in your life?

TA: It was a gradual process. It did not happen at a fixed moment. The period when I decided to travel around Europe in 1965 was critical. I saw the Parthenon in Greece, the Pantheon in Rome, and many works of Le Corbusier. That was when I knew that architecture could be a creative force, that a building represented something more than a protection from the weather. That took me to a higher level of thinking about architecture.

MA: As a young man you were also a boxer, semi-professional. Assuming that we learn something from everything, is there anything you learned as a boxer that has helped you with your architecture? They seem like strange bedfellows, one so much about motion and violence, the other still and classical.

TA: They are of two different worlds—architecture in the realm of the creative and boxing in the realm of the purely physical. The one thing I can say is that in boxing you have to be courageous and take some chances, always taking one step deeper into your opponent's side. You must risk moving into a dangerous area in order to fully take advantage of your skills and eventually win the match. Creating something in architecture—not just building something but creating something—also requires courage and risk, moving into areas that are not so known, taking that extra step forward. If you stay in your day-to-day lifestyle, just building buildings without thinking about why you build buildings and never questioning yourself, it doesn't require courage. To create a form of architecture, something that may not look familiar, you have to take that extra step into the unknown.

MA: Is the element of balance also something they have in common, both requiring a kind of physical and visual balance?

TA: Of course balance is important, but to win you have to move forward boldly, and forget about your balance for a moment, only hoping that you naturally have balance as you strike forward. There are many good buildings with balance, but that does not necessarily mean they are creative buildings. They are buildings with no problems, but no questions either. To make creative architecture you have to take one more step forward, and then you make problems and maybe some important questions, too. Then, as an architect, you have to solve the problems and answer the questions in order to complete the move forward. In boxing you must finish the move in order to win.

It is particularly important to take steps forward in a museum building for contemporary art. The living artists are very courageous. They are stepping forward all of the time. We must meet them moving ahead. We must share the fear of challenging the unforeseen world. We are all humans and we can be courageous, but we cannot escape the fear when you take risks. Fear is a way to measure our abilities, to understand the fear and solve the problems without being reckless. As long as you have courage to step forward, and some experience, you are not likely to fail.

MA: **What are some of the other aspects of the Fort Worth project, besides the double-skin structure of concrete and glass, that you see as courageous or daring?**

TA: There is an image I have in mind that is not typical of any of my buildings. I envision this building as a swan floating on the water. From a distance, it is the image I think you will see. To make a building look like a swan is not an easy job. [*laughter*] But it is not impossible. It has been done before. There is a famous temple in Kyoto, Byodo-in Temple in Uji. It looks like a phoenix, a legendary swan that is a reflection in the water. The Fort Worth project is part of this image. When the Fort Worth building is lighted from the inside and its form is united with the reflection on the pond, it will make a very beautiful image.

Of course, a building is not just about a shape. You have to give people an experience of space. People will be able to see the art in an intimate way, but also there will be spaces that combine inside and outside, nature and art. You can be one with nature, looking out over the pond away from the art or inside

toward the art. In some cases art and nature will share the space. This is unusual I think. The glass and the water make this a very unique space. You will always be aware of nature in this building. I think of it as an arbor for art. I don't think there are many art museums like this in the world. I have not seen any. This building is about serenity, and we have to be very careful to allow this serenity to grow from the building and its site. It's a hard thing to achieve.

MA: It sounds like a very Japanese concept for a public building.

TA: I think so.

MA: Japanese architecture has a long and distinguished history, and modern architecture, it seems to me, has a separate history. One involves a kind of sacred space; the other, a secular one. Would it be fair to say that you are trying to bring these two separate histories together?

TA: Here in Fort Worth, yes.

MA: What about in general? Don't all of your buildings do this in some way?

TA: The art museum, like the church, creates a special space in people's lives. Day-to-day life is very busy, very hectic. At the museum, although it is an extension of your life, you are allowed, by facing the art and the environment, to reclaim yourself. If you can be with yourself and your thoughts in a serene place for even just one hour, then this space can provide a special point of energy. I don't want people to come to be entertained, but to come to reclaim and nourish their spirit and soul. That is the place I want to build. So, I see the ideal space as being both sacred and secular, to allow the individual either possibility through the serene openness of the place. For me, I like to think about being in a space that allows you to forget about the secular side of life, and focus on yourself, which is the sacred. Maybe I am too philosophical today, but when I talk about the individual and the space, I am talking about approaching the space of the cosmos. Even if the space is small there can be the potential of the cosmos. If the space is constructed with a forceful imagination, there is the possibility of entering the space and leaving it at the same time.

MA: So from your point of view, the universe is inside the individual and the architectural space turns in on the individual. It's not an illustration of an outward space. The space, if properly constructed, is always a reflection of something inside you.

TA: Yes. The universe, of course, has many faces. It is the basis of aesthetics, of harmony and balance. The universe is the future and the past. So an architecture that can approach these conditions becomes more than just a building. This is a Japanese kind of thinking, which is not so much American. I think what you say is true, that Japanese buildings, the best ones, work toward a sacred space and the best American buildings have a strong secular space. This is not always true, but in general, I think.

MA: The vocabulary of forms you use seems very basic: the square, the rectangle, and a kind of circle or ellipse, which particularly fascinates me. I can see it in modernist terms—Le Corbusier incorporated curves, and Frank Lloyd Wright, among others I probably am not thinking of; Louis Kahn's vaulted roofs at the Kimbell, for that matter. But your use of the curve is somehow different. It is often a half circle.

TA: Are you familiar with Zen?

MA: Somewhat.

TA: The essence of Zen philosophy is a circle. The circle, of course, represents infinity. When you are talking about my curves, you are talking about maybe one-fourth or one-sixth of a circle as the symbol of infinity. So how you connect the rest of the circle to make your universe is up to your own mind. I try to achieve the possibility of that completion in the mind of the viewer. You fulfill the space. A number of great buildings in the West as well as the East incorporate this concept: the Pantheon in Rome, for example. The upper half is a perfect semi-sphere. The lower half is a cylinder, both created with the same radius and height. The light penetrates through the center of the dome into the space. It is a perfect space. The scale is perfect for the human body and for the possibility

of thinking about the human form in relation to the universe. When they conduct the choir in that space, the human voice resonates like a universe. At 10 o'clock in the morning on Sunday, they do a choir and chant. I was asked to give a lecture at the University of Rome last November, and I was able to attend Mass. That event reassured me that architecture is not just a form, not just light, not just the sound, not just the material, but the ideal integration of everything. The human element is the key that ties it all together. A great building comes alive only when someone enters it. A form is not imagination. A form brings out imagination. The Pantheon does that in a powerful way.

MA: It seems ironic that someone who never attended a university has taught at Harvard and Yale, and now has a professorship at Tokyo University, one of the most difficult universities to be accepted into in the world. How does a self-taught architect teach a philosophy of architecture to some of the brightest university-trained students?

TA: To begin, as you say, Tokyo University is a unique place. The students are very carefully screened through a very competitive system of learning. They come out of a system of all study and no play. Their heads are packed with as much information as is humanly possible. They are not allowed to come into the University until they have gone through this rigorous training. But accumulating information and thinking are two different things. To teach architecture to these students is to make them realize that architecture is interesting and even fun, and that knowledge does not make you a good architect. Artists like Constantin Brancusi, Henry Moore, Alberto Giacometti, Isamu Noguchi, and Richard Serra are all great thinkers. Their knowledge is tremendous, but knowledge alone did not make them great artists.

MA: So if intelligence and knowledge are not enough, what is the other part of the equation? What is the other element? Intuition?

TA: I think it could be memory, the strong memory of something that we all carry with us. Some things that we encounter, for some reason, we never forget. These memories inspire us to do some things in a certain way, to make a form

or to write something that intelligence and knowledge by themselves would not produce. For those who grew up looking at the Pantheon in Rome, then the memory of that space will be with them for the rest of their lives and will affect, in some basic ways, what they do and how they do things. For me, for us in Japan, the great cities Kyoto and Nara live within us as a strong memory. Those cities and ancient buildings are with us all the time, wherever we are. We have to learn to cultivate that memory, because memory organizes our philosophy about time, space, color, politics, everything. When Frank Lloyd Wright went to Japan, that experience transformed his work, his way of looking at the world, for the rest of his life. You can also see his memories of his trips to Mexico. I carry the memory of the house I grew up in. So reading, studying, and talking is good to mature the mind, to exercise it, but you have to go out into the world and experience it. You have to have direct contact with the spaces, the materials, and with people. This is why I traveled so much before I began designing buildings. You must find out how many great memories you can accumulate. That is the only way to complete the education. It is all about making powerful memories.

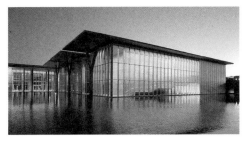

Modern Art Museum of Fort Worth. Photograph by David Woo.

1 *Engawa* is the narrow space in a traditional Japanese building that serves as a transition between a room and the outside environment; similar to a Western porch or veranda.

2 Kenzo Tange designed the Peace Center in 1952. This is a memorial building for praying for eternal peace, commemorating the atomic bombs dropped during World War II.

GEORG BASELITZ

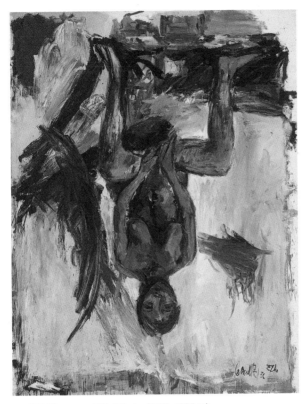

Elke, 1979. Oil on canvas. 98½ × 75 inches (250.2 × 190.5 cm)
Collection of the Modern Art Museum of Fort Worth.
Museum purchase, The Friends of Art Endowment Fund, 1994.

ELKE

December 5–6, 1996
Derneburg Castle, Germany

Michael Auping: The first Elke portrait was done with a group of portraits of friends and family that you did in 1969, right after you began painting your images upside down. Was it a coincidence that the portraits began at around the same time you started painting the image upside down?

Georg Baselitz: The choice of portraits as a subject was related to what I was trying to do. It was important to paint something that was conventional, a traditional genre like portraiture, so that the subject would not distract from the painting, the act of painting. I didn't want a popular or symbolic image. The most obvious choice was portraits of my wife and friends. That's when I started painting portraits of Elke. Most of them I painted from memory, sometimes using photographs. The challenge was to paint a neutral image, no erotic element, nothing to do with man, woman, artist, model. Elke was the first woman I ever painted. I never painted a portrait of my wife or any other woman until 1969. It was only when I started painting things upside down that I thought I could paint her, because everything then became more neutral. When you paint someone upside down it's difficult to give them an expression or at least a conventional expression. The result is something less predictable.

MA: So the challenge for you as a painter was to neutralize the personal content?

GB: I want personal content, but it should come through the painting. I wanted to use typical subjects, like landscapes, nudes, and portraits, because they are a standard subject. You have to paint something, but the point is not to begin with something personal. You must have the will to deny content in order to begin to make a painting that will exist for itself. . . . The painting takes its course but Elke comes in and out of the picture. It's very complicated. I begin with an idea, but as I work the picture takes over. Then there is the struggle between the idea that I preconceived in advance and the picture that fights for its own life.

MA: Are you saying that turning the image upside down makes it abstract and thus empties the picture of meaning?

GB: No. It is not abstract just because it is upside down. It still has meaning, but the meaning is approached in a different way. You approach the meaning through the act of painting. The figure—not pure abstraction—has always been the central thing, the thing you act on or react to. You can eliminate it, but it is there by implication, as a way of measuring space. What is done to it is a matter of style and strategy.

MA: I would argue that you can't help being personal because it is your wife. They are your friends. They're not neutral subjects.

GB: You're absolutely right. It's often the problem in art that what you want to do isn't what you end up doing. I want to be neutral, but I realize I can't be totally neutral. But that's what I try to be. I try to keep a neutral attitude but it's impossible to stop personal things from getting mixed up with it. I don't illustrate Elke. If anything, I try to remove her, but I usually can't. She comes into the process whether I want it or not, through the back of my mind.

MA: When you painted the first upside down painting, you didn't paint it right-side up and flip the canvas.

GB: The canvas was on the wall and they were painted upside down. They weren't right-side up and then flipped over.

MA: But at a certain point you began painting from different sides of the canvas, not just upside down. Why not paint them right-side up and then flip them?

GB: If I painted the image right-side up and just flipped the canvas, it would not be the same painting, and it probably wouldn't work as a painting. Paintings have a special kind of gravity, pictorial gravity, and you need to adjust for that with line, color, color weight. If you flip one of my paintings, the balance is gone.

MA: There's an interpretation of your upside down pictures as being a symbol of the German art world being in a state of upside down. That this was a reason—

GB: It has to do with my belief that painting is not a mirror of reality. That is a myth. It's about reinventing reality, and one of the best ways to destroy this myth is by painting the image upside down. It is its own reality. I'm sure there are other ways of doing it, but that's one of the most obvious ways to me.

MA: Going back to the Elke paintings, in a sense you paint Elke because she's convenient.

GB: Yes. If I didn't paint Elke I would have to paint another woman. Then I'd have to ask, "Why do I want to paint another woman and not my own wife?" I agree with Picasso. Everything is a self-portrait, whether it's a tree or a nude. Everything that you see is a reflection of yourself. When research is carried out to determine the authenticity of a painting from the Renaissance, for example, one of the ways in which the study is undertaken is to pick out physical traits like ears and eyes and noses—Titian always painted the same eyes and ears regardless of who he was painting. He always painted the ears in the same way.

ROBERT BECHTLE

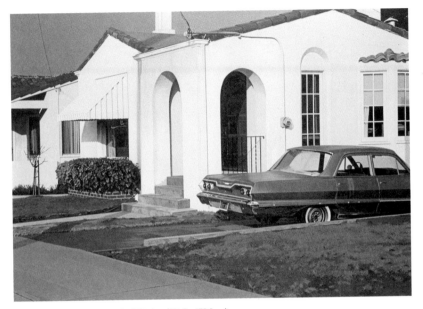

'63 Bel Air, 1973. Oil on canvas. 48 × 69 inches (121.9 × 175.3 cm).
Collection of the Modern Art Museum of Fort Worth.
Museum purchase, Sid W. Richardson Foundation Endowment Fund, 1996.

SOMEWHERE

April 10, 2004
San Francisco, California

Michael Auping: **How would you describe the subjects of your paintings?**

Robert Bechtle: Well [*laughter*], why start with such an easy question? . . .
A truthful answer would be I'm not sure I know. I suppose the subject of painting
is painting, but of course it's never that simple. You need to find something to
paint. I'm just painting what is available to me—these neighborhoods—some
of the peculiar things that catch my eye.

MA: **Where are these places?**

RB: Here in the Bay Area, most of them, the greater Bay Area. I suppose on
some level I'm a landscape painter and this seemed like a good place to start.

MA: **These neighborhoods—could we say they are the suburbs?**

RB: In some cases, but not always. I suppose "suburb" is a kind of generic that
covers a good deal of ground. In my case, some of the images are close to the
city. Some are a bit farther out. I can tell you exactly where they are, and then
maybe you can define what they are. You could probably say I am trying to
locate them myself. It's where a lot of people live—somewhere between the
city and somewhere else. I guess it's the suburbs. I'm not sure I know exactly
what the suburbs are. Do you?

MA: **No—even though I grew up in them, in southern California. The neigh-
borhoods I grew up in looked a lot like the ones that you paint, even though
they are at opposite ends of the state. I could swear that I've been down
some of the streets in your paintings. Do a lot of people say that your images
look familiar?**

RB: Yeah. They do. In that sense, maybe the suburbs are not a specific place
as much as they are a period of time after the war—like stucco and plastic. It's
a certain form of American domesticity.

MA: It's one thing to be confronted with how other people live, and another to be faced with how I lived and actually still live. The good news is that the suburbs are very popular now. In the last few years, it seems like the suburbs have become the new hip genre for artists and filmmakers.

RB: It's a place that comes in and out of focus depending on society's interest at the time.

MA: But you have been painting these neighborhoods for five decades. To my mind, you're the grandfather of suburban realism.

RB: I'm not sure that's the moniker I was hoping for—but maybe longevity has its advantages.

MA: It strikes me that what you do requires a very special eye and mindset, walking down these streets finding view after view of exquisite ordinariness. How do you sustain that interest and attention?

RB: On one level, it's the visual texture. It's a landscape that is so immediate to me. I live here. I can study what I see and try in my own way to represent it. I approach it almost as a still life. And like all still-life painters throughout history, I suppose I'm interested in the history of domestic materials. Postwar America is a huge landscape of interesting materials and objects.

MA: Do you think of the automobiles that you have been painting for all these years as objects?

RB: Sometimes. When you are painting something, you often think of it as just an interesting, peculiar thing. Since I began drawing as a young man, I always thought of cars as large, very interesting things.

MA: Of course, they're also a symbol, too—particularly in California. They are probably the symbol of postwar California.

RB: Of postwar America. They are a huge piece of postwar Americana—domesticity on wheels.

MA: One of my favorite images is the one of you, your wife, and kids standing proudly in front of your station wagon. I can't tell whether you are being ironic or sentimental or factual. The fact that you often include yourself and your family—your wife, children, even your mother-in-law—in these images makes them . . . well, poignant, for lack of a better word. It's like you're looking at your surroundings from the inside out, rather than the outside in.

RB: Well, I'm probably trying to do both. . . . As a painter, it all starts with finding something peculiar about a scene. And for me, that's usually not something that you would think of as being very dramatic. What inspires a painting may not be the most dominant thing in the completed painting. It may be in the background. It's usually something that really only translates, at least in my mind, through painting. How people or objects are placed in a certain situation. . . . It often comes back to the issue of light—how light hits something, and of course light hits everything in one way or another. I can find myself staring at the dark, fuzzy line between a sidewalk and a lawn.

MA: How would you describe the light in your paintings?

RB: It's usually early morning or late afternoon. I like to get some shadows involved. I think the shadows are important in my paintings, at least they have become more so over the years.

MA: You talked a while ago about Magritte. There is a certain kind of light in those paintings, like twilight. Do you ever think of light in stylistic terms, how different artists have used it?

RB: Sure. Every artist does, I assume. But light crosses between styles in interesting ways. I know what Surrealism is historically, but it seems to me that term has another life through the use of light outside of its historical context. In terms of light, I think you could say Hopper is surreal.

MA: The light has an almost material quality. Everything in it seems almost unnaturally real.

RB: Yes.

MA: Would you say that your paintings have a surreal quality?

RB: Sometimes, even though I've tried hard to be very deadpan. That's why I began using the camera—to create a more factual situation to paint.

MA: The movement you helped pioneer—Photorealism—was that about just presenting the facts?

RB: To a certain extent.... When I was involved in that—I still am, for that matter—it seemed to be a time when looking at America was an interesting thing to think about doing. I remember coming back from a long trip to Europe—where I was away long enough that I had almost separated myself from being an American—when I came back I remember seeing this country in a whole new way—not good, not bad, just in a fresh, maybe more exacting way. It looked different enough to me that it didn't need any embellishment. You could just present it as it was and that would be enough. I remember thinking that I wanted to present it like a real-estate photo.

MA: It seems to me there is an edgy side to these images—maybe because of how you portray these places, maybe the shadows, or maybe it's just this factuality you're talking about. Do you see that?

RB: I think I do, but it's all tied up in the visual information that makes up the scene. To me it's all part of the image, formally and even in terms of any kind of content that may or may not be there. You had asked about books that I read. I do remember reading—and maybe this comes up because of what we are talking about now—Theodore Dreiser's *American Tragedy* in the early sixties. As a novel, it struck me as very plain or matter-of-fact, even though it was about a murder. At that time, it seemed unusual, and I think it had some effect on me. It was made into that movie *A Place in the Sun*.

MA: Do you do have specific feelings about these images? At the end of the day, after all, you are not just a camera. You are a human observer.

RB: Yeah, of course. I just can't always articulate that outside of how they are painted. I have feelings like anyone else, and I can let them roam free, but as a painter if I have too strong of feelings about an image—by feelings I mean emotional ties, that kind of thing—then I don't think I could describe it in terms of the odd things that are going on visually. I'm not trying to interpret it as a narrative, but just experience the peculiarity of it as an image. If I can do that successfully, then a new kind of feeling comes into it, a different feeling than I might have brought to it initially. I don't know if that makes any sense.

MA: I think so. If we somehow identify with these images, no matter how pedestrian they might seem, then it becomes about each of us trying to identify ourselves within it. In other words, why do we identify with it?

RB: That's just as true for me. These neighborhoods are about where and how I and my family have lived. It may not be perfect, but it's not something I can turn my back on. To a considerable extent, I am a product of this place.

JONATHAN BOROFSKY

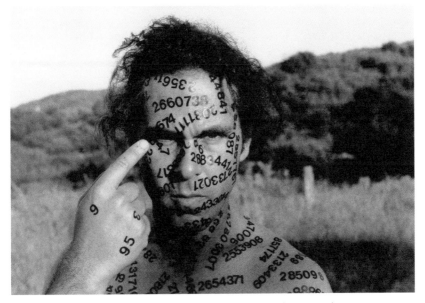

Self-Portrait, 1980–87. Black-and-white photograph, edition of 6. 35½ × 50 inches (90.2 × 127 cm).
Photograph by Megan Williams, courtesy of Paula Cooper Gallery, New York.

DRAWING AND COUNTING

April 30, 1994
Houston, Texas

Michael Auping: I think of you as an artist who primarily draws.

Jonathan Borofsky: That's interesting because for the past few years I've simply thought of myself as a sculptor. I'm accumulative. I bring a lot of things together, which is generally a characteristic of sculpture. I can't deny that drawing has always been in the work. In fact, you could say it's the most utilitarian vehicle for my imagery. It's where almost all the images start. I'm a doodler. Some of my best images have come from semi-conscious doodling. Drawing was the best way to get the dream images down. It was also the most expedient tool. It allowed me to be spontaneous and to keep the image fresh. With painting and sculpture, it seems like you're always thinking about what kind of a "style statement" you're going to make. Drawing is somehow more democratic and childlike. I don't mean childish. I mean childlike, as in directness.

MA: You stopped making paintings and sculpture for a number of years in the late 1960s, which was very early in your career. Did you see yourself as part of a loose-knit Conceptual art movement?

JB: Yes and no. I'm not sure if we can precisely define what Conceptual art is. All art is idea-based to some degree. At what degree does it become pure idea, telepathy? However, I did have what I called my "Conceptual period." It had a lot to do with ideas I had about the universe, where I stood in it, and the nature of time. To look back on it now, and in response to what we are talking about, I could see it as a kind of large drawing as much as it was an idea. I used Conceptual art to diagram ideas, whether the diagram was in the form of writing, notations, counting, or doodles.

MA: What was the evolution of these diagrams?

JB: I was getting too consumed about making things, without taking the time to think about what I was doing and where it was going. So I stopped making objects and sat down in my studio with a pad of paper and started writing my thoughts. I think Sol [LeWitt]'s writings on Conceptual art must have been in the back of my mind. But I didn't have any intention of making a formal statement

like he did. I was just trying to figure out my plan, not just in the art world, but in the universe.

So I started writing down my thoughts, and the thoughts became diagrams. As I think back, they were visionary drawings, but they often had the look of something scientific or systematic, something well thought-out, even though they weren't. I was just drawing and trying to find out what was inside my head, without having to take the time to make something.

MA: **What about the counting?**

JB: Well, some of the drawings were interesting, some not so interesting, but the notes and images still seemed too elaborate somehow and without direction. I felt like I needed a very simple direction. So I found myself counting —1, 2, 3, 4, 5—consecutively as something very basic to do. For whatever reason, it seemed like the best thing I could do at that moment. Eventually, I decided I'd count from one to as high as I could go. I liked the idea of counting to infinity. It was an idea with structure, and obviously it would keep me busy for a long time. For hours at a time, I'd write numbers on 8½ x 11 sheets of paper. I remember thinking it was very freeing, even if it was strange. I could justify it vaguely on the grounds that it had the general feel of Minimal and Conceptual art. For me, however, there was a larger content, not so much better but more personal, maybe even spiritual, like a personal meditation. I had assigned myself a monumental project. I was drawing time, creating what I thought to be a very pure line of projection.

MA: **When did you start drawing figuratively?**

JB: At some point during the counting, I found myself drawing figures and heads on parts of the counting pages. After a while, one or two of those scribbles caught my eye. I decided to do a painting of one of them. So I got some canvas board and a little paint set, like I used when I was a kid, and did a painting of the drawing. Rather than sign the painting, I decided to put the number I was on in my counting on the painting. It made perfect sense to me.

I had my conceptual theoretical side fulfilled with the numbers and I had a very personal, recognizable image. For me, it was the best of both worlds....

At a certain point when I was in analysis, or "group," as we called it then, I started drawing my dreams on scraps of paper. It seemed to me that if I wanted a more personal image in my art, I couldn't get much more personal than that. I'd also enlarge those onto small canvases. In a lot of cases, I was really just drawing on canvas with paint. I wanted to retain the character of the original drawing, like a fleeting, unedited notation of what was in my head. Discovering the opaque projector was a great break for me. That's when I realized I could make these personal drawings public without being overtly commercial. I also discovered that I could transform a room—the whole feeling of a space—by projecting drawings all over the room. At one point, my studio was covered with drawings on the floor, walls, and ceiling, and it dawned on me that I had made the space a metaphor for the inside of my head. I've pretty much operated with that goal in mind ever since.

LOUISE BOURGEOIS

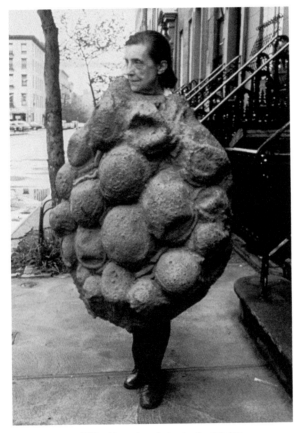

Louise Bourgeois in 1975 in a latex costume designed and made by her.
Courtesy Louise Bourgeois Archive. Photo © by Peter Moore.

GRATEFUL

October 25, 1996
New York, New York

Michael Auping: Where do these *Personnages* sculptures fit into your forty-year career?

Louise Bourgeois: They are from some of my very first shows. You can see how they had no bases and they all just lean or stand. The first sculptural debut was in 1949. I had three shows in a row: 1949, 1950, and 1953 at Peridot. *Depression Woman* was in the 1949 show, and *Breasted Woman* was in the 1950 show.

MA: That was a very dynamic time in the New York art world. It was the height of Abstract Expressionism.

LB: Yes, but I don't know what that has to do with me. My association with these works is people, real people. Art is interesting, of course, but for me people are more interesting—people, friends, personalities. The people I knew at the time explain the sculpture. They are about people I knew or remembered. Their spirit came to me while I was working on the sculpture. Or sometimes the memory came later and I connected it to the sculpture. When I work, the symbol is mostly unconscious, you see. What is important is that they are called *Personnages* because they are about people that were in my mind.

MA: Specific people?

LB: Yes, of course. But it wasn't just about individuals, but relations between people. For that first show I made a social gathering of people. I tried to make them relate to each other. So they would have a dialogue in their different forms and personalities. Some are a trilogue—it's a word I invented—which means three people relating. The trilogue is usually the nostalgic overtones of the child with the two parents. Three is a good number to create relationships, generally a more interesting dialogue than with just two.

MA: So the whole installation of sculptures is like a party or an art opening.

LB: Oh yes. They turn around on their bases. They can look all around the room, but usually they look at each other. Another point is that the early Peridot exhibitions were conceived as a four-sided room. The early Peridot show was an installation, not just a group of things. The idea of making sculpture as a space, as a large entity, with no pedestals, was not really done at that time.

MA: **Did many people see these exhibitions?**

LB: Some friends, of course. Marcel Duchamp, other French-speaking people I knew. Peridot Gallery was at 6 East 12th Street, which was right next door to the Chess Club. This is why Marcel Duchamp was always roaming around and once on his way from his home to the Chess Club, he looked in the window and he saw these strange things. This is how he became familiar with Peridot and that is why he told his friend, Pierre Matisse, to come and see. He told him, "Just snoop around and look what you see. It is interesting. There is an environment there. You just go and look."

MA: **What did Duchamp say about those?**

LB: He was interested.

MA: **Did he ever say anything? What did he think about them?**

LB: Well, he didn't say much. He was a man of few words. But he would say, "Louise, tell me about it, what does that mean?" Duchamp sent Pierre Matisse to see these early works. He also sent Alfred Barr. Barr, who was quite a card— that one, you know, I could write a book about Alfred Barr—he came into the room, and he looked very detached, very museum-like, *un gros légume*. He pretended that he was not overly interested, that he had come because Marcel had told him. Very detached, you know. So I didn't know what to say about that. And then, I noticed that he approached a particular piece that was full of little pieces hanging from it—*Persistent Antagonism*. So, he stood a long time in front of this piece and he touched those little hanging things. I was watching, I didn't say anything. I always say the wrong thing. But I was watching him, and

he took them like this and he lifted them. He was having a lot of fun. Then he said, "This is very erotic." I didn't answer. Better not to answer, right? And he went all around the room, and he made believe that he was interested in one piece, when actually he had the intention of buying another piece, right. Finally he decided. I'll have to make the story short—but finally he bought one piece for The Museum of Modern Art, *Sleeping Figure* [1947]. It's totally anti-erotic. Even though he was a Puritan, he did not deny to himself the fact that genitals gave him a kick. And he paid $400 for *Sleeping Figure*. Alfred Barr was a fantastic buyer. He knew how to bargain.

MA: What do you remember about *Depression Woman*?

LB: It's from the first show. I used to call it *Spoon Woman* and then changed it to *Depression Woman*.

MA: **You wanted to carve a spoon?**

LB: Oh no, a spoon-like shape. Well, a spoon-like shape when you are used to carving wood, is not a rare shape. It is something that you're gouging, and that comes naturally. It is not an elaborate thing. It's a simple thing. It's natural— what I call emotional geometry. It gives a good feeling when you are making it. But as you are making it, it takes on other qualities that have to do with emotions and memories.

MA: **Who is** *Depression Woman*?

LB: That is not so important to know. It is only important that through the form a personality can stand on its own, be a presence in the world for its own sake. The important thing is that what they all have in common is a strange projection. Maybe they are also self-portraits, and this is the way I feel. I would not usually do that consciously, but sculpture takes time, carving is slow. One starts with a model and then the model becomes the maker. Some people don't understand it, but sculpture is an emotional medium. Otherwise it is just another thing. So there is that fragility, a great, great fragility, and the fragility is the personality of the object.

MA: When I first saw the white shape of *Depression Woman*, I didn't read it as a spoon. When you tell me that, now I see it as a spoon.

LB: But it's also a head.

MA: I read it as a lily, a flower . . .

LB: No.

MA: . . . because of the way these things emerge, you see. It comes out like a bud?

LB: Very interesting. So you have me mixed up with the Santa Fe girl.

MA: Georgia O'Keeffe?

LB: Yes, you have me mixed up with her. [*laughter*] No, no, no. . . . They are all people. They move and can turn around. Now, I had a difficulty with the gallery about that because I wanted to nail them into the floor so they could rotate. The director said, "No, no. I do not want any nails in my oak floor. You are not touching my floor." So this guy was more interested in his floor than in my sculpture. That's that! That is why some of them were placed against the wall. I wanted them like a group of people at a party, all in the center. This is what I wanted, but it's not what I got.

MA: I see. I'm sure you've been asked this question before, but I'll ask it again: What relationship, if any, do you see between your *Personnages* and Giacometti's standing figures?

LB: I did not know Giacometti at the time. You have to be very careful about that. The work is very different if you really look. His works are not so fragile. It is not a criticism, but they are more . . . distant, aloof. His bases—the feet of his sculptures are massive. They get thinner and thinner from the base. The *Personnages* go the opposite way. They get thinner toward the base. They are

delicate on their feet. They are not monuments. It is a more fragile balance. Physical and psychological presence is a balance. That is the tension of being human, the fragility of people. We are always afraid of falling so we balance ourselves. The main resemblance between Giacometti and me is that we make vertical figures. There are too many more differences. My figures are very portable. I carried them around with me. They are not bronze. They were like companions. I don't think you could pick up a Giacometti. Also, Giacometti's things are always walking away, and mine are there forever—immobile, because I don't want them to move away. I want to keep them all right there. I want them close. One of them is my brother. I carried them around. It's very personal and an immense feeling of possessiveness in what I did with the *Personnages*. I don't want them to walk away. I want them to stay there for me. Some have no arms. They're standing there forever. Not walking away.

MA: **Are we looking at** *Breasted Woman*?

LB: Yes. It's a woman, and all these little appendages here are things that she possesses, namely what I possess—a family with three children. So I'm there with my belongings, right? I'm not walking away. I'm there forever. In spite of the precariousness, I'm there. It's a search for identity.

MA: **Let me ask you—and this may be a very male question—but if you didn't call that** *Breasted Woman*, **how would I know it's a woman?**

LB: By the openness of the gesture. She's completely open. And all her appendages. You see, I'm very proud. It's very strange, but I'm very proud of what I possess. Physically and personally; the children, the house, and the friends.

MA: **What is the symbolism of** *Breasted Woman*, **which is dark-colored mostly and then on the back just a little patch of red?**

LB: The red is, I don't know. It is not geranium red, which means blood. It is a little fantasy. It ferments beauty. Maybe the spider, the black widow spider? Again, the ambivalence—beauty, danger, a protection of the possessions. It's difficult to say.

MA: Violence, danger, not the passion of the heart?

LB: Not at that period. The passion comes later. The passion comes . . . well, let's not talk about that, it's another subject. [*laughter*]

MA: Although I often hear your work associated with American Minimalism— a more personal or content-based Minimalism—your work seems to me better related to European sculpture, perhaps Brancusi.

LB: I knew Brancusi, you know. But you see, the generations aren't the same. I met Brancusi because—this may not interest you—I met him in his studio, and I had a chance to enter the temple when I was a girl. And when he looked at me, he thought I was a collector. I was introduced by mistake. He had not seen my face and when I entered the room he was a little bit puzzled. His room was full of wood beams, and I can tell you where he got the beams. The big boats would come from Dakar, Africa, and those beams were the ballasts for the big African boats going back and forth. The beams were often left on the banks of the River Seine. They wanted to get rid of them. And the artists were invited to take those things. This is where Brancusi got his material and his inspiration. But I think his work has very different overtones. Mine were personal and family overtones.

MA: Were you interested in African sculpture?

LB: Not at all. I was haunted by the dialogue of people. Do you like me or don't you like me? My forms have always been very personal and emotional. I haven't changed so much. A more personal influence was Fernand Léger. Léger was very important to me.

MA: What did you see in Léger?

LB: In Léger, I saw the courage he had to transform the figure into what he wanted to see, his personal vision.

MA: I see. But somewhat geometric and rigid.

LB: Very, very rigid. He was very rigid, very limited. But he could find emotion in that geometry. Léger could be hard and intimate at the same time.

MA: Do you remember any other strong influences?

LB: A man called Roger Bissière, who was a tapestry maker. The people who most influenced me were my teachers. I am actually talking to the Bissière family today. Paris was full of academies, which is a very interesting subject. In my furious desire to express what I wanted to say, I went from academy to academy, and I was not very . . . I didn't have much money. I was a student at the time. I was disgusted with the Beaux-Arts and the academic schooling, so I wanted to go off the roadway, off school, and be rebellious. And I ended up with l'Académie de la Grande Chaumière, l'Académie Othon Friesz, l'Académie Bissière, l'Académie André Lhote, and Paul Colin and A. M. Cassandre, who were both poster makers. And I was running, running like a rabbit from one to the other in search of being able to express what I wanted to express. That is to say, my fear of life itself—*la peur de vivre*. And I made myself useful because I had a friend called Paul Jouvet, you know, the theater man, and he kept saying, he had only one sentence: "Make yourself useful, dear. Make yourself useful, dear." And I kept that, and would always think to make myself useful, but how was I going to do that? "Make yourself useful." I don't know what to do! [*laughing*] So I kept this in mind, and I said, "I will become a student of this great man, you see, if I make myself useful." My father used to say, "Be grateful," which sometimes made me angry but I later understood. So now I have the two important things I need to know: Be useful and be grateful. For me it was always a relation to the elders, to the father, to the people who knew things. They influenced me. This is where my gratitude lies.

MA: What did you mean by trying to express your fear of life? Is that what you said? Your fear of life?

LB: Yes, right.

MA: Is that still a part of your work?

LB: *Mais oui.* This is why I'm conscious about it long ago. I'm still interested today in my distant past. Has your life been significant? It's an anxiety. Are you still grateful for what you've got? There is an anxiety behind the word *grateful*.

MA: In the beginning, many young people are afraid of life. I know I was.

LB: Absolutely. There is a book called *La Peur de vivre*. Don't ask me who wrote it. But, *La Peur de vivre*—the fear of life.

MA: But as I get older I'm more afraid of death than of life.

LB: Oh no, you cannot admit that. You have to repress that. You jump ahead. You say much more than I do. You cannot admit that.

MA: Well, sometimes it's good to admit it, I think, to say it out loud.

LB: Well, you are more advanced than I am. I don't admit that.

JOAN BROWN

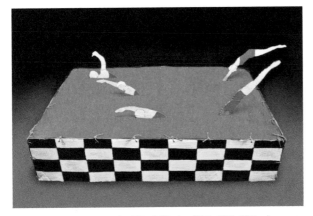

Swimmers, 1974. Mixed media. 16 × 36½ × 24½ inches (40.6 × 92.7 × 62.2 cm).
Photograph courtesy of Gallery Paule Anglim, San Francisco.

SWIMMING, DANCING (AND PAINTING)

March 14, 1979
San Francisco, Califonia

Michael Auping: So all of these images—cats, rats, dancers, cars, all of them—somehow add up to a self-portrait?

Joan Brown: [*laughter*] Unfortunately. I have this need to unravel myself—to reveal to myself, as much as to anyone else—the circus that I'm in the middle of.

MA: And you're the circus leader?

JB: Oh no. I'm just part of it, imagining myself in various acts. Right now, I see myself as the trapeze artist, swinging with only one arm and barely holding on....

MA: At one point—maybe the late fifties?—you were an abstract painter. How did that change come about? You're identified with the Bay Area Figurative movement, but I'm not clear on how all that evolved—so many artists deciding to go from abstraction to figuration around the same time. Were you all talking about it and then at some point someone said, "1,2,3, okay, let's go figurative?" Obviously I'm being—

JB: [*laughter*] It's confusing and ridiculous when you speak of styles and try to align individuals to them. That's why it's difficult to bring it all together under Bay Area Figurative. We all had different ideas, and came to figurative art for different reasons.

MA: You were the only woman.

JB: I was one of the few women, particularly among the painters. It was very male-dominated. People make a lot of that now, but it wasn't something you really wanted to talk about then. At an early point in my career, all I wanted was just to be a fucking painter. I didn't want the distinction made—"female painter," or "She's good for a girl," all that crap. I still get very pissed off when people make those distinctions. It's such bullshit. At a certain point, you couldn't tell my paintings from any of the guys' of my generation, except that in some cases mine might have been better. In the early days, like all the guys, I just wanted to

be a part of something, part of the scene. Later, I decided I didn't give a shit. I went in the opposite direction. I just wanted to be able to make and show my art outside of any group or style—better if it was outside any group, to be on my own.

MA: But do you think that being a woman might have had something to do with—not so much your making figurative art, but art that is more autobiographical? I'm thinking of someone like Ree Morton in New York now, and how she used a female sensibility to go against the grain.

JB: I don't know about that. I've gone back and forth between representation and abstraction more times than I can count, and I've been a woman with each change. But it is fair to say that figuration is somehow connected to my becoming an individual—making paintings where I felt the content was distinctly mine. . . . I've always been in love with the act of painting, and early in my career it didn't seem to matter if I was painting something abstract or something with an object or a person in it. I just liked the way paint filled up a brush and drooled across a surface. I still need that in my art. But then there came a time when I felt that painting was definitely my life, but my life wasn't a part of my painting. So I started gradually putting my life in my painting— images that represented my life as I felt it. . . .

MA: You seem to come back to certain images, or maybe I just remember certain images more than others. There are a lot of swimmers and dancers.

JB: Those are two things that I love to do, almost as much as I love painting. For me, all three are related. I'm a very physical person. . . . I think of life in terms of different forms of action. . . . When I'm painting or swimming I think of so many parallels. They're both a liquid performance in different ways, and with both of them, the harder you try, the deeper you sink. You have to relax at the same time you exert energy and concentration.

MA: You swim in the ocean, in these marathon swims in the Bay, right?

JB: Yeah. That's what really excites me, because you are really out there when you are in the ocean or the Bay. You can't just stand up in the middle of the pool and stop. You have to stay relaxed and strong just to survive. In the ocean, it's easy to drown, even with a lot of people swimming around you. You just have to keep to yourself and keep swimming. When you commit yourself to being an artist you kind of have to do the same thing.

MA: **What about dancing?**

JB: Well, that is like art for an opposite reason. They are both so frivolous but absolutely powerful when you give yourself permission to do them and see what you're capable of expressing about yourself and your attitude about life. That's if it all goes well. If it doesn't, you look like a fool. But what the hell. These things might mean more than we think.

IAN BURN

The Capitalist Art-eagle once more refeathers itself and flies off to California (a business trip)...

METTERE LA CODA DOVE NON VA IL CAPO*

The Understandable Tale of the Results of The Guest Curators Trip to New York

When Michael Auping came to New York looking for 'new work' he found no lack of arriviste artist-believers 'dug in' in the trenches of New York's mythological 'vanguard' hegemony. He found out about these by visiting a lot of art-galleries — quiet salons where ideological imperialism and pretentious aimlessness are carefully guarded as the seamless web of 'Western Culture'. (E.g.,) Joel Fisher's fetishes and Pozzi's decadent minimalism and all the other boorish cultivations of idiocy and waste are better never than late. The obviously ignoble celebrants of mystification in self-fossilizing abstract art (e.g., Jennifer Bartlett, Ron Gorchov) just as obviously reinforce the bourgeois heritage. It's no surprise, therefore, that M. Auping should end up sanctifying the bloody morass of the dictatorship of the bourgeoisie ...

Dialectical and Historical Materialism

Class analysis in Class conflict, the development of contradiction in practice, the science of Marxism, reveal and develop the advanced revolutionary class, in part, by revealing which sections of classes (and classes as such) are not advancing and are not revolutionary. Though development of conflict in this ("art") situation may seem like going after mice with an elephant-gun it is important to remember that Capitalism (mouse or paper-tiger) will not lie down of its own accord. Commitment to Class-struggle demands flushing out the vermin on an ad hoc basis, in part. The development of this particular 'set' of contradictions is 'useful' insofar as it exemplifies instances of Class-collaboration-in-Class-struggle.

A Word of Warning, Beware of Capitalist-Roaders

Semiotiques, exposees, confessions of meaninglessness and other quack-marxist historic predictions-cum-valuations are the evidence of the latest mutations of opportunism on the part of the uncommitted; a commitment to Class-struggle operates as a closure on empiricism and heads off self-predictive and self-aggrandizing historiography.

Farting in Paper Bags and Sticking Your Nose In

The art-world once loved Paris in the springtime. Today (Californian) art is completely subordinate to New York art. New York art dealers, critics, museum curators, artists and a variety of bureaucrats make the terms of making history. Californians and others can fight this hegemony, not by half-ass regionalism, but by recognizing (and understanding the necessities of realization) that what's wrong with (California) art is the same thing that's wrong with (New York) art: Capitalism-Imperialism. Study this problem: as long as California attempts to affect the social relations of art that are built on the social relations of culture that are built on the social relations of capitalist production (whose real art is the creation of surplus-value) it comes into direct conflict with the Social-social-relations of production in the context of Class-struggle.

Where's the Fire? In the Treetops?

The development of contradiction is not spewing forth 'socialist content' for Capitalist consumption. The development of contradiction means conflict, not the harmony of consumption. "Learn from the contours of experience, act humanistically" advise the Capitalist-roaders. "Organize to correctly reproduce the social conditions of our learning-in-Class-struggle" we say. Fight a life of 'spectacle' (watching yourself) with organized social power.

Californians

The Ruling-Class expects artists to serve and save their (the ruling-class) stinking history. Instead, make history that is commercially inconvenient, ontologically insecure and untidy, and history that is the end of Capitalist society — for good.

A saying quoted by Lenin in One step Forward, Two Steps Back, Progress Publishers, Moscow-page 207

(Provisional) Art & Language, *Mettere La Coda Dove Non Va Il Capo*, 1976.
Offset lithography. 11 × 8½ inches (27.9 × 21.6 cm).

A FOX

June 7, 1976
Long Beach, California

Michael Auping: I'm curious to find out what you thought of the questions I sent you. It's force of habit for me to deal with interviews from a chronological point of view, asking about your background and that kind of thing, especially when I feel I'm in unfamiliar territory.

Ian Burn: There's nothing unusual about the questions. However, there is something they brought home to me. Given where we are all coming from, given the kind of class-split environment we live in, we are really encouraged into asking the wrong questions. It happens to everyone. There are so many "smoke screens" around us that it is incredibly difficult to see where to start. So, we nearly always end up asking a wrong question, or asking a question by which we align ourselves with a distinction that exists only within a bourgeois culture —or, I should say, is necessary only to a bourgeois culture. Our questions unwittingly reaffirm a status quo while assuming to challenge it.

MA: What do you mean by "smoke screens"?

IB: Well, for instance, one of the things which struck me reading through the questions was the tendency to want to treat people I work with as artists. In other words, treat us as objects. What this culture does, as unrelentingly as it can, is turn people into things, into objects. People become objects of history rather than subjects of history. They are acted upon rather than being able to act. In asking the questions like that, you are presupposing the very situation you should be challenging. . . .

There are a lot of questions here about me and about Art & Language. Essentially, I think it's a waste of time talking about myself as well as a waste of time talking about Art & Language. However, there *are* some very important things to talk about. If we're talking about trying to change things, change things in a substantial way, then we have to construct how we might actually partici-pate in the already ongoing process of change. In that sense, asking what Art & Language is doing is asking a wrong question. This happens when we speak fairly spontaneously, our intuitions are channeled through layers of bourgeois ideology. What happens then is it becomes easier to fixate on, say, Art & Language rather than real issues. This kind of society, if you can even call it

a society, virtually compels you to ask wrong questions in order to cover up the structural relations of its economic base. This happens particularly within the art world, which is one of the more insignificant sections in our culture and is about as divorced as you can get from the means of production in the society. It is incredibly difficult to even glimpse those base relations. Which is why we tend to go around in meaningless circles within the art world.

For instance, if you look at various Marxist theories of art, so-called, you find that most of them are really of not much use. They try to construct or reconstruct a Marxist theory of art from "inside" the art world. If you want to find a real Marxist concept of art, you are going to have to forget about "art," at least to start with, and deal with society "as a whole" and then see where, in terms of the logic of capitalism, this minuscule unimportant area we call high art has its place—and why. At this point, its place is way out on the cultural fringe in respect to social or political impact. It is a powerless area which lives off the profits ripped off the wage-earners of this and other societies. It doesn't produce anything in terms of profit. It just eats up surplus value in the society. Capitalism is a wonderful system for reproducing superfluous structures on a superstructural level. The point is, we really have to know our place. Once you see it in relation to the overall landscape and you see it as the social and economic phenomenon it is, then it's pretty difficult to take seriously any suggestion of reconstruction *within* the section itself—or even *of* the section.

MA: How do you explain the existence of your publications, then, which are only available at art bookstores like Jaap Rietman and not at local newsstands, where they would be available to a wider base of people? Have you made any attempts to broaden your audience in that way?

IB: We realize the work is trapped in many contradictions, but we aren't utopian. A few people in the group have expressed interest in trying to make what we publish available to a "wider audience." But that in itself is problematic. Basically, the working class is better off without what *we* publish . . . at present, at least. It doesn't need our stuff. It knows, at least on an intuitive level, that art is totally fucked up and to get their heads into that is simply to fog up their brains even more. *The Fox*, for example, is addressed specifically to an audience of artists

and their acolytes—and the limits of that kind of direction are pretty obvious to a lot of people. We're very conscious of this and see its use as a short-term strategy only—although, admittedly, not everyone involved sees it that way.

MA: Then, in terms of any kind of social revolution, you see your immediate job as trying to create some kind of consciousness-raising within the art system—and if you can effect this, then you're doing your part in terms of the social revolution as a whole?

IB: No. I disagree strongly with that. If we limit what we do simply to the art world, we end up perpetuating that world, legitimizing its elitism, and thus legitimizing its social and political function in this economic system. Basically, as an artist in the high art world, you exist strictly as a *symbol*. What you say and what you do doesn't matter a damn. The audience is taken care of by the fact that your efforts don't get beyond a very specialized and limited group. We can write vicious diatribes against Nelson Rockefeller or whatever, but while it stays "in" the art world, it is essentially harmless. In fact, Nelson Rockefeller would probably be delighted because we would be behaving ideally as symbols, if you like, of the liberalism, of so-called "freedom" in this society. We are symbols to the rest of the world of a kind of freedom that really doesn't exist in this economic system! The kind of freedom we have, and which artists revel in, is a sort of "freedom" which is permissible *because* we are marginalized.

MA: Wouldn't it be more productive, however, to drop art contacts altogether and get a job in an upper-echelon area of NBC or ABC or IBM and try to change things from there?

IB: Yes and no. I mean, you are getting at one of the most obvious contradictions we find ourselves in, that is, where we expend the most of our energies . . . and it's the one which I think will force some of us out. At the same time, it's not easy to give up acting as a bourgeois artist. Actually, trying to change your audience comes down to committing class suicide, and we all have been conditioned into a bourgeois fear of violence and this kind of suicide is especially violent to our egos and to all the things we have been made to feel so comfortable with.

Maybe I should mention that *The Fox* was a contentious project in many respects from the start. A number of us were opposed to a number of aspects of it. For most of us it is conceived of, as I said before, as a short-term strategy, essentially a temporary front which logically has to collapse in its own contradictions. It reflects that same problem of trying to construct from "inside" the art world outwards—well, you can't do it. You are forced into presupposing "art." In terms of a logical construction, you get to a point where the contradictions are so blatant the construction collapses. Read any Marxist analysis of art and notice what is left out, where the analysis stops in order for the argument to be convincing. At the same time, of course, it is preferable to bourgeois art criticism! The better stuff in *The Fox* is an example of that "stopping short." There's a sense in which it bumps up against the walls of its own fictional world. In that way, maybe it is useful in a small way. For instance, some of Hans Haacke's stuff does a similar thing, bumping up against the limits of the fictionalized art world in terms of how far it takes it. But, like all of us, he could go a lot further than he does. . . .

Given the presuppositions that you start off with, there is a logical limit on how far you can go before the construction you're making collapses. One point is, this kind of work is still dealing with an abstract audience, whether it reflects the normal art world audience or is hyper-critical of the normal art world audience. At the same time, it doesn't identify any other audience, thus you still end up with an abstracted audience. That's what we have done. That is why a term like "the working class" is still somewhat of an empty concept for us. Our independence from the art world can only happen through subjectively experiencing a different dependence, a different living presence, if you like. That cannot happen by declaration, only by a continuing concrete or real experience. It means a situation where you have to particularize an audience. You are then talking to, say, a construction workers union; you are talking to a specific community, or whatever. That is very uncomfortable for most people who are artists because there is a wonderful myth about the universality of art and the internationalism of contemporary styles which we have all been fed on and is very attractive and compelling. If you specify your audience in that way and actually try to communicate with a particular group of people "outside" the art world, there is always the fear that nobody "in" the art world is ever going to hear about you. That frightens a lot of people. They want bourgeois recognition for their

working-class sympathies. That's the classic petty bourgeois dilemma, trying to have two consciousnesses at the same time, switching from one to the other whenever it's convenient.

MA: Given the contradictions, does the Art & Language group have an overriding goal it is shooting for?

IB: I can only give you generalizations, like sorting out some way of participating in a socialist transformation of society, and that is both as concrete and as vague as I can get.

I think there are things we can and will do. I don't know if it's things we can do as artists. That really doesn't matter.

MA: In other words, you would like to see this society based on a socialist structure. Could that be considered part of your goal?

IB: It's not our *goal* to change the society. We see our only task being that we might be able to sort out some way of participating in that transformation because it *is* inevitable. It's going on now! God knows what it'll be like in this country, what kind of socialism will develop here when it eventually does come together. This will probably be about the last place that socialism establishes itself.

Socialism is unavoidable, however, because capitalism is a system which can transform its nature, its rapaciousness, only so much. It can never lose its need to have an exploiting class and an exploited class. The kind of art we have today is really just a throw-off of the maximized profit, a function of the capital which is poured into it. The kind of art we have today, and the kind of art world we have today—well, we're not talking about that in the future. There's an article by Samir Amin where he argues that there is no possible way that you have culture under capitalism since there is no direct apprehension of use values of things. He defines culture as the mode of organization of the utilization of use values. For capitalism to exist, it must isolate use values and define them through a dominance of exchange values. We have a culture that is based on exchange value. We have an art world dependant on exchange value. In that sense, it is a non-culture . . . capitalism is the moment of negation of culture.

MA: In respect to your working in a group situation, would you say Art & Language is totally a collective phenomenon?

IB: Well, it depends on how you want to define "collective." The only way you can really define "collective" is in ideological terms. In those terms, I would be very hesitant to say that we were a collective because I don't think there is, at present, that degree of ideological unity between us to say we are a collective.

In terms of a working group, we do work collectively some or most of the time. That's simply for practical reasons. Some of us started working together over ten years ago. We never made any conscious decisions about doing it or anything like that. Most of us tended intuitively to work towards that kind of relationship as a way, if you like, to avoid the individualism and personality cult thing that operates in the art world. A way of trying to maintain some kind of personal-ideological space. We've been talking about what an artist is in this society. Basically, an artist becomes exactly that which he is trying to create. In other words, he becomes the object and is what is sold. I suppose, in terms of avoiding something like that, we intuitively went towards a collaborative form of working.

One could probably say it had something to do with cultural backgrounds also. We were faced with modern art being dominated by American art, not even American art really, but New York art, which reflects a most perverse projection of individualism and personality. Coming from Australia, which is culturally more English than American, there is something obscene about the kind of commod-ification of people, the commodification of personalities, which is so rampant in this country.

At the same time, I am not saying we are immune to such things. There are some pretty big egos in the group. But a lot of the problems we have are problems from the social and cultural environment which we live in, putting pressures on the group, and which usually emerge in terms of people's psycho-logical reactions within particular situations. We're operating in a market which demands individualization of the product *and* the producer. If you use an orga-nizational form which isn't compatible to that economic structure, then you are going to be constantly bounced around—and we're constantly bounced around. This manifests within the group in terms of a lot of psychologically

based conflicts. I don't mean in terms of needing psychoanalysis or whatever. Maybe "psycho-social problems" is a better way of putting it. There are social problems which are internalized and manifested in affairs within a working group in a society like this. You either sink under the conflict or see it as part of the struggle in a larger sense. If we begin to see our seemingly small personal struggles as part of the larger worldwide struggle, it changes a lot. Some of the people we work with tend to want to treat conflict as a norm of our going-on. That is right, I think, but I don't like the stress it gives; I would rather say it was a fact of going-on and that *struggle* was the norm.

Recently we've been trying to sort things out a bit better—or sort ourselves out a bit better. We've been trying to collectivize the group along more ideological lines so that we might be politically a bit more organized and abrasive. Of course there are problems—most of them to do with money. People become very fearful of losing contact with that economic base. But that can be struggled over as long as there is an ideological commitment to struggle. When there isn't, or there appears not to be that commitment, then schisms appear which are not ideologically bridgeable. That has happened, particularly around Joseph [Kosuth]. . . .

MA: Are there any differences between the English Art & Language group and their North American counterpart?

IB: To make any kind of comparison like that you have to treat the people working in New York as having static relationships and the people in England as having static relationships, and that is impossible. There are disagreements, of course. I tend to disagree with some of the assumed relationships to language that some of them in England hold to. However, there are people in New York that will disagree with me about that, and agree with the people in England. So it becomes rather complex in that sense.

They assume a sort of natural relationship to their style of language and there isn't a natural relationship to it, at least not to the form—there may be a natural relationship to the content. . . . If they're going to deal with it, they have to see the form of language in terms of political strategy, and I think a lot of it is rotten strategy. In terms of what they say, I agree with it. In terms of how they say it,

I don't always agree. On the other hand, they see a lot of the stuff in *The Fox* as oversimplifying the problem and localizing it too much "in" the art world. To an extent, I agree with that too. A lot of the articles in *The Fox* give a somewhat simplistic view of problems which are much more complex. They also localize things too much in the art world. Moreover, *The Fox* is *very* New York—based, the extent of which I've kind of realized more from being here in California. Basically, New York is an extremely isolated "art world," in respect to any sense of community. You might have ten or twenty thousand artists working in the same area, but there is very little input into it. It has a kind of baseless arrogance which produces a provincial mentality because it loses sight of its relations to other contexts. It feeds off itself and doesn't permit very much input. Everybody is trying to feed off everybody else, which gets to a point where the most trivial changes are welcomed with such relief that they are treated as if they were the most revolutionary breakthroughs. It's all rather silly and pathetic. To maintain its position of power, it must pretend to be self-sufficient, and this isolates it from any healthy social resources.

In the rest of the country, I would suggest you have people who, at least on an intuitive level, are much more progressive than people in New York. Probably more progressive than we are in terms of publishing *The Fox*. What *The Fox* does is unwittingly appropriate those kinds of progressive attitudes, that is, appropriate them *as a function of New York*. It dresses them up in more sophisticated language, since we are more practiced at talking about some of the issues, and ships them back out and shoves them down people's throats. They don't need them, if they sort out their rather bizarre dependency relationship with New York.

MA: **Then what is your relationship to New York, and why is Art & Language based there?**

IB: Well, for instance, Mel and I came to New York because—I don't know—it seemed like a good idea at the time. In retrospect it's rather difficult to remember what seemed so good about it. However, we stayed there, and now there are a number of people we're working with who also live in New York. To move out of New York and to assume the same working relationships, we're

facing a rather large logistical problem. But there are *other* more important problems to be sorted out before we might even consider anything like that— if then, even.

But it's really not accidental that we're in New York. We went there because that's where the art world was and we were into being avant-garde artists.

MA: I haven't noticed that any women play leading roles in Art & Language. Why do you think that is?

IB: Again, you're fixating on Art & Language. But to try and answer your question, in terms of our original collaborations, we were (and still are) a male-dominated group. We reproduce the structures of bourgeois ideology as much as anybody else. It's only come up as a real issue recently when some women have gotten involved. Until then it wasn't an issue because there weren't any women involved. There are no blacks involved or Chicanos or Eskimos either. To a large extent what we've done is fairly representative of white, Anglo-Saxon, male-dominated art. What can I say?

MA: It's awfully hard to get away from competition and individualism in this society. Do you have any problems within the group regarding competitiveness? How do you deal with it?

IB: Competitiveness usually emerges in various guises of opportunism. How do we deal with it. Well, not very well, so far. Hopefully, we can learn to deal with it better.

MA: Do most of the people in the group feel competition is a totally negative phenomenon?

IB: No. The real issue you have to raise is about the *possibility* of competition in other than economic senses and *that* isn't possible under capitalism! Capitalism hasn't really been competitive for the past one hundred years or so. It has been corporately monopolized so that real competition literally can't exist. It has gradually transformed every possible area into monopoly and eliminated or

restricted competition because monopoly means *control* of the market. You can maximize profits on a scale which you can't in a more competitive situation. I've lost your question . . . how do we see competition existing in art?

MA: . . . competition in terms of trying to come up with a more innovative idea before someone else, or to come up with a newer idea and get it out faster than someone else, that kind of thing.

IB: I see what you're saying. But individuals really don't "come up" with ideas. There is a sense in which everything comes up in some kind of social way. If you look around and see the art that is being produced throughout the non-socialist world, you see the same kinds of art being produced everywhere. There's an obvious monopolization of culture, a centralization of power, and a dominance by media going on. But the kind of art that is produced, if you want to call it art, still represents collective effort which is appropriated by individuals for self-interested ends. People don't have isolated ideas. They are springing off somebody else, then somebody else takes it over, and so on. It's a complex social process. Most of what we write, for instance—well, it would be incredibly difficult to try and figure out where some of those ideas came from, and who did what with them. However, they usually come out with somebody's name on them, which is simply an example of a kind of cultural form which you are coerced into using in order to have the "right" kind of relationship to a market, in order to get people to *read* it. For instance, you would have a very different relationship to, say, *The Fox* if it came out without names on the articles. You have certain expectations. You want to recognize individual bits of writing. We have all been conditioned like that.

MA: If we could move on a bit, I've been wanting to ask you what, in your opinion, should the function of art be?

IB: There is no way we can blueprint the future! What we can talk about is the function that art serves in the present society. We can talk about how one might go about transforming the present society. However, the ways of transforming it or changing it are *not* through art. Art plays a very minor role in relation to that

kind of change. When we actually have a social and economic revolution in which the economy is organized along different lines, then *that* will generate different kinds of social relationships between people, we will start to have some kind of a more real culture, and perhaps a kind of "art" flowing out of those social relations, who knows.

But there is no way you can get into predicting what that will be. Sure, I could come out with a few utopian ideals, although I tend to think that probably fucks people up more than helping them. Basically, in respect to the kind of critique that we are generating, and anybody else who is critiquing modern art, it obviously reflects a certain point of view. That reflects certain ideals which you can interpret, if you want to. On such a level, if you want to talk about what the function of art is in this society, essentially it serves as a kind of symbol, as we said earlier, of something that really doesn't exist. It represents a means of violently appropriating creativity, and containing it within a very small area. It specializes creativity. It also marginalizes it. In that way it becomes a very political instrumentality which denies the basic creativity of most things that people do or might do in their lives. Its function in society is, on a mass scale, to repress creativity.

I realize creativity is a rather funny word to use here, because it's been taken over by the psychological interpreters of bourgeois art history. I'm not talking about it in that sense, but in a social sense. In the sense that it might imply a certain relationship to what we do, a relationship through which we might regain control over our lives—a relationship which might help us achieve that.

MA: In terms of psychology, for me there is a definite psychological aspect to art, a kind of personal communication between myself and the art object. It may involve some kind of personal iconography—archetypal iconography. I'm not all that sure how it works, but there is a kind of subconscious communication going on. Does this idea come into play in terms of your philosophy of art? Do you acknowledge that aspect of art?

IB: There are a number of sides to that. The mode by which the art industry individualizes production tends to put the artist in an exclusive relationship with himself and nobody else, which means the psychological elements are obvious

and the social relations are not. So social issues in the world tend to be reflected only within a psychological context, which is a way of making them hard to deal with in an active or engaged way, in fact, hard to realize as even being socially based.

I'm not putting down psychology, etc., as bad in themselves, but how they are used and the sorts of relationships they reproduce to people . . . which are just insidious. We are constantly encouraged to treat the psychological as a natural base for relating to things, which is scandalous. In this society it isn't natural, it's political—it's embedded in bourgeois ideology. We have to begin to reconceive of ourselves in relation to and in association with other people. We keep coming back to the most basic and simple bits of Marx—the individual as the sum of his social relations, and so on. In a bourgeois society, the individual is defined as sovereign unto himself or herself, as not fundamentally existing in any kinds of relationships. Look at the form of individualism that exists in this sort of environment, and how the individual is treated as exclusive of relationships to other people. Then, look at the kind of art that is produced in this society, and you see a very strong bias towards formalisms, where the whole idea is based on manipulation of internal relationships. That's the other side of the coin, if you like, the individual as a domain unto him- or herself—and the object as a domain unto itself—bourgeois individualism and bourgeois art. If you have that concept of individualism, you have to have formalism. This is the intimate connection between psychological content and formal content. That's why all the current bullshit about post-formalist art and criticism is laughable. We won't get away from the dominance of formalism until we start living differently, until we start relating to other people and to ourselves differently. Again, it's getting off on half-assed analyses of the problems, or perhaps opportunistic analyses would be the more accurate way of putting it.

MA: Do you feel your work is void of formal decisions?

IB: We all make formal decisions, but what comes first? Do you decide on a form, and then try to fit something, a point of view, into it? Or does the content precede the form? Obviously the content must precede the form. However, if you presuppose modern art, you presuppose form, and presupposing form

is negating the possibility of real content in anything except a weak metaphoric sense.

The history of modern art from the middle of the nineteenth century on is fairly plain. The official history of modern art (meaning what has been singled out as *the* history) has, in the relations of form and content, placed increasing value on formal decisions while content has been slowly lost or redefined as form-as-content. People talk about the content of Jules Olitski's work as being color, edge, line, surface, saturation, etc. That's not content, that's form masquerading as content. That's basically talking about an inability to have content.

The type of relationship between, on the one hand, the concept of individualism you get in art, which is just a slightly more perverse form of how it exists in society, and, on the other hand, the kind of formalism you get operating in the official history of art, well, you have a very funny relationship between people and objects, a necessarily *passive* relationship. Then, the only way you can encounter art objects is contemplatively, and that basic relation of contemplation is really a function of a fundamental structural relation of capitalism. The needs of capitalism demand all the relationships between people and between people and things be transformed into passive ones. This sort of relationship is necessary in order for commodity production to predominate. The problem is fundamental, but it's rather difficult to talk about. Our language is built for talking about things, not relationships. Passivity means fixed relationships, which means structural immutability. But it is just such passivity that allows you to feel there is some kind of, as you say, psychological empathy between you and the object. However, it's an empathy of contemplation, and you passively "enjoy" it, but there is no way it engages you in an active way. It doesn't inspire any sort of activism. It doesn't make a co-worker out of you. It makes a *consumer* out of you! It turns you into an object as much as it itself is an object. In art, we've come to recognize this as the social function of contemplation. Throughout society as a whole, it manifests in many other ways, but it all comes down to the same sort of basic structural relationships whereby there is an isolation between people, and an isolation between people and things. It's basic alienation. Take the television set, for example. How often do you watch television and get inspired to do something, anything? If they can keep revolution on television and off the streets, there is little problem in controlling people.

MA: You really bring the hammer down on most of the art being made today, and I'm wondering what alternatives you leave for the rest of the contemporary art community. I mean, is it strictly black and white, with no gray areas in between, a kind of "you're either with us or against us" situation?

IB: Again, you're asking me to hand over some kind of blueprint for an alternative, but any kind of alternative ends up being conceivable and defined in terms of existing circumstances, and that's no alternative! It's minor reform. We can't conceive of something like an alternative. You end up talking about utopian enclaves, utopian in the sense of dropping out, but dropping out entirely, and forming some sort of utopian commune. That has no political point to it.

Basically, people have to come to an analysis of the situation themselves, and have to build their own ways of dealing with it. It has to grow in every person's consciousness—class consciousness and consciousness of their history. There is no mass way of dealing with it, yet. I think we will all know it when there is. There are only personal or small collective ways of dealing with it, and, depending on who people are, where they are, how far they are prepared to go, etc., they will decide what they can construct themselves.

This is a very common question that comes up. People say, "All right, you've got all this criticism, but where does it leave people?" In terms of teaching situations, we are confronted with this a lot. Administrators sometimes complain we leave students "paralyzed"—meaning students can't use the analysis they have achieved in any of the traditional art forms. We have that problem ourselves to some extent, of not knowing how to act in such a way to fully use the analysis we have. Part of that is a result of the fact that we're also operating from an incomplete analysis of the situation. No one really has a thorough analysis of the situation, yet, if that is even possible.

MA: In teaching, would you encourage a student to get out of the "art world" situation?

IB: I can't answer that. It's a decision students have to make for themselves. The most I can do is try to give them some kind of frame of reference in which they can come to an analytic understanding of their own situation. They've got to sort

out what they can do. There are a lot of people who say they would just as soon be bourgeois artists.

Also, even if I work with some students for a long time, I'm a very small influence in terms of all the influences working on them. They have to make the decision. In general, art schools are not the best places to make decisions. Remember, when you go to art school, you are working in an environment and being taught skills which have a given bias towards the interests of one class and against the interests of another. Art educational institutions are repressive to those inside them, and oppressive to those outside. They are control centers. They are, again, one of the means by which creativity is contained and controlled, and ultimately negated. If I'm in there, then I'm also acting as a function of that controlling structure. All I can do is try to make my situation as *explicit* as possible. That is, to try and explain to the students the relationship that I have to them under the circumstances. A certain amount of work *is* possible. However, even if I work out some sort of ideal situation in which there are pointed and free-flowing discussions and a lot of give and take, and I'm not treated with any more respect than anyone else in the room, there is still the material issue gnawing away at all our psychologies that I'm getting paid and they're paying. There's no getting around that one. So all you can do is point out the extent of the control—the obvious and the discreet—because control tends to render itself as invisible as it can, as if that kind of structure is not really political, but natural—which, of course, it isn't.

The whole situation is extremely problematic. Should I go into art schools, and try to turn everybody into Marxists or something like that? Obviously not. I go in there and try to provide them with some conceptual tools with which they can come to some kind of concrete analysis of their own situation. They have to make the decisions from there.

SCOTT BURTON

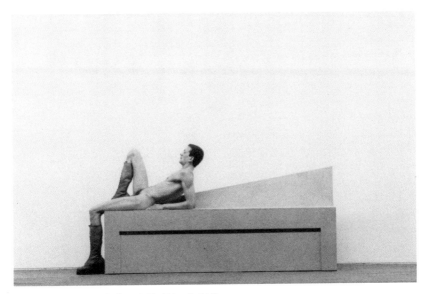

Individual Behavior Tableaux. Performed at the University Art Museum,
University of California, Berkeley, 1980. Photograph by Ben Blackwell.

NAKED

October 10, 1979
Berkeley, California

Michael Auping: Could we talk now a little bit about Minimalism and your relationship to it? Maybe we could start with Judd, his ideas about Specific Objects and a sculpture as a thing unto itself. I always interpreted that as being about an ultimate reality—a singular abstract object with no reference— a form in a vacuum. Do you think such a condition can actually exist?

Scott Burton: That's one of Minimalism's dilemmas. Judd's work is an extension of a pure side of modernism. My work is also an extension of modernism but I want to take it into a less pure condition, a more social or behavioral condition that doesn't exist in a vacuum. People relate to things and things relate to people on many different levels. On one level, our bodies are sculptures in the midst of a field of sculptures. In terms of the history of making things, we design the world to either fit or modify our behavior. The style of objects is a behavioral condition. That's why I'm interested in furniture.

MA: Without sounding too crass, what makes you different from a furniture maker, then?

SB: It doesn't bother me to be called a furniture maker. Should Fellini care if he is called an artist or a filmmaker? I doubt it. He would know that art exists in a number of conditions besides the "art" world. He didn't like using actors. He preferred people off the streets who would not act but react to his situations. He would take found behavior and modify it. Now that I think of it, I can imagine some of my furniture in some of Fellini's films.

MA: Maybe this is the point to talk about some of your performance pieces. How did you get involved in performance, or what led you from an interest in sculpture and design into performance?

SB: Performance was where the fringe people found themselves when I was making my way in the art world. I like to scratch around the perimeters of things, and performance is good for that. Also the human body is central to my work. A piece of furniture, even without the presence of a body, refers to human presence. You argue that its absence exaggerates its presence. When you see

a piece of furniture presented as a sculpture, it creates a dynamic of us versus it. Is it designed for us, or are we designed for it?

MA: Some of your performers are nude. Is that—

SB: I think that exaggerates the dynamic. I've always thought of sculpture as the ultimate condition of nakedness. The body and the furniture are presented on equal terms, both stripped down and exposed. Placed together, they create a kind of subliminal narrative—a kind of psychology of poses.

MA: You mentioned Fellini, but even more generally there is a kind of filmic aspect to these. The performers, for lack of a better term, strike various poses, and then the lights are abruptly cut out, and then they abruptly come back on and a new pose is presented.

SB: That's how it is in this piece. It does have a perverse filmic quality, sculpture in the vicinity of film. I also think of Muybridge sometimes.

MA: Are the actors, if that is what we call them, performing around the furniture/sculptures?

SB: They are actors—literally, in some cases. And they have to move to very precise gestures that I direct them in.

MA: Do you make the furniture for these performances?

SB: In this case, I had it made. Sometimes I find it. I collect furniture. I see it as sculpture. I think it has an even more interesting typology than sculpture.

MA: Are these gestures from classical painting, or just invented?

SB: They're hybrids of art history, psychology, social gestures, street signals. They can be dramatic or very subtle—mostly subtle, sometimes barely visible.

MA: Someone just sitting or standing somewhere in a particular way?

SB: Yeah. It's how they are sitting or standing in relation to each other or an object or piece of furniture that the piece is about—spatial/behavioral relationships. Basically, we are talking about body language, which can be very subtle, very subversive, very secret. So subtle that you don't even see it. That's why I have to direct the performers to move extremely slowly. You could call it behavioral minimalism.

MA: If I can be perfectly honest and ask whatever I feel I need to—and none of this has to be in the essay—is there a strategy that relates to gays more specifically?

SB: I could answer that, but I'm not sure you could understand it. Certainly someone who is gay could relate to many of the gestures my performers make. It's a language you learn. But this is not gay art, if that's what you are getting at. These actions are a language that everyone uses. I am gay, so there are some subtexts in the same way there are in other artists' works. You could say that people are like furniture. They take different poses and suggest different genders.

JAMES LEE BYARS

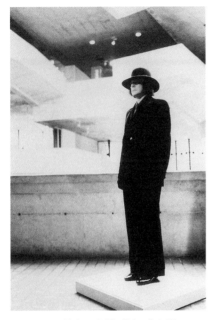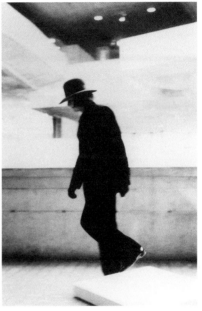

The Perfect Kiss. Performed at the University Art Museum,
University of California, Berkeley, March 1978.
Photographs by Colin McRae.

PERFECT

December 1977
Venice, California

Michael Auping: **This performance,** *The Perfect Kiss*, **exactly what is it?**

James Lee Byars: It's a suggestion—the possibility of a question. Perhaps an enactment of the possibility of perfect.

MA: **How would you describe it?**

JLB: Lips almost touching and almost not touching—almost not perceptible but immeasurably perceptible to those willing to look, yes?

MA: **So, more specifically, you will walk out into the lobby [of the University Art Museum, Berkeley] every day at a set time and step onto a small pedestal—**

JLB: Wearing a suit.

MA: **A special suit?**

JLB: A formal suit. It is a special occasion, no?

MA: **And then what happens, and about how long will it last?**

JLB: As long as it takes for lips to come together.

MA: **Your lips.**

JLB: Yes. Just touching.

MA: **And that should be perfect?**

JLB: If you can think perfectly, it should be enough. Don't take this personally, or, if you must—well, this interview should be very short, like a question, yes? The perfect interview, like *The Perfect Kiss*, should be short, no? That way you are not sure if it is or it isn't.

CAI GUO-QIANG

Clear Sky Black Cloud (The Metropolitan Museum of Art, New York), 2006.
Black smoke shells. Duration variable.
Photograph by Hiro Ihara and Teresa Christiansen, MMA.

FIRE MEDICINE

February 22, 2007
Fort Worth, Texas

Michael Auping: Let's start by talking about the Shanghai Drama Institute.

Cai Guo-Qiang: The Shanghai Drama Institute was very important to me. In terms of training as an artist, I feel very lucky to have that experience. The curriculum at Chinese art academies at the time focused on very traditional Chinese ink painting or oil painting, and almost exclusively realist. At the Drama Institute, I was exposed to many different materials and many different approaches to how an image could be created. I could not have learned the things I learned there at an art academy in China. I learned to be open to all types of materials. In theater, there is no one media. Many mediums have to be put together. The concept of a multimedia artist has existed for some time in the West, but not in China. Our art academies have been very strict and regimented. I was very fortunate to be exposed to a multimedia approach to art early in my study, even if it came from outside the art academy.

I also learned about collaboration, and that one had to consider how to make a budget for large projects. You could not have learned these things in an art academy at that time. Things have changed, however, and some of these things are now being taught.

Also, of course, studying at a Drama Institute made drama an important element in my art, along with the element of time. Questions about how to create a narrative in space and how an audience will respond to different gestures in space over a certain duration were very important lessons I learned at the Drama Institute. I became very interested in the fluidity of time. Theater deals with stories that are both contemporary and historical. It's like an immense three-dimensional history painting.

MA: I don't really know very much about the character of Chinese theater. I know a little bit about Japanese theater, Noh drama and Kabuki.

CGQ: Those genres exist in Chinese theater as well, but the most popular style of theater in China is the Peking Opera. This type of theater involves a lot of elements: singing, acting, playing instruments, and it includes martial arts. There is always a lot going on in these operas. Also, each region has its own operatic style with some very special features.... The Sichuan Province has the

element of "changing faces." In the middle of an act, the face of a character is instantly transformed into another character. It's like magic. You can't see how it is done. It's not just an expression change. It's a complete facial change into a completely different character. In Fujian Province, where I am from, we have a lot of "Clown" (*chou*) characters, which were adapted from puppetry. Puppetry is a very important form of art in my hometown. It is a folk art, but it creates a great deal of influence outside of folk art. Many of the important stories we learn as children and even later that have to do with politics and personal behavior come from puppet tales. Theatrical actors from Fujian often perform like puppets. This is an interesting discussion because I do sometimes think that my work has been influenced by this regional form.

MA: **The fact that you suspend a lot of your objects and images in space with invisible wires—I wouldn't have thought of it as a form of puppetry, but now that you mention it . . .**

CGQ: I'm sure that puppetry has had some effect on my work, but I don't really think about it consciously. I do know that all of the traditional forms of theater in China have affected me in different ways, particularly in their formal aspects. Formalism is very important in Chinese theater. It holds great respect for the presence of images in space. Also, the symbolism of these images as they move through the narration is very powerful, sometimes shocking but always poetic. I would like to be able to emulate that in my own art. It's very different than Western-style theater where narration is very connected to language and dialogue. In Chinese theater, images often carry narration. It's more of a dream world in which various symbols resonate with emotion and meaning.

MA: **It sounds like a sculptural ideogram.**

CGQ: It's true. Our language is ideogrammatic. It is how we think—through a series of connected images. But in theater, these powerful symbols often have multiple meanings, and some of the best images can have contradictory meanings. This is something that I have often tried to incorporate into my art.

MA: When did you first become interested in gunpowder?

CGQ: In my hometown, people make a lot of firecrackers. Ever since I was very young, I remember firecrackers. All over China, gunpowder has always been a readily accessible material. It's something that I have always been aware of as part of my environment. The Chinese use fireworks as a very basic form of expression—to announce a birth or a marriage or even the beginning of a meeting—and it has many nuances. For instance, if you know that one of your neighbors is pregnant, and then one day you hear firecrackers outside their house—judging by the sound, the loudness—you will know whether it is a boy or a girl. If it is a boy, the sound will be more aggressive, and for a girl, it might be more subtle. Firecrackers can send many different messages.

MA: And many of these messages are emotional.

CGQ: Yes, deeply emotional, with ancient connotations. At one time, firecrackers were called "exploding bamboo," because you would fill one end of the bamboo with different types of gunpowder. You would hold it out in front of you and it would explode into space in order to scare away bad spirits. Gunpowder itself is literally called "fire medicine." It was discovered by the alchemists when they were mixing nitrate with sulphur. You could say that it was accidental that the Chinese were the first to discover gunpowder, and that is partially true, but it is also true that they were very advanced in experimenting with potassium nitrate and sulphur.

MA: It's obviously a discovery that has had a huge historical impact, but even at the time it was first discovered it must have seemed extraordinary, magical.

CGQ: It's hard to imagine now, but yes. It must have been absolutely startling, like the way a child reacts when he or she first sees fireworks. When it was first discovered, they say that the practical quality that attracted their attention initially was the instantaneous explosive reaction and the fact that it made a large sound. The other characteristic that attracted attention was that it was a way of launching light and color. They also realized that this launching effect

could be immediate and close-range, and could be employed as a signal. For instance, the Great Wall of China is about 10,000 kilometers long, connecting the capital to the farthest part of the territory. When they had situations at the border in which they needed to transmit a message to another part of the wall, they used fireworks from signal towers that were placed 1.5 kilometers apart all along the wall. They would use yellow, white, or black smoke to indicate the message. Depending on the color, it could be something celebratory, perhaps the military has returned from a successful operation, or it could be to alert for danger or some kind of emergency.

MA: So from their beginnings, fireworks have been used as a form of public communication, perhaps even an early form of public art.

CGQ: The public projects that I create are in many ways just an extension of this long tradition. I try to mix the messages of the site and the context and create as many layers of the message as possible.

MA: That's not the history we think of—after all, it's called gunpowder.

CGQ: Along with the signal aspect of fireworks was the fact that gunpowder could be used to launch an object or another explosion a long distance. So a weapon was invented.

MA: A very powerful emotional message.

CGQ: Unfortunately, yes, but that is not the only story regarding this material.

MA: The fact that it was discovered by alchemists, and that alchemy was a combination of science and religion . . . there also must have been some kind of religious element involved or inferred in its discovery?

CGQ: Yes, and that came from Taoism. The three religions that dominate in China are Buddhism, Confucianism, and Taoism. Confucianism guides people in their ways of interacting in society. Buddhism addresses life and death cycles.

Taoism deals with nature and the universe. Taoism is the reason why there are so many seminal discoveries in China. It is the foundation of our science, but it is also a religion. Taoism cultivated the discoveries of different herbs and minerals to protect health. During the Dark Ages, the mortality rate in China was very low, and this is attributed to our understanding of Taoism. Taoism in essence deals with the pursuit of an unseen world, the supernatural and the sacred—forces that are behind what we see in front of us. It relates to how one sees the world inside a crystal ball, and that it reveals the structure of an inner universe.

MA: And to the outer universe, the planets?

CGQ: There is a connection, of course, to the Big Bang theory of the universe, but I think more importantly to the sun, which is made up of a series of monumental explosions. When the ancients discovered gunpowder they may very well have felt that they had discovered the secret of light and possibly the creation of the universe.

JOHN CHAMBERLAIN

John Chamberlain with Diana Ross and the Supremes, and Diana Ross's mother,
New York, New York, 1964.

HAIRCUTS

1982
Berkeley, California

Scull's Angel, 1974. Welded painted steel. 29 × 45 × 38 inches
(73.7 × 114.3 × 96.5 cm). Collection of the Modern Art Museum
of Fort Worth. Gift of Mr. and Mrs. Max Walen, 1975.
© John Chamberlain / Artists Rights Society (ARS), New York.

Michael Auping: **What were some of the things that influenced you to become a sculptor?**

John Chamberlain: I was a hairdresser in the early fifties.

MA: **A hairdresser?**

JC: I cut hair. You know, the barber shop, the beauty shop.[1]

MA: **I know, but—your hands look pretty rough for that kind of work. I guess I'm just surprised because cutting hair seems so delicate for someone who ended up crushing metal, hammering car fenders into sculptures.**

JC: It's not just fenders. I use all parts of the car. I use other materials, too—foam, paper. But the point is understanding degrees of compression. The fundamental act of making sculptures is the act of compression. And everyone does it, even if they don't know it—breaking a pencil, how you wad your toilet paper, how you shake hands. Every material has a different density, different weight. And every person has a different nervous system. Every hand squeezes differently. In finding your place in sculpture, you need to find the material that offers you just the right resistance. As it turns out, car metal offers me the correct resistance so that I can make a form—not overform it or underform it. At one time, hair offered me the right resistance. I think I probably learned about resistance when I was cutting hair.

But I think I'm better at sculpture than cutting hair. Maybe not. I was pretty good. I still cut some of my friends' hair.

1 In 1950 Chamberlain studied hair dressing and makeup through the Veterans Administration GI Bill. In 1951 and 1952 he studied at the School of the Art Institute of Chicago, and from 1953 to 1954 he worked as a hairdresser and makeup artist in Chicago.

FRANCESCO CLEMENTE

Self-Portrait, 1980. Oil on canvas. 19¹¹⁄₁₆ × 15¾ inches (50 × 40 cm).
Private Collection.

YOUNG
INTERNATIONAL ARTIST

May 1984
New York, New York

Michael Auping: Should we begin in India, or Naples, where you were born?

Francesco Clemente: Wherever you like. I'm happy in both places. New York is probably my home now. With my work it doesn't matter where you begin. It always goes to the same place.

MA: And where is that?

FC: To the mood of the body. It's a basic source of knowledge. I trust people who think with their body. The body is the basis of thinking and language. A child counts its fingers and toes to understand itself. These are its first thoughts. Everything else is an abstraction.

MA: Have you always been a figurative painter?

FC: As a child, I was a poet, so my parents tell me. But I was really not a writer. I would dress the language with clothes, the clothes of image. I wrote ideograms. It's that space between writing and drawing, but it's really drawing. I like the space between things, between symbols, between art and garbage, between mind and body, between sacred and profane, between man and woman, banality and exquisiteness. That is where a beautiful mutation can exist.

MA: So your earliest works were drawings?

FC: Drawings and collages.

MA: Collage would allow you to put opposites together. Do you think that's why you were attracted to it?

FC: It embraces analogy. An analogical chain is a way of seeing images without skepticism. I accept all images as material that can be used to make other images. We live in the time of the fragment. The Cubists left us nothing but fragments. I piece them back together without any worry about how it was

before the image was broken apart. The image tries to remember its heritage but it can't. So it exists as a beautiful distortion.

MA: What do you mean, "the image can't remember"?

FC: It's like the history of language. We use words whose original meanings have been lost. Images undergo a similar mutation over time. I think of my images like language. They are like ideograms. Do you know ideograms?

MA: Like writing with pictures?

FC: Basically. I make a language of images, but the language has no edges. It invents itself. It does not worry about the beginning or end of the story. I would like my image to be in a state of constant and perfect mutation.

MA: This mutation seems to occur as an ongoing form of self-portraiture. Would you describe your work as essentially self-portraiture?

FC: My images are about thinking with the body, and I use my body because it is the most accessible. I suppose I am a self-portrait artist, but I'm not interested in the idea of identifying with a genre. I'm more interested in symbols, breaking symbols, making symbols up, moving through symbols the way an abstract painter contemplates brushstrokes. When I was a Conceptual artist, I was always more contented with the symbolic.

MA: You were a Conceptual artist?

FC: For a very short time, around 1978.

MA: What was the nature of that work?

FC: Photography, drawings, mosaic, many media. I like to move through media the way I move through symbols. These days I am more traditional, more a painter, but with the irony of a Conceptualist.

MA: I see a lot of drawings around here—not many paintings.

FC: No. No paintings. I'm working up to something. Paintings have to trick me into making them. So far this month I have evaded the tricks.

MA: Do you like working on paper better than on canvas?

FC: I can imagine myself a minor artist who only does drawings, but it is a fantasy. No masterpieces, but small surprising exchanges between images— a constellation of images in dialogue. It's a different strategy. I can execute with paper more quickly to make a constellation of images. You can work with sheets of images and change the relationships and sequences.

MA: So with paper you can make one work with many parts—

FC: On the floor or on the wall. It is only one idea, but it is how I think of my work. Like a field of images that shows strong differences and affinities at the same time.

MA: Is it like constructing a story with images, or like a Surrealist poem of chance?

FC: It's not a story. It's what I call a collection or constellation that is in constant mutation.

MA: What do you mean by "constellation"?

FC: Every image argues for its own way, but at the same time there can be convergences. Something very commonplace can have a relationship with something exotic. Gold is only a rare form of dirt.

MA: So paper allows this better than paintings?

FC: It also has to do with—paper is portable. It makes itself practical to me because I travel. I have to travel and paper is an enduring medium for the traveler. I can't make work unless I travel. It forces me to think. It forces me out of normal thinking, which is a curse for my work. I don't want to be happy or satisfied with what I think. I want to be surprised. If you stay in one place, eat the same food, go to the same clubs, wear the same clothes, you become satisfied and predictable. You will begin to know the kind of paintings you will make.... I have to disrupt my motif of living.

MA: And you can do that in India? Is that why you specifically go there so much?

FC: Have you been there?

MA: No. I'd love to go.

FC: It's an amazing place.

MA: How would you describe India to someone who has never been there?

FC: It's impossible, even if you have been there. How can a year have 365 days and India have four hundred holy festivals? How can a river be a god with three hundred names? It is an impossible place to name, to describe. Image and memory and reality all threaded into—it's impossible.... I'm interested in India because of its collective vision, which is not high art or low art but is just . . . everything, you know, what they are practicing is civilization.

MA: Do you study Hinduism?

FC: You don't have to study, or at least you don't have to believe, to be a Hindu. You just have to be there. It is not a third-generation religion. It's so basic.

MA: Are you Catholic?

FC: I prefer the time of late Rome, a time when all of the religions mixed. So you could believe anything. Well, you know what Ezra Pound said: "Religion is an unsuccessful attempt to popularize art."

MA: **What attracts you to fresco?**

FC: The irony as much as the beauty. It's the medium of the church at a time when the church was the public museum. Now it's the other way around. I think it's ironic to make a fresco in the 1980s, to bring a relic, a medium that is like a relic, into the museum. It's also a very conservative medium, very old in feeling at a time when everyone is obsessed with trying to be new. My generation inherited the idea of having to be radical. Can you imagine Mario Merz making a fresco? It's impossible.

MA: **It's a difficult medium, isn't it? What's involved in doing one?**

FC: There is a long time of preparation and then it's very fast. The plaster absorbs the color as you touch it. You can't make mistakes, or if you do, you must accept them or make the best of them. It's like a large watercolor that weighs hundreds of pounds. They know exactly what time of day to make it so that it will dry in the right way. They even know the winds, their temperature and direction. So when the fresco is drying they know exactly which direction to face the image so the perfect wind dries it gently.

MA: **I think some people have trouble with your focus on orifices of the body. What is the source of that imagery?**

FC: It's about the space between the inside and the outside. We have five million pores on our bodies, so five million holes. That is a fact. I think the meaning of those holes can change. It could be just scientific, a way for the environment to pass through you. Children might think of these holes as humorous, like a piece of cheese. An adult might think of them as dirty, a place of excretion.

MA: How do you see them?

FC: I am not interested in the holes so much as what they connect. When you think of a hole, then you understand that there is an inside and there is an outside. . . . One of the main characteristics of perception is the bonds of what you perceive outside and what you perceive inside yourself. You can think about a change of perception if you compare the memories you had as a child, and how you see your inside and outside now. The line between what is inside and what is outside is always changing, between people, and is different in different cultures. This line is not always in the same place. Some people think my work is only about sex because it is about penetration, about moving between inside and outside. Sex is only a small part of that. Breathing and sweating are more—they are happening constantly. I'm very interested in that. I'm very interested in how much of what happens to us is like breathing.

MA: I keep wanting to find some connection between your generation and Arte Povera. Could drawing be a link, which suited their conceptual purposes and your need to explore lots of symbols?

FC: In a way, drawing is important for every artist, but not equally important. I told you before it's very important for me. I don't see it being so important for Arte Povera. [They are] not a source for drawing for me, Boetti maybe. I take more information about drawing from Twombly and Beuys. Beuys is very special. He is the William Blake of his generation. Beuys is bad taste or good taste—humor or seriousness—religious man or pagan. Beuys has a lot to do with what I believe art is about. I am happy to give credit, but I think I draw differently than other artists. Maybe what I do isn't even drawing. Is an ideogram a drawing?

MA: I think so. I guess a cross between drawing and conceptual notation. But within your so-called ideograms you have a remarkable range between simple notation and complicated drawing problems.

FC: Maybe that's my contribution. Maybe that's my problem. [*laughs*] I'm not a romantic. I actually do not believe in nature at all. I live in New York and I see New York as nature. I live in India and I see India as a kind of metropolitan jungle, you know. I really don't want to believe in nature at all. I don't want to.

MA: You don't want to believe in nature?

FC: No. I think it is not interesting at all. Nature is the opposite of history. I don't believe in landscapes. I'm interested in the body. I'm interested in the balance between inside and outside—and in the extension of the body—how far the body goes, where does it stop. What you see, what you hear, what you remember, where does it stop. I think it is more interesting to think about than these too-big concepts like *nature*. It doesn't say anything. It's in opposition with the conventions of my age. The imagination of my age is just too . . .

MA: What is the imagination of your age?

FC: Well, it's . . . it's in my paintings. You have to look.

MA: So is this your personal odyssey, your personal reinvention of a historic or mythic event?

FC: I hate to say *myth*. I simply don't see myth the way anthropologists or scientists see it. They see it as if it is all past and they are on the other side of the line. They look back and read it. I don't feel that way. I want to be a part of the mythic imagination, not separate from it. I want to contribute to the mythic imagination in my own time.

MA: A lot of people do use the term *myth* in describing your work, but maybe what we're talking about is *archetype*.

FC: If I insist on the term *commonplace*, it's because *commonplace* belongs to ordinary, daily life, simple language. It has to do with what everyone takes for granted in ordinary life, all kinds of images which flow through our common day

without our ability to see their meaning. I'm interested in trying to catch or imagine these meanings. Whereas when you talk of *myth* and *archetype*, then you put yourself beyond the imagination. I don't want my knowledge to be free from the cloud of my imagination. But I want to live in the world today. I don't want to live in the past. I just want to feel a connection through the imagination. Some critics think my work is about the past. It isn't. All of my images are contemporary.

MA: So you're not a myth-maker?

FC: I am, but I don't quote. You have to see the main problem with the notion of progress is the idea that we know what the dead knew.

MA: The dead?

FC: The dead. I don't believe that. I believe that what the dead knew, they knew. What we know, we know. There's no way we can know what they knew. What the painter is doing is really what he has to do. He has to go through it all again from the beginning because he doesn't build on top of what was before, because he doesn't know what was before, because it was different. The idea of progress is that the world was always the same, perception was always the same. Perception always changes, so we don't know, we really don't know how they thought, so we have to do it again. So there is never a quotation in my work. All my work really comes out of experience, of living right now.

MA: Is there any specific iconography in your work, anything we can use to read it?

FC: No. I think that is not valid. I think I really have to answer you the same as I have been answering, which is that I think I'm traveling through iconography. I think you have to travel through iconography, stay out of its grip, so you can remain in the imaginative place. I'm not stopping anywhere.

OLDER
INTERNATIONAL ARTIST

April 1999
New York, New York

Michael Auping: We haven't seen each other in fifteen years. How is your life now compared to how it was in 1981 when we first met?

Francesco Clemente: It's not easier. Should it be? I don't think so. I just keep wandering. It seems my life proceeds according to my inclinations, which always wander. I like to think in terms of space more than time. I like to think that different realities exist in the same space and not necessarily one after the other. It seems like only five minutes ago that we were sitting here talking, doing an interview that is now fifteen years old.

MA: What surprises me in looking at some of these new works is how familiar they seem. In many ways the work hasn't changed that much. We're still looking at self-portraits. They seem a little grayer, the subject a bit wiser and more contemplative—no flies buzzing around the face, no pimples and small sores on the skin.

FC: Maybe the flies and sores are underneath the skin now. [laughter] I don't know. My work has a kind of uneven chronology. I enter into a procedure and then I leave it behind. Then a few years later I pick it up again and leave it behind again. The self-portraits are usually a good way for me to enter into a new procedure.

MA: After all these years, it dawns on me that I've never asked the most obvious question: Why do you do self-portraits? Or maybe more broadly, why do you think artists do self-portraits? Can you talk about what you learn from them?

FC: I don't know if learning is an issue. Pleasure is an issue. Healing is an issue. Again, space is an issue, the marking of a territory. Remembering.

MA: One thing I have noticed about these new self-portraits is that there is not a lot of color in them. They are grisaille. I have always thought of you as a very special colorist, and yet here you are draining so much of the color away.

FC: Actually, there is some color buried between the whites and the blacks, but maybe I believe what I have been told—that I can use color well—so my reaction is to make images that don't need color to prove to myself that I can operate without it. Also, the mood of these images does not require loud or aggressive color. I can't think of too many painters who have not gone through a period of exploring gray, black, and white. For me, and probably for most other painters, it is not just a formal preoccupation. It is somehow a translation of an experience of myself and my surroundings.

MA: Where were these self-portraits made?

FC: In New York. [*laughter*]

MA: They're not strictly grisaille. There are some dashes of color, particularly orange. Is there any significance to that color? Do you ever use color symbolically?

FC: Never. I'm a twentieth-century person. I'm not trying to resurrect something. Maybe I'm trying to invent something. No, in fact I *am* trying to resurrect something, but it is the experiences that are prior to symbolic codification. I'm not a theosophist. Color is always in motion for me. Color would not be useful for me if it were static.

MA: Why do you think you decided to do grisaille paintings all of a sudden?

FC: My travels to Bali in the last couple of years suggested the possibility of grisaille. In Bali there is a whole tradition of grisaille painting, and Bali is a place with no color.

MA: I have never been there, but I always thought Bali was a place with a lot of color.

FC: That's what everyone thinks, but the truth is that it is very gray. The earth is black there. I always knew about grisaille as an academic tradition, but in Bali

you see it as a mood, a place. Again, though, that is the magic of life. Right before I went to Bali, I was in southern Germany and I saw those crazy Rococo churches and they were filled with grisaille frescoes. So within the space of fifteen days, I saw Rococo grisaille and the grisaille of Bali. When a single thing presents different realities to you, it's time to embrace it.

Also, they are not exclusively black, white, and gray in the academic tradition. There is some color and there is graphite and mica mixed with the paint. So there is a certain sparkle to the image.

MA: Were the self-portraits done in any sequence, say, one a day, or were they all done at a certain time of day?

FC: I usually work in sequence. It helps to open up the work. Each work has a kind of cycle. I usually begin very aggressively. Then I enter into a more accurate rendering. Then if you stay with the work long enough it opens. You begin to get impatient so you look for a way to be more direct and that opens things up. Then you have to go back to a little more detail. It's important for me to not be consistent. I like to seek an uneven treatment of the subject.

MA: You said you do them in sequence. Do you do one a day? What time of day do you work? Does it matter?

FC: Yes. It matters. I work in natural light. I work in the morning. There is always one painting that establishes a certain attitude that I then pursue in different ways.

MA: Which one is that?

FC: It would be unfair to the others. More importantly I can't remember.

MA: You always used to say that you trusted people who think with their bodies. You've been making self-portraits for twenty years. Over that time your face and body change. When your body changes, does your thinking change accordingly?

FC: Well, as you get older, I think there is less and less glue to keep you together. In the end, what is left is the crossroads of a number of people's experience of you. They make you who they think you are. I don't think I have as much to do with it as I would like to think. I'm sure that when I was younger I saw myself as more solid than I see myself now. I seem almost nonexistent now. It is not an unpleasant state. You get used to depending on others or to what is alien to you because that is what makes you what you are. When you are younger, you really think that you are someone, but of course you are not. In my early self-portraits I was experiencing different states, and different ways of trying to penetrate this solidity that I thought I had. The portraits now are somehow more pure, more open.

MA: One thing that has remained constant is that your face is still slammed up close to the picture plane. It's like your face is trying to escape the picture. Or do you use this device to entice the viewer closer to the picture?

FC: I'm only trying to see. When I make portraits I'm ridiculously close to the subject, embarrassingly close, maybe only a foot away. I'm always struggling to not know what I'm doing, if you know what I mean, and this device of staying close does not allow an objective position. I only step back sporadically to see what I have been doing, when it is too late to affect what I have seen or done. This way you see the subject, myself or someone else, in minute fragments. I'm not sure how this affects the way the picture is perceived.

MA: Given the large number of self-portraits you make, do you ever think about the fact that your audience might think you are vain or narcissistic?

FC: No. I think beginnings are important, and for me, the self-portrait is the beginning to an essential knowledge, to find out who is speaking. In the world we live in, it is very hard to find even brief moments of truth. One way to find them is to always ask who is speaking. There is so much mediation in the world we live in, and so much packaging. It's very hard to ever know who is speaking. I try to establish that in the beginning for myself. Basically, there is nothing wrong with narcissism, except that it avoids the real issue of knowledge. Maybe

we talked about this before, years ago I think we did, this idea of the discontinuity of the self. If you bare the self to its essential nature, it is simply a voice saying "I am, I am, I am." This is what all contemplative traditions teach. I see the self-portraits as a record of the self continually coming to life—every time new, every time pristine, every time unknown—simply affirming that voice. Nothing more than that. You have that kind of iconography in the East, a thousand Buddhas, a thousand selves. It is an imagery that relates to reincarnation. The point is that we do reincarnate in our daily life. I'm only giving a record of this process of being.

MA: I am curious about the new anamorphic paintings. There are different meanings that hang around the term *anamorphic* or *anamorphosis*, one being that it is "a technique of perspective to produce a distorted image that will look normal when viewed from a particular angle or when viewed with a special mirror." I've seen most of the ones you've done over the last couple of years, and I've looked at them from every angle and they don't look normal to me from any position.

FC: [*laughter*] Did you close one eye? Maybe that would help or maybe you are correct in how you see them. The question of the nature of distortion is a philosophical question that lingers with these works, I think.

MA: The anamorphic paintings are also self-portraits, aren't they? They just contain some other elements in the picture. By its nature, self-portraiture is a distortion.

FC: That's how my interest in anamorphism got started. I was thinking about these issues in some of the very early self-portraits. You remember those self-portraits I did when I included my whole body, but it was like looking at the body from different, unusual perspectives. It is the way we really see the body, not from a distance but close to the head and at strange angles. Any image we have of our body is a fragmented, partial image. Again, we are talking about fragmentation and the void—the fact that the self is not perceived as a continuous phenomenon. There are gaps in our awareness of ourselves. I've always had an interest in these gaps.

MA: My sense is that the way you are describing your work now is quite different than when we used to talk fifteen years ago. Your attitude seems much more contemplative, less intellectual, maybe. You used to talk about the body as an ideogram and that your imagery was an act of dressing the ideogram up in different ways.

FC: I received the ultimate critique of this notion from Stella Kramrisch, you know, the great scholar of Indian art. She said, "Francesco, you talk about your work in terms of ideograms, but what you are really doing is dealing with forms, and forms come to life before ideas. Forms unify and ideas divide." I was very enlightened by this. She made me think of my work in a different way. For me, it was a very daring idea, that these essential forms do exist. It also helped explain to me the healing power that I always thought that images can have. Form does have a healing power, more so than ideas.

MA: I raise this issue of the ideograms and the idea of dressing them up because I was interested in the fact that you have titled this recent exhibition *The Painter's Wardrobe*. How did you come to that title, if not through the idea of ideograms? Is there not some connection to that previous idea?

FC: My interest in disguise is less today than it was then. Also, I have much less interest in being exactly up to date. My notion of the ideogram was a way into a variety of issues about the self that at that time was, I think, very up to date, very contemporary. I can't think in those terms now, of being up to date with my ideas. I have to think in more basic ways. I'm less preoccupied with theory.

MA: Well, the other thing that struck me about the title to the show—*The Painter's Wardrobe*—is that they are all nudes. Where's the wardrobe? There has to be some irony in the fact that you are always talking about clothing, and yet you are always taking your clothes off.

FC: [*laughter*] I guess the wardrobe is in my head. I have huge arguments with my wife every morning when I leave the house because it may be very warm outside and I will be wearing a heavy coat and hat and she doesn't understand

what I'm doing. I always have to say to her I don't dress for the way I look. I don't dress for the weather. I dress for the way I feel. The wardrobe is a psychological tool. In my work, the wardrobe may include the full moon, like Shiva has the moon stuck in his hair. In contemplative traditions, the body is also considered a dress, a garment that should be discarded at the appropriate time.

I work alternatively in open forms and then in more closed forms. When I speak of closed forms, I mean I set up a number of elements that I want to receive guidance from. In this case, what I did was start with a list of the Shaman's traditional tools. The Shaman traditionally has a basic set of tools that is part of his wardrobe. The titles of these paintings are based on those tools.

MA: Is this your invention, or are you adhering strictly to a tradition of iconography? How many tools are there?

FC: I have painted twelve. This all comes from research that has been done in which they identify a certain number of elements, a vocabulary of elements, associated with shamanism. I didn't make it up. I looked it up. Then again, what I look up, I forget. I misunderstand. This kind of information is very much alive for me. It's not calculated. Memory or lack of it is a part of the process. What we are talking about is the relation between what is in movement and what is static. My main affinity with India and the Eastern traditions is my sympathy for the contradictions that exist between these poles. The tenet in the East that I totally accept is that everything is real and everything is changing. The idea that everything is real suggests an image of immobility. The idea that everything is changing suggests constant motion. Yet they both exist in the same reality. In some way, the process of anamorphosis relates to this tenet, this idea of an interweaving of immobility and change. Is that possible?

MA: Yes, now that you say it. It is a static image that forces you to move physically in order to be able to see the complete picture.

FC: And you have to find your place in order to see it. That's another element of self-understanding. In all contemplative traditions one of the first steps is to find your place, beginning with your place in the room. You have to pick your place in the room that is only yours. That is your beginning.

MA: Could we talk specifically about some of these anamorphic paintings, *Skull*, for example? You depict yourself, doubled in a mirror; we see your back and your front, but the back of your head is a skull. It seems to me it is a kind of *vanitas* image.

FC: It happens to be, but it didn't necessarily start that way. I set up these restrictions for myself—this set of tools—and see where they take me.

MA: I think both of us think more about the passage of time and age than we did fifteen years ago. I was talking with Georg Baselitz a couple of weeks ago and he was talking a lot about mid-life crisis and mid-life painting. Although you are not at the point of speaking about a mid-life, I would think that some-one who is continually exploring himself and his body would be vulnerable to many thoughts about change—physically and mentally.

FC: I am a little reticent to talk about it, but these thoughts did come about with this group of self-portraits. Because of the nature of painting an anamorphic image, I had to make preparatory drawings that were more naturalistic than I would usually do. They were far more physically descriptive than I am usually interested in doing. So when these drawings were done I looked at them and I did see my age. I didn't expect to see that. It was not the subject matter of this work, but things always come in you don't expect. I have always made self-portraits with the idea of self in the contemplative sense, which is a more ageless subject. I've always been more interested in my future body. I wasn't prepared to see my historical body.

MA: Isn't that the experience we all face every day when we look in the mirror?

FC: Not really. There are reflections from mirrors, but no one really sees what's going on. Again, we don't see in a continuous way. There are all of these gaps. Time goes by and time goes by and we don't see, and then once in a while we get a glimpse.

MA: Can we talk about this painting *Circle*, where the body is relating to the moon? It looks like the body is made of stone, empathizing with the planet.

FC: To me it is the opposite. The moon has as much flesh as the body. I try to aim at tenderness over hardness.

MA: What are the little dots on the figure?

FC: Craters, like the moon. Wounds, small wounds.

MA: That is a device that goes way back with you, the depiction of wounds on the body.

FC: Yes, the *piccolo delore*, the small grief. I don't know how to say it exactly in English. *Delore* covers a wider spectrum than *sorrow* or *grief* or *pain*. For me, it contains a constellation of images that have been following me for many years, the idea of a contagion, something that is contagious. I'm as interested in the small wounds as I am the big wounds. It relates to the idea of fragments, emotional fragments, fragments of time, fragility, softness.

MA: The painting titled *Rainbow*; how is that a tool?

FC: Most shamanic traditions have to do with the control of the weather. The core experience of the shamanic experience is the weather. The rainbow would be a tool or a sign that the shaman would use and interpret.

MA: What is this funky owl doing in the picture? How does that figure into the meaning of *rainbow*?

FC: [*laughter*] You know that is how I work. The imagery is like the evolution of mythology, created through a chain of misunderstandings, losses of meaning, and then recreations of meaning. I am always trying to find connections that have been lost between images. I can't be worried that it will be wrong. It may be disconcerting, but why should it be wrong?

MA: What can you tell me about the anamorphic painting with the bears and the penises?

FC: I don't know anything about this picture, but everyone who has seen it seems to be very interested in what it is about. I don't know what this picture means, but I think it has an audience.

MA: One of the things that I have noticed with these new anamorphic paintings is that your body seems more in action, more theatrical maybe.

FC: Well, they relate to, or are a response to, the first group of anamorphic paintings I did, in which I only depicted the face. Those were very static and introverted in a way. After I did those, I felt I should exploit or push the anamorphic process more. In order to do that, the gesture had to be larger, including the whole body. Also, the shaman is an actor, a performer. He wears a mask. When I was doing these I was thinking about a kind of pantomime.

MA: Another difference that I sense in these anamorphic paintings is the clarity of gender. It seems to me in the past you have often created figures that are androgynous, a mixture of male and female. All these images seem very male. Was this a strategic decision?

FC: It just happened. I see these figures like a little island in the middle of a very feminine ocean. I go through these cycles of identity. Before the Funerary Paintings, it seemed male. Then with the Funerary Paintings it became bodiless. Then after that, the imagery became very feminine. These are quite male-oriented, but the recent paintings here in the studio, as you can see, are really very feminine.

MA: Are you going to continue to do the anamorphic paintings, or do you think you have exhausted the idea?

FC: I like to keep the lines open. Several years may go by, but I seem to return over and over to lines that I start. There is almost always a lineage that you can trace back in my work, even if I discontinue things for a period.

MA: How would you describe the lineage of these anamorphic paintings? Could we call it a lineage of distortion?

FC: Well, I wouldn't call it distortion so much as relativity. I think that my early thoughts about anamorphism go back to Rome. In the Galleria Spada, you can see a tradition of paintings that deal with false perspective. The idea of this kind of space always interested me from the very beginning. It took me this long to figure out how to do it. I'm very slow. You can see in some of the early work images that may have wanted to be anamorphic, but I guess they didn't need to be then.

MA: You said that you saw the works in the d'Offay show as a kind of island of male identity. In the newest paintings that are here in the studio, the figures are clearly female. In fact, overwhelmingly female. What do you think caused this shift?

FC: It's my life. It's my biography.

MA: You mean each of these pictures represents a biographical moment?

FC: I protect myself with these pictures. They are really medicine for me because I am always catching diseases.

MA: Did you use models for these pictures?

FC: No. They come from my head.

MA: Almost all of the figures in these paintings are female and somewhat wild and erotic. I have a sense that women will find these images more interesting than men.

FC: Why do you say that?

MA: I'm not sure. They seem very personal, almost as if they were done by a woman. They have a sense of a woman telling secrets, a woman revealing herself, not just in terms of removing clothing but . . .

FC: I don't think men and women are that different. I like to tell my friends that I am the best woman artist of my generation. I think what is feminine includes what is masculine. These pictures are gestures that are about men and women, and when a woman sees them she will know that they are not just about women. Men will also. Everyone will be able to draw their own line into these pictures. Hopefully there is enough room in them for that.

MA: I don't think we're talking about penis envy here.

FC: [*laughter*] No.

MA: The color of these new paintings is unusual, hot and cool at the same time.

FC: The only restriction I gave myself for these works is the palette. I decided they had to be red and green. The red and green brought in this very feminine feeling. Then I realized as I worked on the paintings that red and green also means orange and green and then it dawned on me that those are the Tantric colors. If you had to make a flag to represent the Tantric tradition, it would be red or orange and green. I didn't realize it when I started the series, and then someone came into the studio and said, "Oh, Tibetan colors."

MA: We used to talk about the differences between drawing and painting, between working on paper as opposed to painting. You often said that you found painting more difficult or at least more demanding, more physically demanding. Has painting become easier or harder for you over the years?

FC: Now I find less distance between mediums. They are not as different for me as they used to be. At the end of the day, the same rules have to be addressed to make a convincing image. Also, I have altered my approach to painting. Now I mix all of my colors beforehand. That has made a huge difference and brought my painting technique closer to how I work with pastel and watercolor. I find that this makes my painting technique more flexible. I can work *alla prima* much more of the time. I have learned to carry the paint around so I can work *alla*

prima, and then also correct details without having to wait for drying. I am also using a different kind of canvas now. The surface is less fine. It has more texture, more tooth. This means the color now lies on the surface of the canvas a little bit like the way pastel does on good paper. The ground of my paintings now is also more mat, which I have always preferred, and which seems closer to the work on paper. It takes time to learn these things. I have always been slow. I think I am much more comfortable now with what I can do, and more comfortable doing it in a way that suits my temperament. When you are young you often struggle against your inclinations. Then when you begin to realize how little time there is and how little chance there is to make really convincing images, you say to yourself you are just going to do things the way that you understand it best.

MA: The women in these recent paintings—do they represent women in general, or are they specific women? I'm not asking the question to gossip, but . . .

FC: No. I know. I was quiet because I wasn't thinking about gossip. I was thinking about god. For me, god is a woman. If I had to practice a form of worship, it would be a form of Tantric worship and I would be worshipping a woman. These are gestures of women that are about . . . a reverence . . . a sensuality. I try not to allow these to be opposites.

MA: You have always been an imaginative reader. What are you reading these days?

FC: What am I reading. Probably the same things I was reading when we first met. [*laughter*] Actually, it's partly true. I'm still reading a lot about southern India, Blake, Focillon. Since we spoke years ago, Warberg is an interesting addition, the essays he wrote about the American Indians. I'm still very interested in anything that comes from India, both in terms of traditional texts or very contemporary writings. Last night I went to the Salman Rushdie reading around the corner at the Cooper Union.

MA: When you and I were working on that first American show, you decided to rent a car and drive by yourself through the Southwest. I thought you were crazy. Now you have a house outside of Taos, New Mexico. Do you think that has had an effect on the work?

FC: Yes, very much so, but as usual with very uncanny connections. For example, I started painting in a double-square horizontal format for the first time in India after the local folk painters who are attached to the temple in Puri. I didn't use that format again for a few years, and then when I went to New Mexico I saw this big horizon, this huge space that demands the double-square horizontal format. It's a simple coincidence, but I think meaningful. That is now the format for a group of portraits of women that I have been doing. They are supposed to be like social portraits, court portraits of women that I thought would be vertical but I have turned them on their sides in this format. It seems to work nicely. These anamorphic paintings are all double squares. I think my New Mexico experience has had a big effect on my use of this device. I love that part of the world. It is soulful, gentle. India offers this huge inner space. America offers this huge outer space, but they're equally soulful and filled with hope.

ROBERT CREELEY

Robert Creeley, Michael Auping, and Pat Auping at a reception at the home
of Stephen B. Sample, then President of the University of Buffalo, 1982.

TROUBLE

February 17, 1987
Buffalo, New York

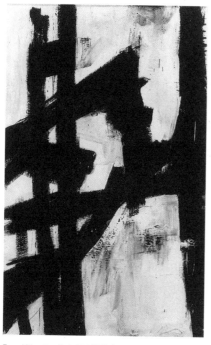

Franz Kline, *New York, N.Y.*, 1953. Oil on canvas.
79 × 50½ inches (200.7 × 128.3 cm).
Albright-Knox Art Gallery, Buffalo, New York. Gift of Seymour
H. Knox, Jr., 1956. © 2007 The Franz Kline Estate / Artists
Rights Society (ARS), New York.

Michael Auping: Could we talk about the relationship between poetry and painting in the 1940s and 1950s?

Robert Creeley: Well, I wasn't around—or at least engaged with that relation-ship—for all of that, as much I'd like to have been. During the forties, I was just trying to figure myself out—my relation to the world, let alone the relation between poetry and painting. I spent quite a bit of time getting myself into and out of trouble. . . .

MA: You did go to Harvard. You couldn't have been that bad of a screw-up.

RC: So you are assuming that going to Harvard inoculates one from making a mess of things? I think we can make a list here and now of people who went to that august institution and thoroughly decimated their lives and the lives of others. Should we begin?

MA: No. Let's stick with your screw-ups, whatever they may be. Are you saying that you didn't learn anything at Harvard?

RC: I came and went at Harvard. I entered in the early forties, and then shortly decided that I needed to go to India to drive an ambulance. . . . When I went back [to Harvard] I wasn't doing much listening, but I was reading. That may have saved me.

MA: From what?

RC: Anger, probably. Poetry and letters, and as you have brought it up, painting also, was a way to release and articulate a mind corrupted by its own unac-knowledged subversiveness, for lack of a more intelligent way of putting it. I had as much anger as ambition in those days. Many people did. I needed to figure that relationship out. I'm still figuring it out.

MA: I heard stories that you got in a lot of fights, fist fights, and that you would pick the fights and it didn't seem to matter if the guy was much bigger than you. Does this ring a bell?

RC: [*laughter*] Who told you that?

MA: I don't remember.

RC: That may be true or it may be part of a mythology that old poets accumulate. I did lose the use of my left eye when I was a child, so I look at people and things cock-eyed, literally. It probably pisses some people off.

MA: Maybe none of it is true. It seems odd that it would even be a story because your poetry and what I know of you over this brief time here in Buffalo wouldn't suggest that kind of a character. Your poetry seems so intimate and minimal, not really violent or excessive.

RC: Intimacy does not exclude the violent. One can indeed have an intimate view of a violent world and one's role in that violence. I'm not sure how to proceed from that thought, but it strikes as me true—as a somehow pertinent fact to the poets, and perhaps the painters as well.

MA: After Harvard you went to Black Mountain to teach, and you met some painters there.

RC: Charles Olson invited me. It was my first teaching gig. I didn't finish at Harvard. I started many things there, but didn't finish an equal number of things, including the degree. One of the things I started that was surely one of the most important events in my career was a series of correspondences with Olson. Relationships can be more important than degrees, if you can figure out what you need to learn and who has that information. With the poetry of your own moment, it's difficult to know because the information of value is in constant formation. We must then decide what part of that river we want to jump into.

MA: Olson had something you wanted?

RC: Something that a number of us wanted. . . . His was a strong voice from a very large man, literally very large, well over six feet—someone, given your

informant's description, I would choose to fight. In this case, I chose to listen and ask questions carefully.

MA: Can you describe what kind of effect Olson's poetry had?

RC: He articulated a new kind of space, which sounds so clichéd to say now, but it was very immediate. . . . It might be more accurate to say that he unleashed a new relationship between form and space, an articulation not previously felt in American poetry, in some ways utterly new.

MA: Not being a poet, I have to ask what may be a very stupid question: how does space manifest itself in poetry?

RC: Well, in painting you would likely call it a "figure–ground" issue. I would argue that [William Carlos] Williams established the ground—an ability to see or experience a thing for what it is, without embellishment. It established an immediate reality, remarkably immediate. With Olson and those of us who followed, the ambition became to find ways to jump from that ground, not in a capricious way, but in some meaningful way, to embrace the space that is coincident with any figure–ground relationship.

MA: That description makes a lot of sense in terms of the painting that was going on at the time.

RC: At the least it allows me to dodge your question. It is easier for me to talk about painting in this regard. I'm not saying I understand it better. It's just easier to talk about. For one thing, painting was much more visible critically in the 1950s and 1960s. From my view of that time, two generations of Americans were looking everywhere for models of how to grasp a new space—a political, psychological, and even physical space that mid-century America suggested to us. How do you get hold of it? How do you articulate it? It seemed to me the painters grasped it quicker, or perhaps it was easier to see in painting than in poetry. . . . But Olson certainly had a grasp of it as well. . . .

MA: Do you think Olson's poetry had some effect on painting as well as poetry?

RC: Undoubtedly, though the effect may have been circuitous. *Projective Verse* (1950) was certainly coincident with the blooming of Abstract Expressionism and the possibility of something epic within each individual, the possibility of something truly honest, an action rather than an idea—Olson was central to that moment of possibility. And at the head of Black Mountain he was a rector of action, along with so many: Duncan, Kline, Rauschenberg, Twombly, and many, many more who should be named and who felt the presence of his high-voltage voice and mind. . . . He was the epitome of a fusion between the epic and the singular.

MA: You could be describing the great abstractions of Rothko, Pollock, and Newman.

RC: I hear you. That was their great contribution to this culture. And unlike poetry it was visible—very, very visible and felt.

MA: You wrote a text about Kline in 1954 for the Black Mountain Review. But it wasn't about space. It was about darkness.

RC: I wrote that some time ago. You'll have to remind me what I said.

MA: Okay. You wrote, "There are women who will undress only in the dark, and men who will only surprise them there. One imagines such a context uneasily, having no wish either to be rude or presumptuous. Darkness, in effect, is the ground for light, which seems an old and also sturdy principle." Then I will skip ahead a little, "But, more interesting, think of it, a woman undressing in broad sunlight, black. What if light were black—is there black light? If there is black light, what is black? In other words, argue to the next man you meet that we are living in a place where everything has the quality of a photographic negative. Take hold of his coat, point to anything. See what happens." Then you briefly mention Kline's use of black and white, and the possibility of their being reversed.

RC: Well, that's how I saw it then, and I don't see any reason to correct that vision or make it more logical. We all know where art ends up if you apply logic to it—having all the pristine vacuity of the nightly news. . . . But it does strike me, reading over this after so many years, that it may be more about space than you have yourself read into it. I was pointing outside my position as a viewer, but to an active space. The edges of Kline's paintings do the same thing, far better than I could write about it. His gestures fly off the edge, way off into the distance, and the action of that painting is continuous with all that space. To me, that's what those paintings of the fifties were about: being continuous with all of the space we inherit. At least in hindsight that's what I think. I have no idea what I was thinking then.

ROBERT DUNCAN

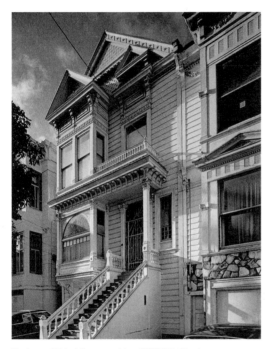

The home of Robert Duncan and Jess, 3267 20th Street,
San Francisco, California. Photograph by Ben Blackwell.

WONDER TALES

May 14, 1983
San Francisco, California

Jess, *Will Wonders Never Cease: Translation No. 21*, 1969. Oil on
canvas mounted on wood panel. 21 × 28⅛ inches (53.3 × 71.4 cm).
Collection of the Hirshhorn Museum and Sculpture Garden,
Smithsonian Institution. Joseph H. Hirshhorn Purchase Fund, 1986
(86.5885).

Michael Auping: Where does your language or your imagery come from—
in the most basic sense—even just finding a place to begin?

Robert Duncan: I understand a need, a desire, to ask that question, but who
could answer it—what artist, poet doesn't ask it themselves? We never get an
answer. We can never really provide ourselves an answer. It would indeed seem
odd if we could give one to you. Think of it. If we knew where to begin, we
would probably know where to end, and that would be the end of the imagina-
tive construct. You can't have the answers and still connect to the imagination.

MA: I know it's a stupid question, but it seems like it always needs to be asked.
So it has been asked. Let me ask another stupid question. Do you have a . . .
a routine, a way of working up to starting your work?

RD: Now that's more available as a point of discussion. We [Duncan and his life
partner, the artist Jess Collins] read. We read to each other as a routine. Right
here in this kitchen—often in the morning. We have our morning discussions.
We try to connect a text or myth to things in the household. We project our-
selves out to engage the imagination from the microcosm of this household—
this domestic cosmos.

MA: I can understand that—even envisioning you here in the mornings, like
we are now. This house is like a giant book. There are bookcases everywhere.
It's a literary playground. All kinds of stuff—gothic novels, Greek literature,
science fiction, children's books. Do you read children's books to each other?

RD: Jess has a great collection of children's books. We love them.

MA: The innocence of childhood?

RD: No. That's the modernist conceit—the supposed intellectually advanced
modern mind seeking some simple, indivisible reverie—the myth of a simple
truth hidden in the imagination of the child. We're interested in the wicked
complexity of the childhood imagination—the prismatic ironies and opposites

that are presented in any given moment, experience, or story. . . . Our household is partly about that—children's books, fairytales, nursery rhymes, Mary Butts, puzzles. . . . Jess has an immense collection of puzzles. It's the perfect metaphor for how we view the imagination. Rather than using the metaphor of the book for this house, I would use the image of the puzzle. We surround ourselves with a puzzle of myths. You can't take a piss in this house without being hit with a myth.

MA: The third floor where I'm staying is really spooky. You need to get some more lights for those rooms. I hope there aren't too many myths flying around up there. All the books on those shelves are pretty strange.

RD: That's the science fiction and surrealism floor for the most part. . . . There are some wonderfully off-center stories and poems from the twenties, thirties, and forties up there. There are a fair number of goblins up there.

MA: That's what I was afraid of. It's where the Mary Butts novels are.

RD: Yes, I think so. They are wonderful stories published in the twenties and filled with a rich field of symbols—remarkably visionary. She moved in and out of circles with Eliot and Woolf, but she was very unique. You might think of them as surreal fairytales, if that is not redundant. You should read *Armed with Madness*. It's like Eliot's *Waste Land* but in a magical natural world with goddesses ascending and descending through layers of mythic realms. It's a puzzling-together of fragments of the stories and myths that make up our present reality.

MA: This puzzling-together of realities—I can see how that feeds into Jess's fragmented collages and the sectionalized surfaces of his Translations. But how do they feed into your poetry?

RD: For me, it's about lost romance or rediscovering romance. . . . Shelley, Blake—the whole construct of romance—the romance of remembering the mysteries that we've lost.

MA: Romance. I'm not sure exactly how you mean that. When someone starts talking about "romance" I cringe at the whole sentimental—

RD: Well, that's it! Of course, it's a cynical time. Anything that is not cynical is marginalized. We've lost sentiment. . . . There are no models for falling in love. The romance novel of a high order, the fairytale, may be the highest form of romance we have today. . . .

MA: You were associated with the Beat poets. That doesn't seem so romantic, or maybe it was and I am misreading it.

RD: I was never a Beat poet. You have misread that. They had no romance, or at least not the high level I am speaking of. . . . What I am talking about are the stories, the myths that lead you there—to that unexplainable precipice of human love—no matter how spooky or strange the story may be—the communal fairytales that we share, and that connect all of us.

MA: Like the circle of children holding hands on the cover of your book?

RD: *The Opening of the Field*. That is a viable image for the construct we're talking about—wonder tales, which is what fairytales used to be called. We think art needs more wonder tales.

Courtesy of The Poetry Collection of the University Libraries, State University of New York at Buffalo.

MORTON FELDMAN

Philip Guston, *Untitled*, 1952. Ink on paper. 18 × 23 inches (45.7 × 58.4 cm).
Collection of the Modern Art Museum of Fort Worth. Gift of Musa and Tom Mayer, 1999.

TOUCH

May 20, 1985
Buffalo, New York

Michael Auping: **You knew Guston.**

Morton Feldman: Very well. I knew many of them [the Abstract Expressionists].

MA: **Why don't we start with Guston. How well did you know him, and what role do you feel his paintings played in the 1950s?**

MF: We were together all the time in those days. I was around his studio all the time. We'd talk, he'd paint, we'd go to the deli, he'd come back to paint, I'd watch.

MA: **What was his process like? Did he paint those fifties abstractions quickly?**

MF: He wasn't quick. He could be, but he wasn't generally. He painted very carefully. He considered every stroke like it could be his last one. He understood color as well as anyone, even when he wasn't using a lot of color, especially when he wasn't using a lot of color. He could use colors that no one else could use.

MA: **Like what?**

MF: Orange, green, pink, rose, purple. Not what you'd expect from one of those guys.

MA: **Not your macho palette. You wouldn't want to come strolling into the Cedar Bar wearing clothes that color.**

MF: [*laughing*] Not on your life. But Phil made them [the colors] tough. His colors made you think about color and what happens when it is put in different situations. But his real gift was his touch. He was so careful about how much paint he put on the brush and how much pressure he applied when he put it to the canvas. I loved watching him do it. There is this relationship—applying paint could be like touching the keys to a piano. You can strike softly and go long, or strike sharply and quick. Pollock and de Kooning were quick—Guston and Rothko soft, elegant, and long. My music is soft and long. That's how I thought Phil painted.

MA: Was Guston interested in your music?

MF: He said he was, but who knows. . . .

MA: Let's talk about some of the artists who didn't seem to demonstrate a brushstroke—Rothko, Newman, Reinhardt, that group. What was your relation to those artists?

MF: I knew Rothko very well. . . . He is someone who loved music. He didn't know as much about it as he thought he did, but damn well understood it. He understood the space of music. . . .

MA: How would you describe the space of music in relation to the space of painting?

MF: Well, the notes are one thing, but the spaces between the notes, that's where the music takes place. It's the same with painting. What's important is everything that isn't what you think you are seeing. The great thing about painting is seeing things that you think are not there.

MA: I'm not sure I know what you mean. Do you mean like exposing the bare canvas?

MF: Not even that. A completely different space. They were creating a new philosophy of painting in the fifties. Some of us were doing the same in music. It was a different approach to space. To understand the compositions that were being developed—both on the canvas and on the sheet—you needed to think about space and time.

MA: Do you think that avant-garde painting at that time was influenced by avant-garde music?

MF: Could be. I was more interested in what was going on in painting than I was in what most of my music friends were doing. But there were some exceptions.

What is true is that painting got a lot more attention than avant-garde music did. But I always suspected that the painters were secretly envious of music, the same way I was envious of painting.

MA: Why? Why do you think they were envious of music?

MF: They understood the abstract nature of music. Historically music is more naturally abstract than painting, even though you may have what we will call your orchestral illustrators that make sounds like a train or a coyote being hit by an anvil.

MA: The orchestras behind cartoons.

MF: Yeah. That's what happens when you stop thinking about music and you just play for other people or you play what the lowest common denominator wants to hear. When that happens in painting, you make Hallmark cards. When it happens in music, you go to Hollywood. . . . Like I said before, it had to do with creating a new kind of space. In music that meant pushing tones, octaves, sounds out to the edge, to the periphery.

MA: The periphery of what?

MF: Maybe human audibility.

MA: You mean you couldn't literally hear it?

MF: In some cases. But also to the point where you couldn't count it, couldn't count with it, probably what you would think of as not having a beat. You couldn't hear the structure. There was no narrative, no beginning, no end—a completely open and indefinable structure.

MA: Your pieces are often very, very long. Are you talking about duration?

MF: Partly, but not for its own sake. Otherwise the world would be filled with very bad, long songs. You could say, however, that when you stretch music you enter a similar condition as when you stretch the size of an abstract painting. You create a kind of suspension, a space that is too big to comprehend. You can call it "the sublime" if you want to. I think it's just the human mind set adrift. It's about being alone with sensation and time. That's all it is. That should be enough. Like Philip [Guston] said, "Make more than what you know."

VERNON FISHER

Project photograph from *Annette*, 1977. Courtesy of the artist.

K-MART REALISM

February 29, 2007
Fort Worth, Texas

Michael Auping: I was thinking about how we tend to think categorically, i.e., how we assume that popular imagery died out with Pop art but that there may have been residual elements in Conceptual stuff in the seventies. I think we are still in a very Pop moment right now, but I wouldn't have said that about the seventies. There is Baldessari and Ruscha, but. . . . To get to the point, what was the value of popular imagery for you in the early work? Do you think that Texas has its own brand of popular imagery?

Vernon Fisher: I was never interested in popular imagery for its own sake; that is, I never saw myself dragging "low" into an elevated context like the Pop artists. I was, however, interested in what I saw around me, and though there was the occasional ironic detail like the Dairy Queen sign saying, "God Bless Anita Bryant," for the most part the imagery was pretty ordinary. For the stories I was writing, that was kind of the point.

In many respects, the stories, which tended to come first, led me to the imagery I used. Just as [Sol] LeWitt's "the idea becomes the machine which makes the art" led the Conceptualists to unpredictable visual forms, the stories I wrote led me to imagery that otherwise would have been hard to imagine.

MA: I've read a lot of your stories and one of the things I like about them is how dysfunctional they are in terms of a narrative. It's like the detective saying to the suspect, "It seems to me, Mac, there are a lot of holes in your story." If, as you say, the image comes out of the story, how do you derive an image from a dysfunctional narrative unless you have seen this image out there on the road on the way to the story?

VF: I had been an abstract painter in the years before I began the narrative work and one of the first things I noticed when I began writing (perhaps because it felt so strange and slightly uncomfortable) was that in writing fiction you had to proceed through the world on the way to feeling, that is, the realm of objects and events. Maybe that accounts for the "popular" flavor you're picking up in the work. And I must admit, there are more than a few stories with a kind of "K-Mart" setting. At the time, I was renting a house for 75 bucks a month, so K-Mart was a good part of what I knew—along with cars that broke down frequently. I'm

attracted to the ordinary and to trash, but I don't have any feel or enthusiasm for the commercial. Perhaps my associating the Pop artists primarily with the latter is misplaced. I don't really know. Or maybe the difference is between K-Mart as setting and K-Mart as subject.

As far as the texts go, there are more than a few stories where "things aren't working out as planned," or where the narratives are loopy and kind of drifting. Is that what you mean by dysfunctional? As far as combining image and text, I didn't want to just illustrate the story and because of that I was oftentimes attracted to images that were relatively inert. Other stories, in turn, suggested excessively dramatic images: ships sinking, missiles launching, H-bomb explosions, etc. I tended to work the extremes. I wanted an initial disconnect between what you read and what you saw—think of the voiceover of Sissy Spacek in *Badlands*. The relation of text to image was always complicated. To finally get to the point, at the time I felt that somehow the text "justified" the image and that that made it different, at least in motivation, from Pop art. Looking back today, I still would make that argument, though less strenuously.

MA: Earlier you mentioned K-Mart Realism and Bobbie Ann Mason. Could you elaborate on that, or on any commercial or genre literary influences. It's always hard to get artists to talk about sources or influences, but since you like to write stories and since an interest in writing almost always means there has been an interest in reading, what reading has affected or inspired your art the most?

VF: I mentioned Bobbie Ann Mason as a writer whose work has been described as "K-Mart Realism." She is probably most known for her novel *In Country*, which was made into a movie with Bruce Willis. Basically, she writes about the working class in rural Kentucky, where she lives—people who do their laundry at Laundromats. In that, she's not unlike a lot of other writers—Raymond Carver comes to mind. I have an attraction to that subject matter myself and have written my share of pieces featuring Dairy Queens, grocery stores, Laundromats, third-rate motels, etc.

As to a "Pop" literature, I'm having a hard time thinking of any writer whose work might be considered "Pop." I guess Donald Barthelme, who makes a kind

of textual collage of high and low, might be a candidate. Attitude toward the material is important, I think. I guess I want to maintain a distinction between "camp" and "ironic," though I pray to God you don't ask me to define either one.

That being said, I do think I understand what you're getting at. In art, Andy Warhol more than anyone opened the doors to this material. The literary lineage is more complicated, though Flannery O'Connor is certainly lurking back there somewhere.

My reading has always been pretty eclectic, but during the time you're speaking of, Don DeLillo's *White Noise*, Joan Didion's *The White Album*, and most of Richard Brautigan stand out. Obviously I was attracted to ironists, and I read Brautigan to learn how to "write short." Later I read everything by T. C. Boyle as it came off the press. Currently I'm reading Jonathan Lethem and David Mitchell.

MA: Switching gears to specific images, the cartoon character Nancy shows up a number of times in your work. What does her image represent for you? As cartoon images go, she is a pretty strong female figure. Could we call her K-Mart feminism? Do you think of her as having a meaning beyond simply being a formal device? I'm looking at *Ellipse*, where she is paired with a Nazi zeppelin.

VF: In *Ellipse*, as is typical of my pieces, there are several intersecting "stories" (this has become *de rigueur* in movies nowadays—see *Crash, Babel*, etc.): the Hindenburg image (even pictured aloft as in *Ellipse*, we're conscious of its catastrophic end); the "ellipse" text, which, in my version, begins as a straight-forward dictionary definition then devolves into a kind of stream-of-conscious-ness narrative; and the Nancy cartoon (the manhole where she's lost her ball is essentially an ellipse as shown in perspective). In addition, the cartoon's frame is tilted to parallel the orientation of the Hindenburg in flight. The point of intersection is, of course, the ellipse. Taken together, the piece becomes a meditation on meaning.

Over the years, I've used not only Nancy and her gang, but Mickey Mouse, Donald Duck, and several other Disney characters, the Three Stooges, Huntz Hall and Leo Gorsey of the Bowery Boys, Frankenstein, the Wolfman,

stereotypical characters from genre movies—film noir, westerns, etc. Maybe they serve as a counterbalance in pieces whose tone is otherwise relatively serious, I don't know. Their presence does tend to undermine the authority of the piece, rendering their meanings somewhat inconclusive.

And Nancy? Well, I kind of stumbled onto Nancy. I was working on the piece that turned out to be *84 Sparrows* [1979] and looking for images to bracket the photograph of a camper with sanded-through text when I came across a Nancy comic strip depicting a bar of soap flying through the window (someone was distributing free samples, apparently) and landing in a bowl of chocolate fudge Aunt Fritzi was making, splashing all over her while Nancy looks on in amazement. As the camper text describes a tragic accident (with blood spattering onto the rocks, etc.), it occurred to me that the Nancy cartoon could be seen as essentially a banal version of the same thing. I liked that it departed from the rather grave tone of the story—providing an alternative view, if you will. This may have had something to do with an idea that persisted in a lot of stories I wrote in those days: the notion that the universe is arbitrary and capricious— no one's "up there" looking out for us—and at some level, funny. Something along the lines of "the joke's on us." Some time later Janet Kutner pointed out in a review that the arc of the soap flying through the air echoes the shape of the camper top, so there was an unforeseen formal justification as well. This was in 1979, and as you know, Nancy's been a frequent component of my work ever since.

There's a lot I like about Nancy. She's kind of odd-looking, and simplified, and I like the way each frame is organized in a kind of asymmetrical balance. It's also a strip you always read because you don't want to miss the day it might actually be funny. For years these were my standard replies to queries about Nancy. Later, years later actually, I began to realize that there was a psycho- logical relationship to the strip as well—that the characters were stand-ins for my family: Aunt Fritzi for my mother who, when I was a kid, looked a lot like her; and Nancy, in her wide-eyed wonder, for my little sister who was mentally handicapped. Apparently there's a kind of survivor's guilt that accompanies being the "normal one," and putting Nancy in my pieces was a way of "bringing her along with me."

MA: Is Mickey your favorite? Everybody loves Mickey. I never really thought that much of him as a character compared to Pluto and some others, but I do have a soft spot in my heart for Mickey because in his very first couple of cartoons he smoked. You gotta like a mouse who smokes and then goes on to found the Mickey Mouse Club.

VF: Mickey smoked? That breaks my heart. I don't know what to say. . . . Mickey only appeared [in my work] a couple of times prior to the blackboards: once, in *On the Waterfront*, a narrative piece about going to a crumbling drive-in movie somewhere out in West Texas, where he comprises one of three text panels; and in *Annette*, where, to be fair, he doesn't appear in person, but is represented by a photograph of me wearing a Mickey Mouse Club hat. In the blackboards, however, he begins to show up regularly, appearing perhaps dozens of times.

There's a lot about Mickey that makes him useful. He's everywhere— everyone knows what he looks like, so any deviation from form or character is immediately apparent. And do people really love Mickey? He's been used as a shill for powerful corporations almost from birth (though I guess you can't really blame Mickey for that; I mean, I don't. I kind of feel sorry for him . . .). Nevertheless, he's a treacly character, almost completely without depth, not nearly as complex as Donald Duck with his anger issues, for example, or, leaving the Disney studio, any of the Looney Tunes characters. That sentiment is reflected, I think, when people disparage something by calling it "Mickey Mouse." But he *is* a star, and being typecast as he is, he's extremely useful to appro- priate, as a whole constellation of expectations walk out on stage with him.

But the main reason I use him is he's easy to draw. He's constructed almost entirely of circles, his design owing a lot more to Euclid than to order Rodentia, and you can draw him with just a few quick marks. This became important to me when I was doing the blackboards, as the size of the chalk itself, the way it comes, carries with it certain expectations. Chalk doesn't really lend itself to detail, for example, and the moment you break from these expectations, the piece ceases to be convincing as a chalk drawing on blackboard slating. In addition, there's a kind of gestural feel to the chalkboards, owing mainly to the erasures, but also to "drawing from the shoulder" in the manner of the Abstract Expressionists—a kind of markmaking to which Mickey lends himself graciously.

JENNY HOLZER

Michael Auping and Jenny Holzer at the 44th Venice Biennale, May 1990.

PUBLIC VOICES

1988–91
New York, New York; Buffalo, New York; and Venice, Italy

Truisms: Money Creates Taste, 1986. Dectronic Starburst double-sided electronic signboard. Installation: Caesars Palace, Las Vegas, Nevada. Photograph by Thomas Holder, courtesy Barbara Gladstone Gallery, New York. © 2007 Jenny Holzer, member Artists Rights Society (ARS), New York.

Michael Auping: There was a point in the late seventies, I remember, when narration was something that some people were doing and some people were thinking about doing. But most people in the art world thought that art shouldn't have a narrative element, other than maybe Conceptual art, which was documentary. Do you remember thinking about any of those issues?

Jenny Holzer: I was suspicious of narrative just because it seemed like something "old." I've changed my mind about that now, but at the time I only gave myself permission to write the *Truisms*, because I thought of them as real pieces of ideology rather than stories. I wanted to write so that I could be very direct. I could say exactly what I wanted on any subject, and I could address specific topics. This is impossible to do with abstract painting. That's how I came to use language. I had the desire to be explicit and I felt the need to study dearly held beliefs.

MA: Do you see yourself as a poet or a sculptor? I don't think it is important to categorize, but it helps to know your intention.

JH: I know very little about avant-garde poetry, but it's a safe bet that my writing doesn't break any ground. I'm not a poet. I do not present my work as poetry. Some of my writing is more "poetic" than other bits of my prose, but that's almost beside the point. However, I do try to write as well as I can. I don't think I am a sculptor, but I hope I am a visual artist of some sort. When I work, I consider color, form, composition, and material, and getting this right is important. I have called myself a public artist and an installation artist. I wanted to try to find a way to talk about real-world issues to a general audience.

MA: When you first moved to New York in 1977, who were some of the people you met who you felt were supportive of this idea of going more public, as it were?

JH: A number of us who came to town at roughly the same time were mutually supportive. The artists in Collaborative Projects were the ones who were most helpful. People in this group were interested in doing public work, art about

pressing issues. This confirmed my suspicion that political public art was important, and it helped me realize it was possible because a number of Colab members were doing it well. I was impressed by Tom Otterness, Robin Winters, Colen Fitzgibbon, Diego Cortez, Kiki Smith, Stefan Eins, Rebecca Howland, Justen Ladda, and others.

MA: Was this around the time you developed the *Truisms*?

JH: Oh, it was a little later. I started the *Truisms* when I still was in the Whitney Museum Independent Study Program. That was my first important peer group. Some of the other students in the program were Becky Johnston, who has gone on to make a film with Prince; Pat Murphy, an Irish filmmaker; Mike Glier; Gail Vachon; Jim Casebere; and John Miller.

MA: What gave you the "permission" within yourself—because I know you to be fairly self-critical—to put the *Truisms* on a poster and put them out in public?

JH: It was a process of elimination. I knew the *Truisms* weren't poetry, so they shouldn't go into a little book, and I knew they weren't a novel, so they didn't need to go in a big book. I had to think of a form that was appropriate for them. After I halfway became convinced that they were legitimate, I realized that they had to go outside. They were useless as a list on a desk. I hoped that people would get something from reading them on the street. I more or less swiped the idea of a poster from Mike Glier, who was thinking of making one. There also were lots of music and club posters around town at that time, and many political posters. It was a postering society downtown.

MA: I remember when I first started seeing them in New York. I was intrigued by them, but one thing I remember most—and it may not be an important point at all—is that it seemed to me many people in the art world thought they were done by a man. I'm curious as to your reaction to that.

JH: I have made much of my work sex-blind and anonymous so that it wouldn't be dismissed as the work of a woman or the work of an individual. Also my interests aren't only what are traditionally known as "women's issues." Because the *Truisms* are gender-neutral, maybe they seem to be male.

It's funny. Somebody asked me if the reason I was selected for the Venice Biennale was that I am a woman, but a woman who acts like a man and does art like a man. I was taken aback. Maybe you can tell me what that means.

MA: I don't know. In a male-dominated society you associate the voice of authority with a male voice, and since you appropriate the voice of authority through your image, I think that people immediately assume that you are male. In a sense, you are hijacking that voice and making it yours, not just for yourself, but for other women. I think that is one of a number of reasons that women are particularly taken by your work.

JH: It's possible that people believed the *Inflammatory Essays* were written by a man because they are wildly aggressive, which, for better or for worse, is commonly associated with male behavior. I use whatever voice I think will be effective.

MA: I also wanted to ask you about the politics of doing certain public art projects in which you have to deal with other people's politics in terms of the context that you show things. A classic example might be your *Truisms* on the huge color electronic sign at Caesars Palace. What are your thoughts on that?

JH: That one was somewhat problematic because Las Vegas supposedly is all mob money and mob money purportedly is all rotten. Reality is more complicated. You don't know the "quality" of the money that goes into art museums. How many workers' widows were put into the street to augment the money that helped build the Frick Mansion and collection? I would not do a project if I knew the sponsoring institution or individual to be notably corrupt.

I hope that my content is worth placing in public, that it might even counteract some of the worst messages to which we're subjected. This is how I have decided to go ahead. It's difficult to know if I'm kidding myself.

MA: The *Survival* and *Under a Rock* series are pretty emotional for public consumption.

JH: *Living* and *Survival* were somewhat controlled, but *Under a Rock* was about having fierce hope, then despair, fury, and madness.

MA: In *Under a Rock* there are passages that appear to be reportorial, and yet they are extremely gruesome and not something you would normally read in the paper. What is the process that forms the final text?

JH: Often it's deciding what type of writing is suitable for the subject. Rape and murder are horrifying, so you might choose to keep a tight grip on the text. The writing for "Crack the pelvis . . . " seems like how-to instructions for a fatal rape. I thought the language had to show control to be effective, to make people recoil. I wanted other texts to be rapturous. The outer space piece was space-jockey joy.

MA: *Under a Rock* was also the first formal installation.

JH: It was the first indoor formal installation. The benches came about from the need for seating. Doing an entire room came from wanting to introduce more visual elements . . . color, movement, composition, light, atmosphere, form, the many elements that are considerations when you're making more traditional art.

MA: I've always said to you that I see your environments as embodying some of the qualities of a church or chapel, with the stone benches as pews and the signs as an electronic altar. You've said that you generally saw them more as a kind of "stadium." Could you elaborate on this idea of a stadium?

JH: I say *stadium*, or *auditorium*, so that religious references don't dominate. I like the spiritual to be an element of the work, but I don't want it to take over. This said, the array for the *Mother and Child* writing was something like a futuristic altarpiece. This seemed right for Venice.

The *Under a Rock* installation looked like a combination of a church, a space

station, a Greyhound bus stop, and a high school auditorium. It was a place where you could sit by yourself or where people could gather to review information. There were a number of benches so a crowd could form.

The Dia installation was meant to look like a crypt, or an armory doing temporary duty as a morgue, or a cathedral.

MA: How did the *Laments* [at Dia] come about? Are they about giving up hope completely?

JH: No. If they were about giving up, I wouldn't have done the piece. I wouldn't have written the texts. It was terrible to write them.

MA: These are ostensibly dead people talking?

JH: Yes, they are speaking. My work often has been about how not to die. I thought a way to ward off death was to show the tragedy of thirteen people dead from various causes. The *Laments* also were a response to AIDS. The epidemic has been the first mass death in my experience since Vietnam. All this had something to do with using sarcophagi and with writing the inscriptions that are the last remarks of thirteen individuals, lost for no good reason.

MA: It seems to me that over the past few years your texts have become more personal, moving from the multiple voice of the *Truisms* to the personal pronoun "I" in the most recent work.

JH: Some texts are more personal, but I'm not certain this is a trend. The use of private material now comes from my hoping that it will work. It is true that the writing is not aphoristic now, but this has been the case for every series since the *Truisms*.

The history of the "personal" in my work is as follows: In the *Truisms*— ostensibly multiple voices—I use my own thoughts for some of the sentences. I do the same in the *Essays*. The *Living* and *Survival* series put forward a point of view not unlike my own. *Under a Rock* features my concerns but is not in my voice. For instance, one text is about how to rape. The *Laments* are the remarks

of thirteen individuals. Only a few of these people have much to do with me. The *Mother and Child* text is part confession and part fiction.

MA: The *Mother and Child* text coincided with the birth of your daughter, Lili.

JH: Some of the text is autobiographical. Sections came about because for the first time I knew what it was to have a child and to experience the attendant fears. I did use a number of things that I felt or considered.

Part of the writing is fiction. I wanted the text to be complete, universal, so I added ideas that I could imagine thinking. The *Mother and Child* text is more autobiographical than a number of the works, but it isn't entirely so, and it isn't uniquely so.

MA: I was very moved by the fact that one of the coffins in the *Laments* series was for an infant. So the survival of children was clearly on your mind before the birth of Lili.

JH: I thought about it all the time, especially after her birth. I believe that survival at large is a live topic. Everything from the greenhouse effect to AIDS has many people worrying about dying. Ever since the invention of the bomb, survival has been a subsection of people's thinking. You always feel it's possible that we'll be gone. It's a peculiar thing to have as a fact of life. Motherhood makes this knowledge unbearable. Every waking moment is spent watching a child you cannot protect. The mother and child relationship makes the issue of survival especially poignant.

MA: A number of people I have talked to seem to identify with your work in that it somehow personifies the victim, that it is about being a victim. It's also been suggested that the issue of victimhood is a particularly poignant one for women, that it is an issue with which women very readily identify. What are your thoughts on this?

JH: I think John Lennon said something to the effect that "Women are the niggers of the world."

I think that my work sympathizes with victims, although various characters in the series are perpetrators. I often have characters make reprehensible statements in the hope that the reader will, in reaction, land in the right place. I believe that it's accurate, and maybe helpful, to highlight many types of people. I also like to crawl around all kinds of thinking.

MA: Well, it's poignant also because you are not depicting serene motherhood and apple pie. You present a bloody, guilty mother.

JH: Yes.

MA: Some critics have accused you and some other artists of your generation of being overly moralistic. How do you respond to the accusation that you are a "bleeding heart liberal," moving through the art world in the guise of a kind of "correctness police"?

JH: I don't think you can dismiss an artist for his or her interest in ethics. It is stupid to say that there is no place for ethics in art. Of course, individual artworks can be over the top, subpar, clumsy, or ineffective, but this is as true of abstract painting as it is of political art. I'm glad there is art with no recognizable subject matter, and I am grateful for work with a message. I would be sorry if either type were to become extinct. It is interesting to remember that *Guernica*, one of the deservedly famous works of art, is about terror and war.

My personal politics are liberal, but my work is more complicated. A number of the "people" in my writing will talk about or will advocate almost anything, from nonsense, to private cruelties, to betrayal at the government level. I do this for many reasons, some possibly conflicting. In art you should be free to study and to show anything, and I am interested in following my mind anywhere. Also, didactic work isn't always effective. You can present horror, and the viewer will react more appropriately and more strongly than if you had been preaching.

I don't think I am part of the police. My work takes you in and out of advocacy, through bad sex, murder, paralysis, poor government, lunacy, and aimlessness. As ridiculous as this sounds after the last sentence, I hope that my work is useful.

DOUGLAS HUEBLER

THE LINE ABOVE IS ROTATING ON ITS AXIS AT A SPEED OF ONE BILLION REVOLUTIONS EACH SECOND.

SPEECHLESS

April 18, 1977
Van Nuys, California

Michael Auping: I found your work very difficult at first. I had—well . . . a hard time getting a grip on the content.

Douglas Huebler: All of my works have been directed towards the process or the capacity of a work to generate the making of the work by the percipient. In other words, I am not directing the work towards a kind of literature, but in effect I am trying to empty the work of literature. I try to create a balance between the language or the statements and that which is pointed towards, the signified. I have been interested in creating an equation whereby it's clear that there is no past in the work. There is no past in the image. There is a present, and the present is when the person is reading it. The drawings speak during the instant that you perceive that point, for instance, and until the end of the time during which the words are being read.

MA: Everything you are saying makes sense, and yet I remain confused about Conceptual art in general, what it means as a form. I used to think I knew what Conceptual art was, but the more I see it, or read it, the less I think I know.

DH: As you were implying earlier, I can ultimately conceive of Conceptual art as a variant of romanticism. I can only speak for myself, but I see it as a seemingly impersonal approach to something very personal in that it centers its content in the individual—the world as perceived from the inside out. If you experience it correctly, or at least the way I hope you would experience it, the language doesn't make the art, you make the art. The irony is that while I'm using language to hopefully generate this condition, my ultimate goal is to leave you "speechless."

JESS

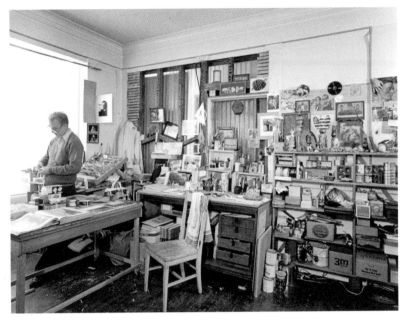

Jess in his studio, 1983. Photograph by Ben Blackwell.

SCIENTIFIC AMERICAN

February 1983–January 1993
San Francisco, California

United States nuclear test, Bikini Atoll, c. 1946.
Photograph from the collection of Jess Collins.

Michael Auping: **When did you first start painting?**

Jess: I was living in a small town, Richland, Washington, at that time [1948–49]. It was a company town with most of us working on atomic defense for the Hanford Project. I took a painting class at a recreation center in my spare time. Art was something that I had always had an interest in but science seemed to get in the way somehow. As a child, I had an aunt that kindled an interest in me for crafting images together, mostly through scrapbooks we kept. Also, painting was a way of taking my mind off of what I was doing at work, which was making plutonium. I mostly did still lifes painted from groups of objects I would set up. One or two of them were vaguely symbolic. I was learning to paint, but I was also learning to understand the presence of images. Everything in the world has a certain quality or spiritual presence, any simple object or image. And when you put them together, a kind of dialogue or story develops. Not a narrative, but more of a dialogue of presences. In the early still lifes, this concept was very vague in me. I would also go out on Sundays to do landscapes. I was a true "Sunday painter."

MA: **When did you decide to leave chemistry for art?**

Jess: Well, I had my dream. At one point, around 1948 while I was working with atomic chemistry, I had a very strong and convincing dream that the world was going to completely destruct by the year 1975. I'm sure the kind of work I was doing had some effect on my state of mind at the time. Anyway, we know that it didn't happen, but at the time I had a strong feeling this would occur. I decided that if that was going to be the case, I wanted to do something that was truly meaningful to me. Art was far more meaningful than making plutonium. So I set about learning more about art. Eventually, I found my way to the San Francisco Art Institute, or California School of Fine Arts (CFSA) as it was then called.

MA: **What do you remember about your student days at the CFSA?**

Jess: [Clyfford] Still's lectures were marvelous. As a lecturer, you would hardly know he was a contemporary painter. Most of the slides he showed us depicted

art of the past and a good deal of European art. That was interesting to me because I was very interested in the visual art and poetics of Europe, and so many abstract artists at the time had the ambition to make an imagery and talk about an imagery that was uniquely American. I remember Still doing a fabulous lecture on Antonin Artaud's van Gogh text. He spent an afternoon reading it to us. You could see that Still felt it was a fundamental text. It was very moving in terms of my understanding of the passion of the immediate image and the difficulty an artist has in arousing a sense of spirit in a societal structure that tends to suppress it.

MA: **What do you remember learning most from Still?**

Jess: He never dictated an aesthetic and abhorred the idea of a style. He taught me a poetics of materials. The thing I learned the most from those student days was an ability to accept an image on the canvas for what the paint would do. I think Still wanted to release the learner from what was supposedly good, right, or proper in painting. As I began to paint nonobjectively, I began to notice that scenes or fantasies would develop. Sometimes they were obvious, but often subtle, so I suspect I might have been the only one to see them. I often let them stay for a while and then later would paint them out. Eventually I let more and more stay. So while I was essentially adhering to a process of nonobjective painting, I was slowly coming to my own type of representation.

MA: **Did you see the Clyfford Still show done by his students at the MetArt Gallery in San Francisco in 1950?**

Jess: That was very important for me. I remember being overwhelmed. I was just beginning my career as a painter and this man had accomplished something so powerfully material and spiritual, or at least that's how I read those paintings. Others had different interpretations. I responded to a kind of mythic quality in Still. The surfaces had a very material quality but they also had a living quality. There was the implication of creating a profound mood that allowed my imagination to go in many directions.

MA: Was it the color?

Jess: It was a complex of things—the multiple possibilities that his forms could take, that interested me a lot. The color was certainly aggressive and moving. But at the same time, I was very interested in Bonnard and Vuillard. But my favorite teacher at the CSFA was Ed Corbett. He was very soft-spoken but he had a way of evoking things from you. I was very attracted to his paintings. They seemed much less about technique than a certain mood. Many of his paintings had a dark and moody poetics, a feeling of spirits hovering.

MA: What kind of paintings were you doing in the fifties?

Jess: I guess the closest description would be romantic fantasies that were generated from my experiments with nonobjective painting. The more I painted "nonobjectively," the more I began to see my image as complex, telling or suggesting a story. Sometimes the story would relate to my readings of romantic fiction and sometimes just my own fantasy wanderings.

MA: Did the image emerge first in this case, or the allegory?

Jess: The image always comes first on its own terms and then as I become aware of what's developing—the story path that I am unconsciously following—then sometimes an existing myth or story comes into view. However, I try not to be too specific or didactic with an image. What I always wanted to do was make the image in flux so that at any given time you could see a woman or an enchanted landscape. One of the things that I've always loved about living in this old house are the water stains and cracks in the ceilings and walls. I can't help staring at them and making pictures or fantasy images out of them. This is what da Vinci said an artist must do—to take note of all stains on the walls and pay particular attention to foliage, things that are very real in an abstract way.

MA: How would you describe your color sensibility in those early years?

Jess: As I was learning to paint, I experimented with all ranges of colors, depending on the mood that I was consciously or unconsciously trying to evoke. I think I would sometimes try to break the stereotype associated with certain colors.

MA: Was it a challenge you put to yourself to take bright, almost sweet colors and make them mysterious, even demonic at times?

Jess: It wasn't something I set out to do, but it always amused me when it happened. I think, however, many people in the art world are too quick to label something pretty or intimate in the derogatory sense when, in fact, the image construction is much more complex than that. Bonnard or Vuillard never struck me as being predominately sweet or intimate, as they did some. It's a whole image complex that in the end determines what effect a color has. There is a dark side to any bright color as there is a bright side to any dark color, if you can find it. I think of my colors almost as personifications. It's like when you name somebody, it's a magic process of calling them into being. Each of the colors that is placed had this kind of calling of intensity for that point in the canvas.

MA: Do you see a painting as a spiritual process?

Jess: Yes, I certainly do. However, I don't see that much difference between the spiritual and the material. All matter is energy, and all matter and energy are infused with spirit.

MA: A number of your works of the 1950s we could describe as landscapes.

Jess: Well, I would say it's a landscape as a field of imagination. I see landscape, particularly in the early work, as a matrix for the imagination.

MA: Am I wrong in saying that the castle image shows up fairly often in a number of your works?

Jess: Yes, it does.

MA: Is it also a kind of metaphor for the ultimate imagination?

Jess: Perhaps, to some extent. When I refer to a castle, it comes from my sense of the romance of the castle, the romance of a medieval idea of a castle rather than the Renaissance. It is a romantic symbol of what might be an unobtainable goal. It seems always to be just detectable on the rise in the distance.

MA: Would you describe some of the early works as symbolic landscapes?

Jess: The idea of a symbolic landscape interested me, but I would not make the symbols up beforehand. They would arrive with the process of painting. There is usually some effect of reverie, I suppose you would call it, that takes place during the quiet moments of painting, and often my reading or daily fantasies will begin to enter my understanding of the imagery that is coming forth. Sometimes the imagery simply remained nonobjective. In other cases, a fantasy image developed. It wasn't a conscious attempt to create a fantasy. It was just something that I saw developing in the paint. What I was doing was not so much in opposition but certainly standing to one side of the tenets that were being taught and talked about by the students at the CSFA, particularly in response to New York Action painting. Representation as a way of painting was scorned. I personally didn't see any reason to make a dichotomy between abstraction and representation.

MA: So you didn't have any trouble moving back and forth between figuration and abstraction?

Jess: No. It was all paint. I'd be lying if I inferred it was an easy thing to do from a social or art political sense. There was ideology all around me like a vortex. I was determined not to be sucked into a single way of thinking. Many of the students were very single-minded in feeling that they were revolutionary in their strict way of painting. At some point, I gave up the idea that there was such a thing as a set way of painting. I never thought of myself as a revolutionary in painting. I was painting to have a dialogue with myself and what I think of as the history of the imagination, through myths, images, and stories. The dream I had

helped change my outlook on things. With what little time I thought I had, I wanted to spend the rest of it painting and exploring the possibilities of the imagination, whether it be figurative or abstract. That dream was what saved me from being a nuclear chemist.

MA: Was allegory something that distinguished your imagery from that of some of your contemporaries or elders?

Jess: All paintings are allegorical. The most nonobjective paintings are allegorical. They are an allegory of the way any one person sees and interprets the structure of reality. A work by Mondrian is an allegory of his way of structuring what he sees and feels, which may have spiritual undertones.

MA: You also studied with Ad Reinhardt when you attended the CFSA. Did Reinhardt influence your involvement with collage in the early 1950s?

Jess: I wouldn't say so. Max Ernst was much more influential. I was very taken by his collages, the mixing of many different images to make something whole. I think the Paste-Ups might also relate to Robert [Duncan]'s ideas about poetry and rhythms and the mixing of themes. None of this was conscious, but we often talked about the element of surprise and disjunction in forming an image. When I am pasting up, I am moving images around constantly, surprising myself with new meanings.

As far as Reinhardt, I liked his comics very much. They had a wonderful sense of whimsy and wit. I don't tend to analyze myself that much when I'm working, but it could be that I was unconsciously thinking about him when I did my Tricky Cad series of cartoon collages. For me, the Tricky Cad Paste-Ups were fun. Many, as I recall, were done at the kitchen table, and certainly not with the idea of a historical statement about collage.

MA: One of the Tricky Cads was included in an early Pop art exhibition. Do you think of your work as relating to Pop art at that time?

Jess: That was a mystery to me. I wasn't really aware of what Pop art was and to this day I don't feel much kinship with that movement. I like some of what I've been able to see of Pop in books. I've never gone out to many exhibitions. But from what I've seen, I don't think we are evoking the same thing.

MA: *Mouse's Tale*, 1951, was your first large collage, or Paste-Up. How did it come about?

Jess: Well, *Life* magazine, which was a weekly at the time, was a gold mine of imagery for me. Collage was a way for me to construct imaginary scenarios in a more realistic rather than a nonobjective way. I really could not paint well enough at the time to create images as fantastic—in all senses of the word— as were available in *Life* magazine.

Mouse's Tale was constructed of male nudes with the idea of showing innocent beauty as opposed to macho bodybuilding. It was a beginning for me to see how I could reuse the recurrent images that would jump out at me, for fantasy or mythological reasons, from all these marvelous and seemingly innocent publications.

MA: The Paste-Ups have become extremely complex over the years and seem to take longer and longer to complete. Have they become the main or important body of your work?

Jess: No. I have always felt equally engaged in all the different aspects: Translations, Salvages, and Paste-Ups. And if you think about it, they are really not that different. It is all about rescuing or resurrecting images. It is true that pasting up is a marvelous way to rescue so much and see the dialogue that takes place. With so much on the table and in my not-so-organized files—old prints, more recent magazines, and posters—the stories or images that can be created or pulled through time seem endless, which probably explains why it takes me so long. Everything has to fit, not only in terms of form, but also in its mythic, spiritual, or psychological presence. And just as importantly, it must all remain in flux so that no single story dominates.

MA: I am interested in your approach to mythology and mystical writings like the kabbala. Do you make a point of studying certain texts?

Jess: No. I am anything but programmatic about those things. I am interested in the path of an image, particularly a certain spiritual or mystical path that I might discover. Robert and I would often discuss a particular image from reading or television and follow its line back in time using our library here. We would always be fascinated by how the imagination travels through time, the image being a constant vehicle.

MA: Why do you prefer the term *Paste-Up* to *collage*?

Jess: It has always seemed more intimate a term. I used to paste things up with my aunt and that experience is probably more central to my love of this kind of work that the modern development of collage, although, as I've said, I came to greatly admire Max Ernst.

MA: How did you arrive at the idea for the Salvages, and what did you have in mind by titling them *Salvages*?

Jess: Well, really all of my work—Paste-Ups, Assemblies, Translations—comes from salvaging. I salvage loved images that for some reason have been discarded and I come across them. I've at times found wonderful things on the street, just thrown away. If you find something that you really respond to that someone else has thrown away, it's a kind of mini-salvation. By using the title *Salvages*, that increases the levels of meaning, I think. Immediately, your mind attaches to the word. The Paste-Ups are a form of salvaging image fragments from magazines, posters, and old prints that would probably be thrown away. The Translations are also a form of salvage in a way, because all of the images I've used for that series I've found in old books, magazines, postcards, or photos that were close to the end of their life sitting and rotting in a used bookstore, and they have spoken up out of the matrix of images that surround them. So they end up being salvaged too, from a possible obscurity. If I find a painting in a junk shop that puts forward a strong sentiment but, for whatever reason, did

not work well enough as a painting to be kept by the owner, then I might try to rescue that sentiment by adding my feeling through paint. If I can do that, and many times I can't, then it becomes a Salvage. I put forward a new layer of sentiment that, combined with the old, may hopefully allow the image to have a new life or at least a half-life.

The term *translation* is also a word that has its layers of meaning. The term *translation* has hidden into it "being translated into the empyrean, into heaven." It is the possibility of being translated to a higher level emotionally and some-times spiritually.

I chose the word *translation* instead of *copies* because they are not copies. I don't intend to present a naturalistic or photographic duplication. If I use, say, a nineteenth-century engraving, I'm not trying to evoke a replication of a nineteenth-century sensibility. I don't have the skill or knowledge to do that. I'm translating that image out of the nineteenth century into my time, using what knowledge I do have, which is not enough. To call it copying—that's too specific. It looks, at first, like copying but it's very different. The term *translation* seemed to me to be the nearest of what was being done.

MA: What about the *Narkissos* project, which was such a major commitment? It was a drawing, a Paste-Up, and then an elaborate drawing of a Paste-Up, which was to take over a decade to be filled in with paint. You completed everything but the painting, and now you have decided to leave it unfinished.

Jess: Well, for a long time, *Narkissos* was a grand obsession, and grand obsessions don't always have logical or perfect conclusions. When I made that first little drawing [in 1959], I saw immediately that it was a vision capable of expanding into great complexity. In the second drawing [1964], I elaborated the field of possibilities, and then the Paste-Up took me years and lured me into what still seems to me to be an endless, magical realm. What I thought would initially take ten years to complete took well over twenty and was not yet finished. Robert's sickness and his passing slowed me, really brought it to a halt. I realized, at some point, that even if I devoted full time to it for the rest of my life, I still might not complete it. So I made the difficult decision to stop. I work on my other projects now, my Paste-Ups and Salvages. They are all about this magnificent constellation. They're all about the same thing.

MA: Is there a specific story behind the *Narkissos*?

Jess: There are many stories. I really would not want to tell you what I see, and that often changes anyway—because that would limit your seeing. To say that it's about myth and the romantic imagination is hopefully enough. For most of us—certainly for me—the mythic imagination carries a level of reality that can be equal to or greater than logic and the scientific method. I try to bring together many story possibilities that will trigger more stories and more possibilities. You see something grotesque that I think of as beautiful and vice versa. It's all about the romantic imagination and creating something that does not stop where my imagination leaves off.

ELLSWORTH KELLY

Ellsworth Kelly at the Hotel Bourgogne, Paris, 1949. Courtesy of the artist.

SECRET CODE

June 23–24, 1988
Spencertown, New York

La Combe III, 1951. Oil on canvas. 63½ × 44½ inches (161.3 × 113 cm).
San Francisco Museum of Modern Art and anonymous co-owners.
Photograph courtesy of the artist. © 2007 Ellsworth Kelly.

Michael Auping: **Did you always paint abstractly?**

Ellsworth Kelly: Of course not. No one of my generation did. We had to learn how to draw and in those days that meant looking at things, still lifes, models, things in the world—looking at them very carefully. . . . I will say that at a very early age I felt that I saw things abstractly. The more carefully I looked, the more abstract they became. It's always been a peculiar irony to me, but it really is what makes me keep looking at things.

MA: **It is strange—strange how people see or interpret the same thing differently. An artist will look at something real—a scene or a landscape of some kind, and see it as an abstraction, which is why I sometimes think artists are freaks a little bit, the way they read a phenomenon. Then someone will see the abstraction and see a rabbit or something—like different witnesses at the scene of a crime. When abstraction was invented, it really twisted the rules of visual thinking or visual interpretation.**

EK: That's what makes abstraction so interesting, not as a historical phenomenon but as a visual phenomenon—simplicity and complexity all wrapped into one single image. . . . Speaking of the scene of a crime, early in my involvement with abstraction I had a funny thing happen, or at least it seems funny now. I was invited to be in an exhibition at the Museum of Fine Arts in Boston. This was in the very early fifties, and I was living in Paris. It was an alumni exhibition. I had gone to the Boston Museum School and I sent one of my early abstractions, one that is in your exhibition I believe [La Combe III]. It was a very conservative exhibition and those were very conservative times. Abstraction wasn't really an accepted language yet, and I think the work I sent was one of the only abstractions in the exhibition. When I shipped the painting a problem arose with Customs. I don't know exactly how it all unfolded, but the Customs people questioned what it was and when they were told it was a painting, they got suspicious because they couldn't see anything recognizable. Remember, this was the Cold War, and it's still hard for me to believe this, but they suggested it was some kind of code, secret communist code. Can you believe that? [*laughter*] It's just funny how we see. Actually, I like the idea they might see some abstract code. Ironically, the image came from a photograph I took of some shadows on stairs. If you saw it with the photograph that I took to capture how interesting the shadows looked, you would see how very real the image is.

ANSELM KIEFER

Anselm Kiefer in a tunnel on his studio compound in Barjac,
France, 2003. Photograph by Michael Auping.

HEAVEN IS AN IDEA

October 5, 2004
Barjac, France

Michael Auping: Titling an exhibition *Heaven and Earth* [Modern Art Museum of Fort Worth, 2005] requires a little explanation. Perhaps we should just begin with the very simple question, do you believe in heaven?

Anselm Kiefer: The title *Heaven and Earth* is a paradox because heaven and earth don't exist anymore. The earth is round. The cosmos has no up and down. It is moving constantly. We can no longer fix the stars to create an ideal place. This is our dilemma.

MA: And yet we keep trying to find new ways to get to "the ideal place," the place we assume we came from—to find the right direction.

AK: It is natural to search for our beginnings, but not to assume it has one direction. We live in a scientific future that early philosophers and alchemists could not foresee, but they understood very fundamental relationships between heaven and earth that we have forgotten. In the Sefer Hechaloth, the ancient book that came before the kabbala, there is no worry of directions. It describes stages, metaphors, and symbols that float everywhere. Up and down were the same direction. The Hechaloth is the spiritual journey toward perfect cognition. North, south, east, and west, up and down are not issues. For me, this also relates to time. Past, present, and future are essentially the same direction. It is about finding symbols that move in all directions.

MA: Our religions all have heavens.

AK: We can't escape religion, but there is a difference between religion and heaven, and one doesn't necessarily lead to the other.

MA: You are not a "New Age" spiritualist. I know that for sure, but some people who see your images may wonder just what your position is in regard to religion.

AK: My spirituality is not New Age. It has been with me since I was a child. I know that in the last few decades religion has been made shiny and new. It's

like a business creating a new product. They are selling salvation. I'm not interested in being saved. I'm interested in reconstructing symbols. It's about connecting with an older knowledge and trying to discover continuities in why we search for heaven.

MA: I can see fragments of continuity in your works between symbols that are ancient and those that take a more modern form, and for me that suggests a kind of hope within your landscapes. But there are also some very dark shadows in your images, literally in terms of color, as well as in metaphor and content. It is as if in the same image we see a liberation of knowledge but the dark weight of history.

AK: There is always hope, but that must be combined with irony, and more important, skepticism. The context of knowledge is changing constantly. At one moment we pray from the top of a mountain and the next from a seat in a jet plane or a bomber cockpit. How can we not see that as ironic and skeptical?

MA: I understand what you are saying, but I'd like to backtrack a little. You were raised a Catholic.

AK: Yes.

MA: Did you attend church often?

AK: Sure. Religion was a part of my childhood and my youth. It was a very important thing. The rituals and rites were important. I can still do them in Latin. Of course, I knew the Latin before I knew what it meant. But I was involved, like many young people of my generation, in learning religion at an early age.

MA: Christian images are apparent in your work, but in many ways not as apparent as Jewish or even Gnostic references.

AK: Later, I discovered that Christian mythology was less complex and less sophisticated than Jewish mythology because the Christians limited their story

to make it simple so that they could engage more people and defend their ideas. They had to fight with the Jewish traditions, with the Gnostics. It was a war of the use of knowledge. However, it wasn't just a defense against outside ideas. It was aggressive. Like politics, they wanted to win. You know, the first church in Rome was not defensive and not aggressive. It was quiet. It was spiritual in the sense of seeking a true discussion about God. It was exploring a new idea about humanity. But then there was *ecclesia triumphans*, the Triumph of the Church. And then the stones were stacked up and the buildings came, and the construction of the Scholastics, Augustine, and so on. They were very successful in limiting the meaning of the mythology. There were discussions about the Trinity and its meaning. Anyone who had ideas that complicated their specific picture was eliminated. This made Christianity very rigid and not very interesting. Whenever knowledge becomes rigid it stops living.

MA: In 1966, you visited the Monastery at La Tourette. Was this before you made the decision to be an artist?

AK: I began by studying law. I didn't study law to be a lawyer, but for the philosophical aspects of law, constitutional law. I was interested in how people live together without destroying each other.

I went to La Tourette while I was studying law. It may sound strange to go from the study of law to La Tourette, but it really wasn't. I had always been interested in law from a spiritual aspect. A constitution is not unlike the idea of church doctrine. People need a context or a content, something to bind them together. This could be stretched to mythologies. Law, mythology, religion— they are all structures for investigating human character. There was a well-known constitutional lawyer, Carl Schmitt. He was a very brilliant man who worked in the 1920s through the 1950s. Unfortunately, he got too involved with the Nazis. He was not really a fascist, but he got entangled with Nazi politics. They adopted him. He was very interesting in terms of bringing together legal theory and religious traditions—quite brilliant; but after the war, he was discriminated against. Nobody talked about him, even though he had made some very important contributions to constitutional law. I studied him because he was a very interesting man, as much a philosopher as a lawyer. When I was in

Jerusalem, I found out that he was an adviser or consultant when they made their constitution. I think it was kept a secret for some time. He wrote a very interesting book about the Leviathan, the giant serpent that became an image of political power. I was interested in people like Schmitt because they got caught between the power of government and the power of God. We are all in that dilemma.

MA: Why did you go to La Tourette in the first place? I don't imagine that you went only to see a Le Corbusier building. You stayed there for three weeks.

AK: The Dominicans were there. I liked their teaching. They have an interesting history. I had read that they had many discussions with Le Corbusier about the shape of the building and the materials. It was a point in my life when I wanted to think quietly about the larger questions. Churches are the stages for transmitting knowledge, interpreting knowledge and ideas of transcendence. It's a history of conflicts and contradictions. A church is an important source of knowledge and power. Le Corbusier knew that. I stayed there for three weeks in a cell. I thought about things. In a place like that you are not simply encouraged to think about God but to think about yourself, *Erkenne dich selbst.* Of course, you think about your relationship to your god.

Also, for me it was an inspiring building in the sense that a very simple material, a modern material, could be used to create a spiritual space. Great religions and great buildings are part of the sediment of time; like pieces of sand. Le Corbusier used the sand to construct a spiritual space. I discovered the spirituality of concrete—using earth to mold a symbol, a symbol of the imaginative and the spiritual world. He tried to make heaven on earth—the ancient paradox.

MA: How do you mean that?

AK: Heaven is an idea, a piece of ancient internal knowledge. It is not a physical construction.

MA: Two years after visiting La Tourette, you made a small book titled *Die Himmel (Heaven)*. I believe it was your first artwork.

AK: It was the first work that I didn't destroy.

MA: You did a lot of books at that time. Probably the most famous, or infamous, was the book of *Occupations* photographs. You photographed yourself doing a Nazi salute at different locations in Europe. That seems so radically different from a book titled *Heaven*.

AK: Well, *Occupations* was done in stages over a longer period of time, but yes. One is a very specific topic and one is a very big topic. It's like the macrocosmic and the microcosmic. I wanted to deal with large issues in my art, but that didn't keep me from studying my own history as a German. Also, that first book *Heaven* was not as romantic as it sounds.

MA: It's a collage book of shapes cut out of magazines—many of them little pieces of sky.

AK: I was very interested in media at that time. I realized that you could use any material to create imagery. What better than to use something so basic as popular magazines to create my own heaven? In a way I was testing to see if it worked.

MA: Did it?

AK: Of course, we can all create our own heaven using whatever materials we want. We always imagine heaven as something physical, as a place rather than as time. We have to have our illusions. I think heaven is about time, and is always changing. So there are many heavens in this book.

MA: Near the cover of the book is a black-and-white photograph of an Albert Speer building.

AK: Yes, but not a building. It was a very good artwork that he made. He collected all the light projectors (klieg lights) that the army used to spot enemy aircraft. They had a lot of them and he put them together and pointed them up to the sky. It's like a cathedral, but much higher. It's a wonderful idea.

MA: Do you think Albert Speer was a spiritual man?

AK: You don't have to be spiritual to get in touch with spirituality. It's easier but it is not always necessary. It can happen that someone who does not think about spirituality, does not consider it in his life, can get in touch with the spiritual through circumstances he is not responsible for or aware of. Speer was a very focused man. He created spaces that in different circumstances could be considered spiritual, but were not used for spiritual purposes.

MA: You have made reference to Speer's buildings in a number of your works. Does Speer represent something specific for you?

AK: Speer's architecture is interesting, but because of his connection to the Nazis he was not being discussed at the time I was using his images. There are many artists who run into trouble on their way to paradise, philosophers also: Marx, Hegel, Mao, Wagner. They have all looked for ways to find their place, their salvation, through philosophy, art, or religion.

MA: It seems to me that Speer's buildings were meant to intimidate, not just inspire. They were powerfully political churches.

AK: The church has always been political. This is nothing new. And politics can pose as religion. Hitler abused religion. His speeches were full of prayers. We know all of this, which is why we have to have some skepticism in our spirituality. Anyway, this Light Dome we were discussing by Speer—I think he wanted to make something very special for the Reich Convention, a political convention. And he made this very beautiful Light Dome. Maybe he was doing it for beauty or for politics. The situation of the artist is not pure.

MA: Could we go back and talk a little bit more about your education as artist? You went to the university in Freiburg.

AK: Yes. But first I had the nineteenth-century idea that the artist is a genius— that art comes out of him naturally and he doesn't need any education. I had

always thought this, even as a child. You could say that I had too much admiration for artists. I thought they all came from heaven. Later I found out that an artwork is only partly done by the artist, that the artist is part of a larger state of things—the public, history, memory, personal history—and he must just work to find a way through it all, to remain free but connected at the same time. Peter Dreher, an artist and professor in Freiburg, was very important for me in this way. I had come from law school and was trying to figure out the rules of this new world of art. Peter Dreher opened me to the freedom of this new world, to the milieu of the artist, and how to operate within this freedom. If you are a genius, you don't need a milieu. So I figured out that maybe I wasn't a genius. He said to me, "Do what you want." And then we could talk about it later. He helped me to understand that first you have to work and then you can talk.

MA: And later on you went to see Joseph Beuys, although you didn't officially study with him.

AK: No. I was living in the forest in Hornbach and had made some canvases. I had heard of Beuys and so I took my canvases to Düsseldorf to show him. He was impressive. I liked him very much. His dialogue was broad and he could be very impressive. He had a world view, not just the view of an artist. I think I appreciated him more because I had studied law.

MA: How so?

AK: Art just cannot live on itself. It has to draw on a broader knowledge. I think both of us understood that at the time we knew each other.

MA: Although I never met him, you and Beuys seem very different to me. He was more extroverted and you are more introverted, or at least less public.

AK: We were different, and as a young artist I needed to question that difference. Nevertheless, I learned a lot from him, even though he was not my teacher. I could talk to him about larger issues.

MA: In his interviews and writings, Beuys often evoked the word *spiritual*. How do you think he meant that?

AK: That is complicated. We were both in Germany at a certain time—a time when a dialogue about history and spirituality needed to begin. It was difficult to separate the two subjects. There was a sense of starting over. To evoke the spiritual not only looking at ourselves but into the history of our nation. It was not just a matter of a critique. It had to be deeper than that. So yes, Beuys was a spiritual man. The artist is naturally spiritual because he is always searching for new beginnings.

MA: Your use of the artist's palette image in many of your works seems to suggest various roles for the artist, not always spiritual in his effect.

AK: The palette represents the idea of the artist connecting heaven and earth. He works here but he looks up there. He is always moving between the two realms. The artists are like the shamans, who when they were meditating would sit in a tree in order to suspend themselves between heaven and earth. The palette can transform reality by suggesting new visions. Or you could say that the visionary experience finds its way to the material world through the palette.

MA: Sometimes your palettes are on the ground, a part of the earth, which is constantly referred to in your work, as a painted image or the material ground for a painting.

AK: All stories of heaven begin on earth.

MA: Often the earth appears to be plowed or burned or both. Many people see your landscapes as referring to battlefields.

AK: In some cases, that is true; but for me there is a larger metaphor. Plowing and burning, like slash-and-burn agriculture, is a process of regeneration, so that the earth can be reborn and create new growth toward the sun. Burning is a method to take out spirit. There is the alchemical reference to *nigredo*,[1] but it

goes deeper than that. Burning is absolutely elemental. The beginning of the cosmos that we have conceived scientifically began with incredible heat. The light we see in the sky is the result of a distant burning. You might say heaven is on fire. But also our bodies are generators of heat. It is all related. Fire is the glue of the cosmos. It connects heaven and earth.

MA: Like fire, it seems to me that all of your images are symbolic mediators.

AK: Sure. Angels take many forms. Satan was an angel. We are not capable of imagining God in a pure state. We need symbols that are less pure, that include human elements.

MA: Like snakes.

AK: Yes. The snake can be an angel. It has played that role many times before in history.

MA: In a number of works you have referred to The Hierarchy of the Angels, and the concept of a celestial hierarchy. Is there a hierarchy to your symbols and the materials you use when you refer to this idea?

AK: No. There is no strict hierarchy to my images. They seem to be always evolving from one form or condition to another. This relates to the thinking of the Greek saint Dionysius the Areopagite. Do you know about the ideas attributed to him?

MA: The idea that heaven is organized in orders of different forms of angels?

AK: Yes—angels, archangels, seraphim, cherubim. More important was the concept that the spiritual realm is a spiral going up and down. So the spiritual realm is moving and twisting. This is important to the way I organize my pictures. I work with the concept that nothing is fixed in place and that symbols move in all directions. They change hierarchies depending on the context.

MA: An airplane propeller could be an angel or the spiral universe itself.

AK: Yes. And of course flying machines have played important roles in history, representing ambitions of transcendence or military power, from Icarus to moon rockets.

MA: I was also thinking about the different levels of spheres and subspheres in the kabbala that deal with the evolution or hierarchies between matter and spirit, and how that might relate to your use of materials. Your studios are warehouses of everything from dead plants and human teeth to sprawling stacks of lead. Are you suggesting a kind of symbolic ladder through your materials?

AK: Not that directly. I collect all of these things as I read and they find their way into my reconstructed stories, but I usually become attached to materials that have more than one side to their meaning. So they can be used to go up and down the ladder. Lead is a very good example. The large sheets of lead that support the *20 Years of Solitude* books are from the roof of a cathedral. Lead can transform itself in all directions.

MA: I've also noticed that many of your paintings can be turned upside down and still carry their message, as if the heaven and the earth just switch identities. It seems to me the orientation is only fixed when you write on the canvas.

AK: I work on my paintings from all sides, so when I am working on them there is no up or down. The sky can be reflected in the water or material can come down from the sky. That is part of the content of the paintings. Heaven and earth are interchangeable. The writing is an attempt to fix a moment or a place, to suggest a fixed state, but the imagery denies. It is active.

MA: Like the stars, galaxies, and constellations you have been referring to— the Astral Serpent or the Milky Way.

AK: The title or language on my paintings is a starting point. The images should expand the meaning of the words. In *Die Milchstrasse*, I thought of the large cut in the land as a puddle of water. When the clouds are reflected on its surface, it looks like milk. A puddle is a very simple thing, but it has the ability to reflect into something much larger. It could be the Pacific Ocean.

MA: On this canvas it looks monumental, but it also looks like a wound in the belly of the earth.

AK: Yes. It could be. When you dig into the ground, you may find something— water, a buried meteorite, a piece of heaven. These kinds of pictures are always operating between the macrocosmic and the microcosmic. The lead strings reach to the sky and then converge down into the funnel, which dips into the puddle. The Milky Way, which has been observed for millenniums as a great and expansive constellation, is really a small thing in the cosmos. It is like a puddle in the cosmos. Establishing a heaven and earth is a way to try to orient ourselves, but cosmic space does not understand this. It is all relative. What is big can in fact be very small. What is up can be down.

MA: It's like size versus scale in your work. Your formats vary tremendously, where size and subject can sometimes seem contradictory—making a monumental canvas for what you call a "puddle," and then making a tiny book about heaven. The book *Die Himmel* is one of your smallest works.

AK: You cannot compete with heaven through size. The universe was once thought of as a large book. The human imagination creates its own heaven with things on earth.

MA: Books are clearly an important symbol for you—important mediators or containers.

AK: You know I did my first book when I was ten or eleven years old. I'll show it to you. [*Reaches for a book high on a bookshelf*] You see here I gave it the number forty-two to indicate that it would be part of a large series. I must have

been a bit pretentious. [laughter] As a young student, we were told to read a book and then write about the book, also making illustrations that would summarize the book from our memory. It was a very typical way of teaching in Germany.

The book, the idea of a book or the image of a book, is a symbol of learning, of transmitting knowledge. The story of our beginnings always begins in the oral tradition, but eventually finds its way into the form of a book. This has its double side. It preserves memory, but it also makes the story more rigid. Everyone tells a story differently, but when it is written down it can become frozen.

MA: It's always possible to interpret the written word differently.

AK: Yes, of course. But as civilization progresses there seems to be less interest in interpretation and more of simply an acceptance. This is why the Gnostics were important. They questioned, interpreted, and reinvented the story. We know very little about them except from later Christians who tried to dispel their questioning. But the questions continue to come. Science has not found our beginnings. The closest we can come to the beginnings are the old myths, the old stories. Questioning them keeps the story alive. I make my own books to find my own way through the old stories.

MA: When did you first become interested in the kabbala?

AK: I can't say for sure. Since childhood, I had studied the Old Testament, and sometime as a young man I began to read of Jewish mysticism. Then in the mid-1980s, I went to Jerusalem and began to read the books of Gershom Scholem. Beside the fact that kabbalistic stories and interpretations are very interesting, I think my attraction has something to do with the way that I work. People say that I read a lot, but in some ways I don't. I read enough to capture images. I read until the story becomes an image. Then I stop reading. I can't recite a passage, but I can recite it as an image. For an artist it is important to have a strong, complex subject. *Kabbala* means "knowledge that has been received," a secret knowledge; but I think of it as images that have been received. As I said before, the Christian church hardened in its knowledge and its symbolism at a certain

point. The kabbalistic tradition is not one but many, forming a sophisticated spiritual discipline. It is a paradox of logic and mystical belief. It's part scholarship, part religion, part magic. For me, it is a spiritual journey anchored by images.

MA: Thinking of it as a journey, an image that has come to play a larger role in your art is that of the Merkaba—

AK: Of course, the chariot—the vehicle that rides to the throne of heaven.

MA: I think of the chariot as a kind of angel.

AK: It is more sophisticated than that. The image is that of a throne chariot of God, which could ascend and descend through the different heavenly palaces known as the Hechaloth—with the seventh or final palace revealing God. It comes from Ezekiel's vision of a mystical flight to heaven. But it is really a meditation tool. The kabbalistic mystics established a technique of using a chariot for a meditation tool. Using the chariot, the mystics would make an inward journey to the seven palaces in their correct order.

MA: Here on the grounds of your home in Barjac, France, you are creating a monumental installation of stacked concrete rooms or "palaces" that go up hundreds of feet into the air, as well as a sprawling series of connected underground tunnels and spaces containing palettes, books, and lead rooms. Are you working your way through the palaces of heaven?

AK: I follow the ancient tradition of going up and down. The palaces of heaven are still a mystery. The procedures and formulae surrounding this journey will always be debated. I am making my own investigation. You know this book the Sefer Hechaloth (Hechaloth Book)? Obviously, this is not just about traveling through palaces, but traveling through yourself in order to know yourself; the old saying *Erkenne dich selbst.*

MA: Recently you have made immense books the size of a human body that you can almost walk into, with the pages covered with stars. But you have

given the stars numbers and connected them with lines. These star drawings have also appeared in huge paintings that include observatories and what look like navigation instruments.

AK: They are numbers given to stars by NASA scientists. Each number in the string of numbers indicates the distance, the color, the size, etc. This is the scientific heaven. But of course it is all illusion. All of the constellations are illusions or ghosts. They do not exist. The light we see today was emitted millions, billions of years ago and of course their source was constantly changing, moving, and dying. These lights we see, this heaven has nothing to do with our current reality. We are afraid, so we have to make sense of the world. We cannot stand not to have a heaven in our minds. If there really was a heaven, it would exist outside of science or religion. I am speaking of religions, with the plural; not just a religion.

MA: So the scientists are making up their own dome of heaven.

AK: Of course. They want to find heaven too, but their stars are always moving, always dying, and some breaking off, making new stars. Scientists are a little bit like artists. Their stars are like pieces of memory that find their way into a painting. You pull them out and stop them for a moment in the painting. It is stopped only for the instant you recognize it and then you change position and you see something else, another relationship in the image, but again, only for an instant. There are only glimpses.

1 *Nigredo* is defined as "The initial black stage of the opus alchymicum in which the body of the impure metal, the matter for the Stone, or the old outmoded state of being is killed, putrefied, and dissolved into the original substance of creation, the *prima materia*, in order that it may be renovated and reborn in a new form." Lyndy Abraham, *Dictionary of Alchemical Imagery*.

RICHARD LONG

Richard Long viewing the alignment of *England*, 1967 in Ashton Court, Bristol.

HOMETOWNS

June 3, 2000
Bristol, England

Untitled, 1992. Mississippi mud on rice paper.
72 × 36½ inches (182.8 × 92.7 cm).
Collection of the Modern Art Museum of Fort Worth,
Gift of the Director's Council, 1994.

Michael Auping: You've done shows all over the world. What is it like having a show in your hometown, particularly since it is a small city[1]?

Richard Long: It's quite complicated because of my personal histories with people coming to the opening. I hear musicians say that to go back and do a concert in their own hometown is often the most difficult thing to do. It's definitely a different kind of thing. I will say it made a very nice change to be able to come home to my own bed every day and do the show as if I was just doing my home routine. I would do one room in the morning and then do my shopping in the afternoon, and go home. I could just fit it into my daily life.

MA: Give me some background. You told me once, but I've forgotten a lot of it. You were born in Bristol?

RL: Yes. I'm one of the few artists who still lives where he was born. It's quite unusual for an artist in this day and age.

MA: It's unusual for anybody, artist or not. Where were you born in Bristol?

RL: Up near the Suspension Bridge in an old maternity hospital.

MA: Where was your first house in Bristol? Do you remember?

RL: I do, yes. It was in Osborne Road. It was a big house, owned by my aunt, my father's older sister. We lived in different flats in it. My first memory is living on the very top floor, and then we moved down to a middle floor, and we ended up in the basement, which had a garden. I think I liked having the garden. That suited me. Then when I was eleven, we moved to another house, which was only about a half mile away. Unlike today, I didn't travel very far when I was young.

MA: Tell me about Bristol. I couldn't find a book today on the history of Bristol. Can you give me a kind of thumbnail sketch of Bristol's history?

RL: I guess the heart of Bristol is its maritime history. It made all its money in the seventeenth and eighteenth centuries from the slave trade mainly. All the sailing ships would leave the harbor and go to West Africa to get the slaves and then go to the West Indies, and come back from there and the southern states of America with sugar and tobacco. So the traditional industries of Bristol, apart from the slave trade, were making cigarettes and making chocolate from the sugar. It had an immoral history!

MA: So the town was about a lot of coming and going—a history of movement—ships going out and coming in.

RL: Well, yes, like some of the early people who discovered Newfoundland. I mean, they didn't really discover it, obviously, but I mean people like John Cabot. They sailed from Bristol. It was one of the ports, like Liverpool, where some of the early explorers and navigators sailed from.

MA: Were you aware of that history as a child?

RL: No, not specifically. As a youngster you just get glimpses. There's a beautiful hill here in Clifton, which has Cabot Tower. I was aware of the old tobacco factories still in operation. I still remember the unbelievable reek of fresh tobacco on the girls' clothes that worked in the tobacco factory, when they got on the buses going home. And, you visited me in my studio. That was the school cottage of the country house that belonged to the Fry family, which was one of the original big chocolate families.

MA: And the house that you live in now . . .

RL: Now I live in the old village school.

MA: I guess what I'm getting at here is, you've lived in Bristol all your life. It's so hard for me to imagine. I grew up in Los Angeles, and for better or worse, I'm sure that what I do has some Los Angeles in it. But I didn't live in L.A. the whole time of my life. We moved around a lot. You've lived in Bristol all your life.

How do you think Bristol has informed your . . . not even so much how it has informed your art, but how has it informed your life?

RL: Well, it has informed my art by informing my life first. As a kid I was always playing on the towpath. My natural playground was the cliffs of the Avon Gorge and the towpath by the river. So even as a kid I was fascinated by the enormous tide, and the mud banks, and the wash of the boats as they swept past. You have this wash sweeping up the mud . . . muddy creeks . . . and also playing on the steep slopes and screes of the gorge and in the caves. Because it's lime-stone, it's riddled with caves. So it was like an amazing adventure place for a young boy. Then we have what we call the Downs, which was like a wild park. [*Food is brought to the table.*] So even though I was born in a city, my childhood environment had a lot of powerful natural phenomena. I guess it's right to say that I have used that experience in my art: like water, the tides, the mud.

MA: **What did your father do?**

RL: He was born in a poor part of Bristol, and his first profession before the war was as a barber. He used to cut hair and shave men. And then in the war he was a conscientious objector. He was a pacifist. So he went to prison for a couple of weeks like they all had to, and then he served in the hospitals in the air raids. Then after the war they had programs to retrain people, so he taught himself the piano and retrained himself as a junior-school teacher. Most of my life I knew him as a junior-school teacher who taught music to kids between seven and eleven. I also used to go hitchhiking with him and youth-hosteling. There's a drawing from one of my youth-hosteling trips with him in the exhibition here.

MA: **It's an amazing drawing, like a map of your route. That could easily be something you might do for one of your walks today. You were age nine when you did that?**

RL: My mother kept it all these years, and recently gave it to me. I'm really pleased to have it. My parents came from that sort of postwar, youth-hosteling, rambling generation. I think they actually met in a rambling club.

MA: What's a rambling club?

RL: It's like a walking club.

MA: That's fascinating. That's a lot of connections between your youth, your parents, and what you do today.

RL: Absolutely. It goes on and on. My grandfather on my mother's side, who I knew very well, was a really close friend and also a big influence in my life. He was born in Bristol and also began from a very poor background. He won a scholarship to one of the few further education schools of his generation. He started out as a little entrepreneur. He went down to Nice in France selling postcards and things. He developed into quite a traveling man. My mother was born in Rio de Janeiro because my grandfather happened to be running a small English school there at the time. She came back to England when she was about a month old. Then another job he had later on when my mother was growing up was as a sales rep for Hispano Suiza cars in Spain. So when my mother was about twelve years old she went to live in Madrid for her teenage years. Then because my grandmother had consumption or TB or something, they went down to Malaga to be near the coast and the sea breezes. Then during the Spanish Civil War they had to escape. There was a gun battle and a British warship had to come into the bay and take them out at night. So he came back to England, and then he moved to Devon. This was all before I was born. My grandfather was a traveling man and a great individualist.

MA: A lot of movement in this family. Your whole family was made up of traveling people, in a way. I don't mean gypsies . . .

RL: No, no. I remember my father taking me down to the docks—they were still working docks during my childhood—and they were completely full of boats, from huge ships to small freighters and smaller boats. Once he hitched a boat around Land's End, which is like right around to the south coast. So I got a lot of influence from my father for a love of the sea and nature, also walking and cycling, which he did a lot. My grandfather was also a lay preacher, and a fiery

intellectual. So I get the intellectual side of my work from my mother's side, my grandfather. During my childhood I remember fierce discussions about nuclear disarmament, and the differences between communism and capitalism. I grew up in that postwar world of political debate.

MA: Your mother still lives here in Bristol, not far from you.

RL: That's right.

MA: Do you see her often?

RL: Oh yes, especially in the summer. I cut her grass every week. When I'm in town I talk to her every day, or every other day. She had three children, and I'm the only one that still lives in Bristol.

MA: When I was last here, one of the things that fascinated me by where you live and how you live is that you seem to be constructed of these two extremes: one is this very sincere hometown boy and the other is this world traveler and wanderer. Do you sometimes find it hard aligning those two?

RL: No. I think life develops gradually and it probably makes more sense to go back to how I started as an artist. Drawing and painting was my first language. That's what I was always interested in. As I grew up, got to the end of my teenage years, I went to art school and I sort of put the two loves of my life together and made this life of art, as you like to say. The love of nature and the youth-hosteling side, the camping and walking from my father, and my love of art. I was very interested in Van Gogh and Gauguin as a schoolboy, or Michelangelo, for example. I guess I put those two elements together to make a life of an artist using nature. Then you mentioned the complementary thing about living in Bristol but also looking around the world; that was a very gradual process. The very early works were about leaving the studio and making "art" literally out of what was in my parents' garden, or a neighbor's garden.

MA: How old were you when you did that, when you made a work from your parents' garden?

RL: Probably about nineteen or twenty.

MA: When you were in art school?

RL: Yes, it was more or less when I was still in the art school here, or maybe it was just after. I can't exactly remember. So it happened very gradually, literally from the family garden, then it progressed to making works in nature, just in the local areas around here. *England*, 1968, which is in the show here, was made a quarter of a mile from here on the Downs. And the work in the park (*England*, 1967) was done just over the bridge. Then a couple of years later, when I was a student at St. Martins in London, I would do plenty of hitchhiking between Bristol and London, coming back for weekends, and sometimes I would stop along the way like, say, in Wiltshire somewhere and stop the ride and get off and make a walk, you know, walk through a field and take a photograph. So the work progressed to the landscape of England, first. After I left college in 1968, I went to do a sculpture on the summit of Kilimanjaro in Africa.

MA: Was that your first big trip?

RL: Yes, it was the first big trip. But even when I was at St. Martins I went to northern France and made some walks, and then I made the hitchhiking trip to Ben Nevis in Scotland. So what I'm saying is the working in the world idea spread gradually.

MA: Out of Bristol, in concentric circles.

RL: Exactly. The ripples of a stone in a pond.

MA: I'm also curious about your personality, for lack of a better word, and what you do. I've known you for a while now, and you're a very social person. It's really fun to have a beer with you and talk about things other than art. In other words, you enjoy people. And yet, you live what seems like a very lonely existence. You live alone in your house, and you are generally alone on your walks.

RL: Yes, I do. That's not exactly through choice; that's just through circumstance.

MA: And when you work, you work alone. I know you walk with people sometimes, but primarily alone. I read in one interview that you said, "Well, I never get lonely." I have a hard time believing that.

RL: It's true.

MA: Everybody gets lonely.

RL: Oh sure, I get lonely socially. I can be lonely in Bristol, or in the middle of a big city, like many people. But I'm never lonely on walks. When I'm working and making my art, I'm absolutely never lonely. For example, I've just spent eight days in the Italian Alps, and I literally didn't speak to anyone for eight days and that didn't seem at all unusual to me.

MA: And yet you can get lonely in Bristol.

RL: Yes, occasionally, sure. It's a little bit of a strange life I have.

MA: Do you think all art has to be made out of a certain kind of solitude?

RL: Not necessarily. I think there's a difference between solitude and loneliness. I also think most art comes out of a social environment. When you think about most New York artists or London artists, it's a very social situation. And I, too, need contact with artists. All my friends are artists. When I go to New York, it's great to spend time with old friends. I definitely like to be social when it suits me. I live alone by choice and circumstance.

MA: I'm going to take a break so you can eat.

MA: I know that you don't like to romanticize your work, and it strikes me that in order to maintain a certain view of the work as not being ultra-romantic, you take a very practical approach. What I'm interested in is emotions, and what

kind of emotions one has doing this kind of work. Sometimes, because of the nature of your work and your not wanting to make it seem ultra-romantic, one senses there is no emotion in the work. In other words, "It's a twenty-three-mile walk. Rain soak days 2–4, April 4–6, duh duh duh. . . ." You give the conditions, you give the place, and you tell us the duration, but you don't tell us how you felt.

RL: Well I do sometimes, but it's a mysterious thing. I think my work is very emotional, like all good art. Just because it's not expressionistic. . . . I think there's a big misunderstanding between being expressionistic and being emotional. I think the most cool or minimal or conceptual art can be extremely emotional because it's about powerful, strong ideas, which stir the imagination.

MA: I agree.

RL: My work is not only about physical experiences, but it's about presenting very particular and precise ideas. It's a matter of opinion, but I think they're intellectually stimulating, which is a kind of emotion.

MA: It is an emotion, of course. I agree. I also think that, in order for your work to be effective—as it is—you have to leave room for the viewer to apply their emotion to the image.

RL: That's right, of course.

MA: And so that may be partly why you present your walks as you do.

RL: Yes and also, I suppose in a way I do have a certain agenda. I'm very aware that there is a colossally romantic spin that's put on any art that's made from landscape. It absolutely amazes me even now that, especially American writers, still don't get the idea that art can be made through the medium of walking. Some American reviewers still talk about my work as though they're talking about Wordsworth or Coleridge. They use words like *sauntering* or *jaunts*.

MA: [*Chuckling*] *Sauntering*?!

RL: As though they have no idea what it means to walk thirty miles a day for four weeks or to climb Cotopaxi or put a sculpture on Kilimanjaro. I suppose, especially in the early days, I was aware of trying to work with landscape, but also to work with space and time, and in empty and beautiful places, but not in a romantic way. So it wasn't the point to celebrate the beauty of the walk. My work is about ideas. That sort of dry presentation of ideas is quite deliberate, and I hope helps to make a distinction between romanticism and emotions. Art can be emotional without being romantic or expressionistic.

MA: Would you say that each of your works expresses a different emotion?

RL: No, no. But it expresses a different idea. Even though every walk is a walk, nevertheless each walk is about a different idea. It could be a straight line or about measuring time or about measuring distance or it could be about mapping my route by throwing a stone into each river crossed along the way. So in other words, the walking stays the same, but there's an infinite variety of different ideas to which I can use it. I think that's quite important.

MA: It strikes me that—and I want to get away from this word *emotion*; I got onto that too long—but this idea that—

RL: No, no. There's nothing wrong with that.

MA: I think what happens with all of your work is an expression of the part to the whole, always the part to the whole, so that you're always aware of yourself in relation to the whole. You always make that very explicit.

RL: Yes. That's the fundamental center of my work: my own personal relationship to whatever that whole is. Whether it's a mountain or the walk or the size of the country from coast to coast. It's also very important that my work is made by me, and I don't mean that in an egotistical way, but a fundamental one. I was thinking on my last walk, most American artists now don't make their work. It's fabricated

by other people or it's made by machines. Bruce Nauman of my generation is one of the few artists that you still have the feeling that it has been touched by the artist. Whereas in my work, the center of my work is that the walking is done by me. The mud works are done by my hands. I pick up or carry every stone. And that's partly because it's a pleasure to do it. For me, the emotional pleasure of being an artist and making my work is actually doing it. I guess, as you say, the part to the whole is also measuring myself against the landscape. If I walk across the country it's however many days it takes me and not somebody else. So it's always particular to me; it always comes down to me doing it. I'm the measure against the place. However heavy are the stones I can pick up, and how many, that will dictate the sculpture. That's my energy. If I make a circle on the summit of Cotopaxi in Ecuador, it's not only just the energy that makes a circle in the snow at summit; it's the energy that it takes me to climb the mountain. So there are many subtle layers of what it takes to make my work.

MA: Since we're talking about part to whole, the whole is all of your work and now I want to go back to the one singular part that is Bristol, because it's the part from which the whole comes out of. Let's talk about how you live on a daily or weekly basis in Bristol. You don't have a car, right?

RL: No.

MA: How do you get around?

RL: Bicycle.

MA: You do all your shopping by bicycle.

RL: Right. It's enjoyable and it keeps me fit, and it keeps me relaxed so I can have nice ideas as I go into town every day.

MA: How do you get out of Bristol? Just take a cab to the train station?

RL: Yes. One reason for living in Bristol is that it's a handy place. It has a local airport so there are certain places I can fly to direct from Bristol airport. There's a fast train to London, and there are direct trains to Scotland, either the west coast or the east coast. I can get down to Dartmoor in two and a half hours.

MA: Do you think your walks in or around Bristol might create a microcosm of your larger work?

RL: They could, yes. But there are many microcosms in my work: just about the River Avon, or works using water or rivers, or just works using mud. There are many microcosms in my work. And in a way they're all interrelated. All the different forms of my work, they're all interconnected and they all overlap and they all add up to one whole dialogue of being in the world and living my life— in the world of now.

MA: I didn't want to identify the Bristol walks as something extra special. Only in the sense that because they began very early, and you called this landscape the prototype landscape, anyway. It's just interesting to think of you alternately as world traveler or hometown boy.

RL: But I believe that every artist is first and foremost a local artist. Whether it's a Pop artist, like Andy Warhol—very much a New York artist—or Lawrence Weiner. All those great American artists are big-city, New York artists. And then, of course, if the work is any good then it can be understood by people all around the world. It reaches a wider audience. Like Ed Ruscha is a L.A. artist, isn't he?

MA: It's a good point.

[*Break for coffee*]

MA: I think it was yesterday you turned fifty-five?

RL: I guess so, yeah.

MA: Birthdays are a time, as I was saying earlier, I think we all reflect a little bit. We naturally do that, and I would think someone like you—I don't even mean this emotionally or sentimentally—just that your art is so much about time anyway. And then we talked about the part to the whole.

RL: I guess the first thing to say is it goes fairly fast, you know? It doesn't seem like that long ago that I was doing all those works from the late sixties in the show here. I suppose that if I think about it . . . [*Something is brought to the table.*] That looks great.

MA: Thank you so much. That looks great.

Bartender: What's the interview about?

RL: I have a show at the RWA up the road. I'm an artist.

Bartender: A local one? Oh yeah? Good.

RL: Yeah. Anyway . . . I think the one difference—I'm sure this is not an original idea—but when you're a young artist you don't have any history, so you do things very instinctively and subconsciously. Intuition is still very important to me, like working by chance, working off the cuff, not planning too many shows ahead, not planning too many walks ahead. Just literally going from one idea to the next, especially with the walks. But obviously I have to do it a little bit more self-consciously now to keep that freedom, that intuition. The one big difference that is really positive is that I do have a lot of history now, being fifty-five. I have all this art history on my back—and my own history. So there's no way that I can go down to Dartmoor now and not be aware of all the hundreds of walks I've done on that same piece of territory; crisscrossed it using different ideas, different seasons. What's amazing is that the place, I have to say, is still literally

the same: physically, geologically, geographically it hasn't aged at all. I've grown up, and the place stays the same. One way to look at an artist's work is the cumulative affect. So if I'd made one straight walk once in my life in 1967, that might have been a very interesting work. But because I've made similar straight-line walks or made other kinds of walks in different landscapes all over the world for the next thirty years, that gives it another meaning. I think one of the ways you can see an artist's life is that sense of purpose, that serious way you live your life that lasts all your life. It's not just shows that make you significant or not. It's a big commitment. It's like a point of view that goes through your whole life.

MA: So when you go to a place like Dartmoor now, what you're implying is it's a little harder to make a good work there now than it was twenty-five years ago.

RL: Well, yes and no. It's interesting because I have a whole lot of experience. So in some ways, as I get older, I know more what to do and what not to do. Another definition of being a young artist is you can make a lot of mistakes. You don't really quite know what you're doing. And you only really know what you are doing by having done it, and learning from it. So I've learned a lot from my own work, in a way. In some ways I'm a better artist now because I know how to make exhibitions and I know how to think more clearly. But maybe I'm not so . . . You can never be so original all through your life as when you are when you're twenty-three.

MA: Or your awareness of originality changes.

RL: It's more self-conscious now.

MA: Yes, you're more self-conscious and you're more aware of what's truly original. You're more critical of yourself.

RL: I think, in general, experience is a good thing. It's positive.

MA: Have you had your mid-life crisis?

RL: Oh yeah, many times. [*laughter*] World expert.

MA: That's a long walk.

RL: Yeah, over rough terrain. The truth is I've been happy in my life. I've always been very fulfilled and I've always had great artist friends, always had great support from my peer group of artists, always been able to make money from my work. There have always been collectors out there who wanted to buy it, or museums to show it. So any sort of psychological trauma has been from the other side of my life, the personal side. All the emotional ups and downs in my life have come from the personal or social side. It's a cliché to say, but for me it's very easy to make art. Being an artist is easy. Bringing up children is much more difficult, and I'm sure many people would agree with that.

MA: It does seem to me that you're one of the artists that I would think of that does seem particularly contented or happy as an artmaker, and I was wondering if maybe that actually comes, again, from that experience in Bristol. I mean you have to start somewhere.

RL: And I have to say, yes, that's true. I had a happy childhood and I had supportive parents. And of course you don't know it at the time, but the fact that my parents let me draw on my bedroom walls, or sometimes at Christmas I'd cover the whole house with sort of crazy drawings. I remember when they decorated the front room once and they took all the wallpaper off and they let me do a landscape drawing all over the wall and they left it like that for a couple of months until they put the new wallpaper on. To me, that seemed very normal, but with hindsight I can see that was really supportive.

MA: Absolutely.

RL: It's maybe not true for other artists—their work might come from angst-ridden, emotional traumas—but my work definitely comes from a stable

background, supportive parents, and happy childhood. So I thank you, Mom and Dad.

MA: **What was the art school like here in Bristol? And when did you enter it?**

RL: I cut short my schooling by one year because I knew I wanted to go to art school. So I think I came here when I was seventeen—to the local art school. It was just a classic, parochial art school.

MA: **You enjoyed it?**

RL: Yeah, I enjoyed it until they threw me out. [*laughter*] You knew that, didn't you?

MA: **No I didn't know that.**

RL: Oh yeah, yeah. Everything went very well for a couple of years, and then I suppose there came a point where I just became too precocious, I did too much work. And in that true provincial way, they felt threatened by me; thought I was some rebellious influence or something. Even though I wasn't. I was just some extremely shy and energetic kid. So one day they decided to throw me out. Which was a big shock at the time. They actually told my parents I was insane. They asked my parents to come in and they said, "You're son is mad. We've had to throw him out." [*Chuckling*] It was a typical, provincial mindset— small-time, art-school gangsters protecting their patch. So then I had a year just taking odd jobs. I was like an odd-job boy in the local theater and I worked in a big papermill factory and I worked in a car machine place—you know, spare parts—and I worked on the roads, road-building. It was a time when you could always go in and out of jobs whenever you needed money, and I kept my work going at the same time.

MA: **Do any of those jobs stick out in your memory more than others, say the papermill?**

RL: Definitely. The papermill had quite a big influence. Just seeing these huge cauldrons of paper pulp. One of my jobs was to unbundle the paper sacks—the paper collections from all the domestic throw-away stuff. We had these conveyor belts going to these beautiful, churning cauldrons of mush to make paper pulp. And you had the huge rollers of paper. So physically it was a really interesting environment. It was absolutely enormous: the whole mill, with about half a mile of these enormous, great twenty-ton rollers. Every summer it would close down and we'd have to go into the insides and clean out the filters. You'd find people's teeth or spectacles.

MA: **In the paper?**

RL: Yes. Apparently, before I started working there, they actually found a dead child. When I was there, we'd find money. Sometimes people would accidentally throw their wage packets away. So we had a nice payday between us. But then you'd see a lot of other interesting things like, well, when books are printed wrong and all the photographs are upside down or all the colors are out of register, they'd have to be pulped. So you'd have all these interesting magazines, wrongly printed. Or somebody might have died and then a relation would throw away forty years of love letters tied up in red ribbons or something. There were some interesting things all ground up into that mulch. I'm sure part of my appreciation for paper and books comes from that experience.

MA: **How did you finally end up at St. Martins?**

RL: In the interim time of being thrown out of Bristol and getting into St. Martins, literally just down the road from where the gallery is here, there were some student friends of mine and we had a squat in this abandoned house. So I kept a room there and used it to make work in. Some of my earliest works . . . in fact, one of the works that is now in the Tate Gallery was made in the front garden of that house. It was made of grooves and holes cut into the grass and then plaster poured into hollows in the grass. So anyway, I kept my work going. There was a continuity in my work during the time. I was doing all these odd jobs to make money. On the basis of that work, I got into St. Martins in London. All in all, the best thing they could have done for me in the Bristol school was to throw me out. Going to London gave me a new horizon. I fell on my feet there because it

was 1966—it was the swinging sixties and it was a great time to be in London. I think it was a great generation of friends, a great peer group.

MA: It's fascinating, though, that a work that's at the Tate 2000 collection is a work that was done around the corner here in Bristol, which forms a circle. So we circle back to Bristol. Of course, the circle is one of the paramount images in your work.

RL: That's right. It's the old metaphor, isn't it? There's now actually a communal trail of about forty-five miles that circles around Bristol.

MA: And you've done a number of walks on that?

RL: On or around it. I still consider the West Country my home landscape, my home ground. And then Dartmoor has become a landscape I keep coming back to because it's like a prototype landscape for many other parts of the world: tundra or bogs or swamps. Any treeless landscape is my type of place, in a way. So I feel comfortable in Mongolia because it could remind me of Dartmoor. I often think that if the politics of the world changed, and I could only live within fifty miles of Bristol, I could still be an artist. I don't have to be running around the world all the time to be an artist. I could just do it around Bristol. It's a good landscape. It has fields, cliffs, tides, country roads, footpaths.... That's where I started, so maybe that's where I'll end up, just hobbling out of my front door, down the lane.

1 This interview took place in the Quinton House pub in Bristol, England, on the weekend of Long's fifty-fifth birthday. A number of factors led to the fact that he was in a particularly thoughtful and reflective mood. Birthdays, of course, often promote self-reflection, but at the time there was an exhibition of his work at the Royal West End of England Academy, the most significant exhibition he had had in his hometown. Moreover, he had just returned from an eight-day walking journey in Italy, where he had spoken to almost no one for much of the walk. He was ready to talk. And he talked primarily about his hometown. The circle is a common image in Long's art, and as it turns out, the circles all radiate out of the west England town of Bristol.

AGNES MARTIN

Agnes Martin's studio, New Mexico, 2001.
© Cary Herz Photography, Albuquerque, New Mexico.

INSPIRATION

May 1997
Taos, New Mexico

Michael Auping: **You stopped teaching in about 1950. Have you taught since?**

Agnes Martin: Yes. I taught one year at Skowhegan. It's a rich art school.
Do you know it?

MA: **I do.**

AM: Well, I felt I was out of touch with youth. So I went to Skowhegan and taught summer school for nine weeks. I had eighty-four students and they all had a private studio. That's how rich that school is. [*laughter*] Don't teach anymore.

MA: **Do you see your writings as being a part of your teaching?**

AM: I see my paintings as part of my teaching. Sometimes I write or talk, but it's not the most important thing. Painting is the most important thing. I'm just a painter. They asked me to make a speech in Philadelphia in 1966 when I had a retrospective there. So I did. When you do it once, they keep coming after you. I think it's good that artists talk, but not too much. It's more productive to paint. I like to talk to students and young people.

MA: **What do you talk to them about?**

AM: Living with inspiration, how to accept inspiration. You have to be careful with the intellect as an artist. The intellect struggles with the facts. That's not inspirational. If you are an intellectual and you are going to buy a house, you would think about the cost, check on the taxes, look at the survey, and go through a whole list of things that make you feel better about buying the house. If you couldn't rationalize it, you wouldn't buy it. If the house genuinely inspired you, you wouldn't worry about the list. You would find a way to buy it. You have to deal with the practical matters, but you wouldn't worry about them because you would be involved with your inspiration. That's what artists have to do. They have to stay involved with their inspiration. They can't be constantly worried about the cost of paint.

MA: How do you find inspiration?

AM: I wait.

MA: Do you do anything in particular while you wait?

AM: No.

MA: Is color a source of inspiration for you, color in nature?

AM: I don't think so. It's usually the beginning of inspiration for me. I'm not sure you need to know too much about color. When I need inspiration, I ask myself, "What am I going to paint next?" Then I wait for the inspiration. When it comes, I see it completely in color.

MA: Really?

AM: If I don't, I wait until I do.

MA: But your early paintings didn't have color.

AM: No they didn't. There was no color in the inspiration those days. So I didn't put any color in the paintings. When I had the inspiration for the grids, I was thinking of innocence and the image was a grid. That was it. I thought, "My God, am I supposed to paint that?" I thought that if I paint that, people would never see it as a painting. But that was my inspiration, and it turned out to be all right. The grid was very important for me. It was my way of finding composition and getting beyond it at the same time. Now I'm more interested in color. My recent paintings are about color.

MA: When you make the grids of graphite, do you think about the individual line or just the way the whole field of lines looks? Maybe I should ask how you would describe line in your work?

AM: Well, in my paintings the lines are all straight, and in nature there are no straight lines. I paint beyond nature, non objective. There's no hint of this world. The line doesn't have to describe anything. It focuses you beyond it and beyond yourself.

MA: But your paintings come out of your mind and your mind is of this world.

AM: No the painting is put in your mind from somewhere else. I'm not trying to describe anything. A work of art doesn't have a subject. It has a spirit. I'm looking for a perfect space. We have to watch our minds as these images come in. That is the inspiration. It comes from all directions. We don't know enough to be able to comprehend everything that comes in, but sometimes if we are quiet we can get little pieces of the image. But the image is always immaterial. That's why it's difficult. My art has never been about politics or form. I'm not a feminist the way some people describe it. My subject is the immaterial—immaterial perfection. I tell students that if they could be quiet and think of nothing for fifteen minutes, they would be very productive. That's hard for students. They can't help thinking too much. In the beginning you have so many questions.

BRUCE NAUMAN

Bruce Nauman at a telephone booth, July 1991. Photograph by Michael Auping.

MATH AND MUSIC

August 14, 1999
Galisteo, New Mexico

Michael Auping: I remember you telling me that in high school you studied math and that at one point you were very excited about it, even thinking about that in terms of career choices.

Bruce Nauman: I had a very good physics teacher and then a math teacher who offered to work with some of us on calculus, which was not offered, but was needed for the more interesting physics. So when I got to the University I got into some more advanced courses. While I found that I didn't have a great passion for the kind of physics that was being done, or at least the way it was being taught there, the theoretical math that was going on was of interest and I stuck with that for a while. . . . I always liked the structural aspects of mathematics. It's a rigorous language that stays vital by creating problems that then carry the language farther.

MA: But then you got involved in music and you're still involved in it. You studied and played some classical music, right?

BN: Yeah.

MA: And you played some jazz bass.

BN: Right——in high school and college.

MA: Do you think music has had an effect on your art? Can you think of any particular way—well, I suppose everything has an effect.

BN: A lot of the sound pieces have to do with structuring things in time, and some music enters in there. I can think of a lot of situations where acoustical parts are important, and rhythmic structures in the videos and films.

MA: Terry Allen said you are a good musician; the problem is you just won't play for anybody.

BN: I don't know about that. I like music. I got involved with it later in high school. I started to slip into the music department. Again, I was interested in music theory and composition rather than having to practice, and that didn't go over too well. What was interesting was that I had the same feeling for music that I had for mathematics and eventually for art. For me a lot of it had to do with the rearrangement of conditions within a discipline; seeing if you could find the edge of the structure. The decision to become an artist comes out of all of this somehow, but is still inexplicable to me.

CAT AND MOUSE

December 2001
Galisteo, New Mexico

Michael Auping: So what triggered the making of *Mapping the Studio (Fat Chance John Cage)* [2001], and how long did you think about it before you actually began to make it?

Bruce Nauman: Well, I was working on the Oliver [collectors Steve and Nancy Oliver] *Staircase* piece and I had finished up the *Stadium* piece in Washington and I was trying to figure out what the next project would be. I was trying to come up with something out of those ideas, thinking about where those ideas might lead me next, and I really wasn't getting anywhere. Those pieces had pretty much finished off a line of thought and it didn't make sense to try and extend it. So a year or so ago I found myself going in the studio and just being frustrated that I didn't have any new ideas to work on. What triggered this piece were the mice. We had a big influx of field mice that summer, in the house and in the studio. They were everywhere and impossible to get rid of. They were so plentiful even the cat was getting bored with them. I'd be sitting in the studio at night reading and the cat would be sitting with me and these mice would run along the walls and the cat and I would watch. I know he'd caught a few now and then because I'd find leftover parts on the floor in the morning.

So I was sitting around the studio being frustrated because I didn't have any new ideas and I decided that you just have to work with what you've got. What I had was this cat and the mice and I did have a video camera in the studio that happened to have infrared capability. So I set it up and turned it on at night when I wasn't there, just to see what I'd get. At the time, I remember thinking about Daniel Spoerri's piece for a book. I believe it's called *Anecdotal Photography of Chance* [*An Anecdoted Topography of Chance*, 1966]. You know, he would photograph or glue everything down after a meal so that what you had were the remains. For the book, a friend of his did the subtext, writing about the leftovers on the table after Spoerri had preserved them. He wrote about every cigarette butt, piece of foil, utensil, the wine and where it came from, etc. It made me think that I have all this stuff laying around the studio, leftovers from different projects and unfinished projects and notes. And I thought to myself why not make a map of the studio and its leftovers. Then I thought it might be interesting to let the animals, the cat and the mice, make the map of the studio. So I set the camera up in different locations around the studio

where the mice tended to travel just to see what they would do amongst the remnants of the work. So that was the genesis. Then as I got more involved I realized I needed seven locations to really get a sense of this map. The camera was eventually set up in a sequence that I felt pretty much mapped the space.

MA: So the final piece is six hours long? How did you decide on that length, as opposed to eight hours or two hours?

BN: Well, it felt like it needed to be more than an hour or two, and then I thought if it's going to be that long then it should be . . . well, it just felt like it needed to be long so that you wouldn't necessarily sit down and watch the whole thing, but you could come and go, like some of those old Warhol films. I wanted that feeling that the piece was just there, almost like an object, just there, ongoing, being itself. I wanted the piece to have a real-time quality rather than fictional time. I like the idea of knowing it is going on whether you are there or not.

MA: It seems to me this relates to that early *Pacing the Studio* piece [*Pacing Upside Down*, 1969]. Do you see that?

BN: Somewhat. It generally goes back to that idea that when you don't know what to do then whatever it is you are doing at the time becomes the work.

MA: In that sense, it also relates to your last video, *Setting a Good Corner*.

BN: Yeah.

MA: So the fact that you've done two in a row means that you don't have any more ideas.

BN: [*laughter*] I guess there's nothing left.

MA: Tell me about the subtitle. I think the reference to Cage is fairly clear in terms of the open-ended character of the piece, but why the words "Fat Chance"?

BN: Well, when I chose the seven spots, I picked them because I knew there was mouse activity, assuming that the cat would occasionally show up too. So the given area that I would shoot over a certain period became a kind of stage. That's how I thought of it. So, when nothing was happening, I wanted it to still be interesting. These areas or stages, if you will, tend to be empty in the middle. So that became the performance area and the performers are the bugs, the mice, and the cat. So the performance is just a matter of chance when the performers are going to show up and what is going to happen.

"Fat Chance," which I think is just an interesting saying, refers to a response for an invitation to be involved in an exhibition. Some time ago, Anthony d'Offay was going to do a show of John Cage's scores, which are often very beautiful. He also wanted to show work by artists that were interested in or influenced by Cage. So he asked if I would send him something that related. Cage was an important influence for me, especially his writings. So I sent d'Offay a telegram that said FAT CHANCE JOHN CAGE. D'Offay thought it was a refusal to participate. I thought it was the work, but he didn't get it, so——

MA: So along with the debris in the studio, you're reusing an earlier work in the title as well.

BN: Yeah.

MA: Let me ask you about the issue of cutting and editing for this piece. You refer to Cage, which is about indeterminacy and chance, and you do the piece with that kind of inspiration, and then you go in and cut and edit it——

BN: No. I didn't. It's all real time. The only thing that comes into play in regard to what you're saying is that I only had one camera and I could only shoot one hour a night. So it's a compilation. There are forty-two hours altogether. So it's forty-two nights. The shooting went from late August through late November or early December. I didn't shoot every night. Before I went to bed at night I would go out to the studio and turn the camera on and then in the morning I'd go out and see what had happened. And I'd make a log of what happened each night.

MA: But you have flipped or reversed and then colorized some of the scenes.

BN: Right. There are two versions of the piece. In the first version nothing has been manipulated, no flips, reverses, or color changes. In the second version, there are color changes and flips and reverses. Then there is also a third. I'd show the piece to Susan [Rothenberg] and she'd get really bored with it and say, "Why don't you cut out all of the stuff where nothing is happening?" And I'd say, well, that's kind of the point of the piece. And then she said, "Well obviously that's what you should do then," precisely because it is contrary to the piece. So I did do a kind of "all action" edit. So the six hours gets cut down to forty minutes or an hour.

MA: How did you decide what color to use and when to reverse or flip an image? Was it generally a matter of composition or highlighting certain scenes?

BN: Both. In terms of the colors, I wanted to run through the rainbow, but it ended up having a kind of quiet color. It changes from a red to a green to a blue and then back to red over fifteen or twenty minutes. But it changes at a very slow rate. You can't quite see the color changing. In each of the seven images it's changing at different times so you have a lot of different colors at any given moment. It's a quiet rainbow. The flips and the flops are fairly arbitrary at about fifteen minutes apart. It's a way of keeping the eye engaged, to give the whole thing a kind of texture throughout.

MA: In terms of reading this symbolically, were you thinking of the cat as a surrogate for the artist, chasing mouse/muse?

BN: Not really. I was interested in the relationship between the two of them, but more in a psychological way. Their relationship exists as a sort of a paradox between a joke and reality. They've been cartoon characters for so long that we think of them as light-hearted performers, but there is this obvious predator-prey tension between them. I wanted to create a situation that was slightly unclear as to how you should react. I think there are parts that are humorous

and there are parts that are not at all. But those are glimpses that you might or might not catch. The overall effect is ambiguous, maybe a little anxious. Then you can hear the dogs barking once in a while and the coyotes howling now and again. So there is also an element of what's going on inside and what's going on outside, which I like. There are also two locations on the tape of the different doors in the studio. One door goes into the office and two doors go outside and most of the time during the taping I could keep those doors open because it was still warm. Sometimes you can see the reflections of the cat's eyes outside through the screen door. The mice also go inside and outside because there is a hole in one of the screens and they could come and go. Throughout the piece there is an outside-inside dialogue that deals with being in the studio with all this activity going on and then being aware of a larger nature going on outside that space.

MA: What kind of emotion do you associate with this piece? If you had to assign it an emotion, what would it be?

BN: I don't know about an emotion. What I've felt in watching it is almost a meditation. Because the projection image is fairly large, if you try and concentrate on or pay attention to a particular spot in the image, you'll miss something. So you really have to not pay attention and not concentrate and allow your peripheral vision to work. You tend to get more if you just scan without seeking. You have to become passive, I think.

MA: There's a kind of forlorn beauty about the piece, almost a pathos. This may sound—well, you just turned sixty, so you are now making what curators and art historians call "the late work." Is there any thought here in regard to reviewing yourself?

BN: [*laughter*] I guess it's late work. I hope it's not too late. Maybe in the sense that there's ten years of stuff around the studio and I'm using the leftovers, but I've always tended to do that anyway. Pieces that don't work out generally get made into something else. This is just another instance of using what's already there.

MA: Well, I was also thinking about the fact that the camera is an extension of your eye. In the primary sense, you are the observer. We are following you watching yourself.

BN: That's true. There are times when I "see myself," as you put it, and times when I don't. There are times when I just see the space, and it's the space of the cat and the mice, not necessarily my space. On the other hand, I've had to re-look at all of this stuff before it finally gets put on the DVDs—and I'd forgotten that I'd done this, but the spaces that I'd shot, because I wasn't shooting every night, every hour the cameras move just a little bit. The image changes a little bit every hour regardless of any action that's taking place. I was working in the studio during the day all that time. I would unconsciously move things around. Maybe organize a few things—what you do in a studio when you're not supposedly making art. So the areas that I was shooting tended to get cleaner or have fewer objects in them over the period of the six hours. I thought that was kind of interesting. It didn't occur to me when I was doing it, but then I went to SITE Santa Fe and saw Ed Ruscha's film *Miracle*. In the garage as he gets more precise, the garage gets cleaner and cleaner and he gets cleaner as the film goes on. The film made me think that I had done the same thing unconsciously.

MA: Since I haven't seen the final cut, I'm curious how the piece ends.

BN: It ends pretty much how it starts. It begins with a title and a few credits, and then basically it just starts and then it ends. No crescendo, no fade, no "The End." It just stops, like a long slice of time, just time in the studio.

PHILIP PEARLSTEIN

Philip Pearlstein in his studio, New York, c. 1976.
Photograph by Eeva Inkeri, courtesy of The John and Mable Ringling Museum of Art.

ALUMINUM, SKIN, AND A CHEAP WOOD FLOOR

November 1980
New York, New York

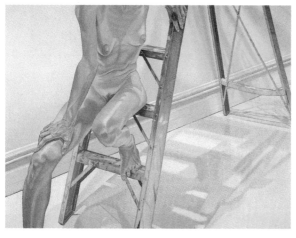

Female Model on Ladder, 1976. Oil on canvas. 72 × 96 inches (182.9 × 243.8 cm).
Collection of The John and Mable Ringling Museum of Art, the State Art Museum
of Florida.

Michael Auping: Could we talk about the painting *Female Model on Ladder*, 1976, and what it was that intrigued you about that image?

Philip Pearlstein: Well, actually, what I liked best about it initially was the shadows on the floor. That was the starting point. The ladder just happened to be sitting here when the model came in. I had been changing the lights. I use the same models for many years—as long as they'll stay with me—and this woman has been with me about twelve years so she's tuned in to my way of thinking and feels at home in the studio. So she said, "Why don't I just sit on the ladder?" So she sat on the ladder. It looked terrific with the shadows on the floor.

MA: What about the relationship between her skin and the cold aluminum of the ladder?

PP: The thing I've discovered working within the limits of this small room is that the initial skeleton of the composition presents itself first and then the complex relationships become apparent as I work with it. So the aluminum ladder and the contrast between that and the skin of the person and this cheap wood floor that's been painted a million times so it looks like linoleum—those three contrasting surfaces plus the plastered wall became very important. As I developed the painting, I tried to get the effect of the different materials and different surfaces.

Also, the ladder has a kind of personal meaning. It's been my companion for a long time. I did a lot of renovation on this house with it. It has all my drippings—paint drippings and plaster drippings. It's me. It's another character in my life.

MA: Did you choose the pose, or did the model?

PP: Everything comes out of the models. It has to be their action. Their action dictates the way the composition will develop. Each model has, every person has, his own way of moving. You can't ask one model to take up a pose that another model has done originally. It just doesn't work.

MA: **How do you choose a model? How do you decide who makes a good model and who doesn't?**

PP: My usual answer to that is to say I choose the ones who show up on time and who are willing to work with me. When I started, a lot of the models were students at the New York Studio School. The school didn't have scholarship money so they let students pay part of their costs with posing, that sort of thing. And I was part of a sketch group that met down there weekends. They were totally different from the crew of professional models that I knew as a teacher in the art schools, because the professional models—the older ones—usually took poses that recalled other famous paintings or Roman statues—very self-conscious. These young people just sat back and moved around casually. It was the movement through space that was important. I've always thought of it as kind of a dance thing. It's body movement that's the interesting thing to me.

MA: **Some people initially have a hostile reaction to your paintings. Critics often say you distort the human figure to look ugly, or unattractive.**

PP: Most of my models have been quite ordinary people, people who think of themselves as artists or who are going to be artists or architects or people who are students of philosophy and history. In other words, they're ordinary profes-sional types and so they don't especially have all that attractive physicality. And in a sense, that becomes a kind of subject matter.

MA: **What does?**

PP: Middle-class America without its clothes on. They're very specific types of people, New York types—university types, actually, most of them—which is not what artists' models have been down through the ages. The men were farmers and peasants. The women were prostitutes or at least assumed to be prosti-tutes. When I was in art school, a great fuss was made about protecting the model. The model was a nice woman who had to be working for a living, and her modesty had to be really considered. There was no casualness to the pose. She always posed with her legs crossed, that sort of thing. And men always wore

something around their middle. When I began teaching at Pratt Institute, Richard Lindner was teaching there also. When I first started showing these paintings, Lindner said that I was doing truly dirty pictures, and I asked him to explain. His explanation was that in Europe—pretty much what I just said—that the people who posed in art schools, the women at any rate, were assumed to be prostitutes ... what to him was erotic about my work or sexy about my work was that I got all these ordinary people to take their clothes off, and for a European that was astounding. I think Americans have other expectations, you know—the old Esquire days, the Petty girls, etc. Any number of people have come up and told me my paintings were such a turn-off instead of a turn-on. And somebody out on the West Coast gave me a terrible review very early, because somehow the men were never exposed full front. Therefore, they wondered what the paintings were all about. It seems to me this person's idea of eroticism is different from Lindner's.

MA: Do you feel your paintings relate to Minimal art of the sixties on any level? They seem to relate to Minimalism in a vague way.

PP: Unfortunately, I've been so busy doing my own thing that I've never had enough time to read what I wanted to read or discuss these things with other artists. I really don't know how most of the Minimalists think, but I recognize a lot of similar concerns—like the white wall in many of my paintings, which is not an empty space as far as I'm concerned. It is a Minimalists' surface, and I use it as such, consciously. Some of my blocks of color relate to Minimalists' blocks of color.

MA: Do you think of your paintings as portraits, in any sense?

PP: Yes.

MA: Although you often crop out the head of your figures.

PP: I know, but the legs, the knees, these are a part of that person, too—just as valid. It's just that we ordinarily put emphasis on the head.

MA: Would you say the movements of your models reflect their personalities?

PP: Yes, but that's not the goal of the painting. I mean the difference between Merce Cunningham and Martha Graham is pretty much what we're talking about. The heavy symbolism that Martha Graham was involved in is something he totally ignores. A movement's a movement, a muscular movement interesting for itself and not because it's deeply rooted in a mythical something or other. Everything we do reflects our character, though I try not to get too hung up with that. If you watch a game of basketball on TV, forgetting the game, just watch the visuals, it's beautiful. There's no meaning, just beautiful movements. It looks like it's being choreographed by somebody very consciously. Baseball has that look, too. It looks like some very serene ritual is going on.

MICHELANGELO
PISTOLETTO

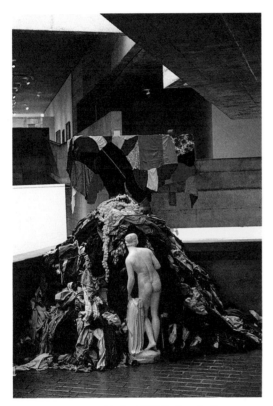

Venere degli stracci (Venus of the Rags), 1967. Marble and textiles.
83½ × 133⅞ × 43⁵⁄₁₆ inches (212 × 340 × 110 cm). Installed at the University
Art Museum, University of California, Berkeley, 1979. Photograph courtesy
of the artist.

VENUS OF THE RAGS

December 18, 1979
Berkeley, California
Translated by Giovanni Tempesta

Michael Auping: When did you start using rags as an art material?

Michelangelo Pistoletto: In 1968. It was a very natural material for me. We didn't have much money, and rags and cast-off clothing were very available and very beautiful. Since childhood, during and after the war, I can remember the women saving rags, cupboards of rags.

MA: Do you collect rags as part of your routine, on a regular basis?

MP: Mostly when I'm working on a project that requires them, like our exhibition here. The rags here in Berkeley are fantastic! There are so many beautiful people carrying rags in shopping carts, and there are piles of rags everywhere on Telegraph Avenue.

MA: There are many homeless people here. They collect clothing—to keep warm, to sell.

MP: Yes. I bought some rags from them, and some of them wanted to donate rags for the pieces in this show. They are nomads carrying their beautiful colors, the flags of a nomadic society.

MA: That's a wonderful way to describe it. Berkeley has a history of supporting poor and misplaced people. Some of them have psychological problems and some are intellectual dropouts. They have no way of fitting in, so they can't really work and have no money, but they find really interesting ways to survive. Being poor isn't really a stigma in Berkeley.

MP: Of course not. Poverty rarely means a lack of intellect or beauty. The problem is a society that can't imagine the value of the used, of the stained—that which isn't new. Poverty is a more intelligent and efficient system than any of our political systems, which are jealous of poverty's ingenuity.

MA: It seems ironic that you embrace these cast-off rags, shirts, and sweaters that are old and out of fashion, and at the same time you are often described as one of the first Pop artists, not just in Italy, but even before Pop emerged in America.

MP: I'm not sure when Pop began. That's a question for the historians. I use many different images. I don't know if my art could be called Pop. I don't think of myself as having a style. Like the rags, I have many styles. However, I have been in exhibitions that discuss Pop. Since this exhibition is mostly about rags, I don't feel like a Pop artist. Pop art is about prosperity, always moving forward to a newer and newer future. The rags are a statement about poverty. But I don't want to use them [the rags] in a melancholic manner. I am interested in the beauty and efficiency of poverty. Maybe I am a poor Pop artist?

MA: Why have you covered the statue of Venus with rags?

MP: Perhaps that is a Pop statement. For Italians, Venus is the Marilyn Monroe of antiquity. She represents a static idea of beauty, a universal beauty that of course does not exist. She is a specific Roman goddess associated with erotic desire. In Italy, you see thousands of statues of Venus, and they are all depicted slightly differently because of the custom of a particular region. So in a way, Venus is every woman, not a specific woman.

MA: And the rags that surround her?

MP: We are not dealing any more with an ideal beauty but with a multiplicity, with many communities, a society of styles and classes all piled on top of each other, all wearing their different coverings. I think that Venus should embrace this society of rags.

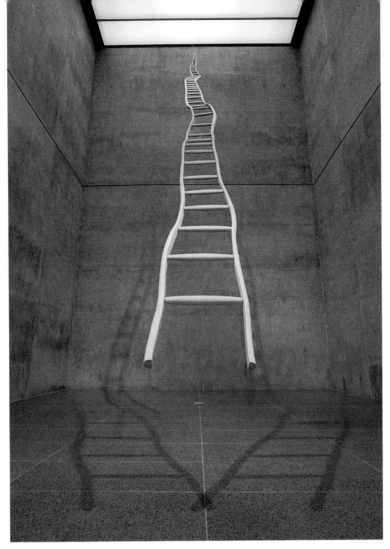

Ladder for Booker T. Washington, 1996. Wood (ash and maple). 432 × 22¾ (narrowing to 1¼ at top) × 3 inches (1097.3 × 57.8 [narrowing to 3.2 at top] × 7.6 cm). Collection of the Modern Art Museum of Fort Worth. Gift of Ruth Carter Stevenson, by exchange, 2003. Photograph by David Wharton.

MARTIN PURYEAR

A FORM OF CARVING

December 30, 2003
New York, New York

Michael Auping: Let's start with a very basic question about the process of making *Ladder for Booker T. Washington* [1996]. Do you remember much about how this piece developed?

Martin Puryear: Yes, absolutely. It was made from an ash sapling—a very tall, young ash tree that I cut on my property and brought into the studio. I kept it for quite a while and I knew I wanted to do something with it because it was such an interesting form. Most saplings that grow in the woods grow ramrod straight. This one had a lot of very interesting undulations in its stem. I've always been interested in working with wood from nature. A lot of the sculpture I do I make from wood that I buy, processed lumber—boards or planks, and so forth, that are veneered. But once in a while I like to get a tree and make a piece of sculpture out of a tree or part of a tree. In this case the undulations were fascinating to me, and I kept it for quite some time just in that shape, with a kind of broad trunk with the bark on it. Eventually I peeled the bark off, and began thinking about it in relation to a ladder. I had been in France working at Alexander Calder's studio on an invitational grant for nine months. This was about ten years ago, and I noticed quite a few of these homemade ladders made in the French countryside, mostly in tiny little towns in the Loire Valley. They would just split a sapling down the middle into two half-round lengths.

MA: Which are the parallel side pieces.

MP: Exactly. The side pieces—the rails. And then they would make a series of simple rungs. Some may have been turned on the lathe, but most were very roughly made. And it just occurred to me that this would be an interesting project to try to do, to make a very tall or long ladder. For a long time I had been interested in working with a kind of artificial perspective through sculpture, which if you think about it is not so easy to do. With a ladder, a very long ladder, I could make a form that would appear to recede into space faster visually than it in fact does physically, by manipulating the perspective and exaggerating it by narrowing the parallel side pieces toward the top of the form.

MA: Like looking down a long road that was floating in space.

MP: Exactly. And what excited me about that was that the length of it was such that you wouldn't really be able to tell whether you were looking at something that had been manipulated or whether it was in fact truly receding into space through sheer length. I certainly was going to manipulate it, but I was excited by the fact that it was long enough that you would actually have confusion.

MA: Speaking of manipulations, the undulations, the wavelike distortions that are in *Ladder for Booker T. Washington*—is that your manipulation, or is that the way the tree grew?

MP: That's the way the tree grew. Like I said, it was a very contorted sapling. That was one of the things that interested me so much. It would be pretty ironic to make a ladder out of something so distorted. So when I made it I actually had to split the tree following the undulations, which was an interesting process in itself. And I also had to split it by keeping the two halves roughly equal. I didn't want to deviate and make one half weak or thin, and the other half too thick. I also had to keep the cut as much as possible in the same plane, if you will. In other words, it undulated but I had to not rotate or spiral the tree trunk as I was cutting it. I didn't want to make the cut rotate on its axis. If it started out vertical, in a sense, it had to come out at the other end vertical.

MA: Almost as if you had carved it as one piece.

MP: Yes, so it was a tricky process. It was actually split on the band saw.

MA: But the curvature on the parallel side pieces, they almost look like they're hand carved, as if you had carved it with a pocket knife.

MP: Well that's because it's been peeled with a drawknife and then probably finished with a blade tool, which is how I do a lot of my work in wood.

MA: So it is a form of carving.

MP: Well, it's not carving to *give* a shape, because the shape is already there. It's simply carving to smooth the shape, you might say. I'm only taking off a very thin layer when I carve, to get past the bark, to get down to a certain layer of clear wood beneath the bark. It can be a delicate boundary. There is a thin line between something that is handmade and something that is overworked. The difference is that very often when the finish is done with abrasive, like sandpaper, you end up obliterating all the surface facets. I don't work with a lot of abrasives. I don't finish my work with a lot of sandpaper or grind away the surfaces to a really smooth contour. I like to work with blade tools—spokeshaves, planes, drawknives—so that the surface has a life. It's kind of like Rodin's sculpture, the way he used his fingers to pinch and push the wax or clay or plaster around. You get the light sort of glancing off the surface in this faceted way. A Rodin sculpture can look smoothly rounded, but when you run your hand over it you realize that it's composed of a lot of planes. The same is true of *Ladder*. The surface is composed of a lot of planes. It's much more alive visually than if it was just ground smooth with a sander or a grinder.

MA: Do you do most of this work yourself, or do you have assistants do it?

MP: I have assistants and we share the work back and forth. I know that I split *Ladder for Booker T. Washington* with the help of my assistants. I wanted to guide it through the band saw, but I needed help with a piece that long. And I'm pretty sure that I peeled it myself. The making of the rungs—I made a couple to see how they were going to look and then I gave the job over to one of my assistants to turn all the rungs on the lathe. I think I made measurements of each one. I could control the way that they tapered, the width the piece would taper and the way that the rung size would diminish. I worked all of that out and just gave him a table of measurements and showed him how to do it. I think I probably did most of the drilling to get the holes in.

MA: It seems that your generation of sculptors—which is essentially the Minimalists and the post-Minimalists—farmed a lot of their work out to fabricators.

MP: I'm aware of that.

MA: Comparatively, your approach seems almost archaic.

MP: It certainly feels that way a lot of the time. I like working with my hands as much as I can, but that's not always possible. To be fair, I also do work through other fabricators. Almost all of my large commissions have been done through fabricators, for two reasons: one, I don't have the facilities or the desire to get involved in the studio time and space it takes up to realize these really big outdoor projects; and two, when I do work outdoors, I don't work in wood. They're almost always made in some material that I consider truly durable outdoors—stainless steel or bronze or granite—materials I'm not set up to work with in my studio on a monumental scale.

MA: Most of the work you do is made of wood, isn't it? That seems to be your preferred material.

MP: If there's another material that follows in numbers it would probably be the wire mesh and tar, and then after that it would be occasional pieces where I've worked in metal. I've done very little cast bronze pieces. Very little.

MA: So while many of the Minimalists were attracted to industrial materials, your materials are for the most part preindustrial. I'm wondering if your early experience in Sierra Leone, working in the Peace Corps in Africa, where there is wooden tribal sculpture, had an effect, or maybe when you studied printmaking in Stockholm and became aware of Scandinavian crafts.

MP: Both of those experiences were important for me, but more in the sense of reaffirming. I think my tendency to work with materials that are more primal goes back even further than that, to something in my childhood and a fascination with where things come from, where materials come from. It's just something I've been curious about all my life. And I've always liked working with wood. Even before I was an artist, or ever knew I wanted to be an artist. I worked in my father's basement workshop. I made guitars, some boats, and furniture.

MA: It's interesting that before you became an artist, your focus was biology.

MP: That's true, and relates to what we are talking about here, perhaps more than Sierra Leone or Stockholm. I was not interested so much in laboratory biology; I was interested in observing nature. I would probably have been a field biologist rather than somebody looking at things in a lab through a microscope. I would probably have been somebody who would go out and study the habits of bighorn sheep or follow tigers in Siberia. I mean, that would be my dream thing to do. Or to count birds in some remote place. That would be my interest rather than microbiology.

MA: It seems to me a number of things distinguish *Ladder for Booker T. Washington*. It's somewhat less abstract than many of your other works. Although distorted, it is a very recognizable object. It also has a very specific title, while many of your other works are untitled. I'm assuming that the title came in the process of making the piece, or maybe later?

MP: The title came about very much after the fact, after the piece was finished. And it was an ironic idea to give it that title. It just seemed to make all the sense in the world.

MA: Ironic from which standpoint? I could think of a number of ironies. Booker T. Washington's philosophy of African Americans advancing in society had to do with a really basic work ethic, that an individual could use their hands as well as their intellect to succeed.

MP: Yes, he was what you would call a gradualist.

MA: I think he would appreciate the physical skills that went into making this ladder. He'd probably also like the irony that it is a nonfunctional ladder, that it is essentially an invention.

MP: Yes, he was very interested in starting our progress from slavery where we were and not being an agitator and not making demands, but just being ready

for whatever advances were offered to us; whatever possibilities were offered to us, being prepared for them. He was quite the opposite of somebody like W. E. B. Dubois, who was a very, very savvy political person and much more analytical about the structure of oppression, and thought that to achieve progress it would be much more necessary for us to actually be forceful, and not to wait hat in hand until somebody gave us a job or gave us an opportunity to progress toward equality.

MA: Also, your *Ladder* doesn't present a perfectly straight path. There are a lot of zigs and zags. So if this ladder alludes to progress, it is not progress as a straight line, but a more eccentric maneuvering.

MP: I think all of these ideas relate to art and society in general, but in very broad ways, and that is the key. I have to say something about the title, in this regard, because I think it can occlude much about how that piece works for me. I think the piece works as an experience of looking at this manipulated perspective. That really is what the piece is about. And the title for me was, as I said, it was an afterthought and it's almost parenthetical. But obviously, given how heightened the issue of race is in our society, it's very obvious that the title would really leap out in front of the experience of the work, as art. Because I think the work itself has got its own kind of power. If I were writing a label for it, I would probably provide some basic information about Booker T. Washington, which is helpful in understanding the work, but I'd put that at the end in parentheses. Say, "Booker T. Washington was such and such a person who did this and this...." And I think that would perhaps let the person make the connection after first of all discovering that the piece was really about a certain kind of manipulated perspective. In other words, are you seeing it where it actually exists in space, or are you experiencing an illusion of great distance?—deal with that conundrum first and then have the historical background, the information that connects it in the title.

MA: What's interesting is that the conundrum that you talk about can be both formal and it can also be political or social as well. In other words, how far have we progressed in any of these endeavors? A ladder is such a universal symbol

for progress, or more broadly, transcendence. So I see what you mean about the specificity of it being titled to Booker T. Washington because it could be titled to anyone who is trying to progress or transcend.

MP: Absolutely. You could name your progression and it could apply.

MA: And that could be through art or politics or science. When I first saw the piece, before I knew the title, I saw more of a spiritual metaphor. You think of the dream of Jacob's Ladder, or the way the piece pinches at the very top and almost disappears, a progression from the physical to the transcendental.

MP: I didn't think of it in a religious or spiritually transcendent sense, although I was certainly aware that it was going to be seen that way by some people. In fact, it is seen that way by a lot of people. But once you make work and put it in the world, it's really on its own and people make of it what they will and that's part of the excitement of being an artist. And part of the effect of looking at art is that you may not get it all, what the artist put into it, but that's the risk the artist takes. The risk you take as a viewer is to open yourself up. So both parties are in a vulnerable position, which makes giving titles a little tricky. Titles can limit the number of directions you can take the form. That's why normally my titles aren't as specific as this. I think of my titles as more akin to poetry, where they are evocative, perhaps, but not locking the meaning down.

MA: It seems to me that *Ladder* relates to a few pieces you've done in the past. I'm thinking of *Box and Pole*, 1977, which consisted of this boxlike structure next to an immense pole reaching to the sky.

MP: That was bigger than a sapling. That was a full-blown, hundred-foot-long tree trunk that had been turned into a power pole, which I bought and subtly shaped before setting it vertically into the earth.

MA: In the way that it reaches into the sky and seems to disappear, it relates to *Ladder*. But *Box and Pole* is connected to the ground, and *Ladder* floats— is suspended off the ground. You've also done some other pieces recently that are suspended.

MP: I've done a number of pieces recently that are about extreme height, sort of like spires. In fact, I'm working on a piece now that's like that. I also did a piece in Paris in a cathedral—Saint-Louis de la Salpêtrière—the cathedral where they have this autumn festival every year. I did a spiral stairway in the form of an inverted cone that went up eighty feet. It was an amazing engineering feat. These French engineers figured out how to build it, and construct it. This was a case of my designing a work and having it made completely by somebody else, in this case with a very good result. That was also a case in which viewers found the form to have a strong transcendent meaning.

MA: And I'm sure that was at least part of your intention.

MP: Well, as you suggest, the idea of moving away from the ground is a conscious reference to transcending, as a verb. But I usually need an ironic element, a human reference. I called it *This Mortal Coil*, which is a phrase from Shakespeare's *Hamlet*. It was in the form of an enormous widening spiral staircase that started out very small on the floor and spiraled upward, and as it spiraled upward it got broader and broader. So it was quite a wide, elliptical oval at the very top, where it reached the top of the building.

MA: Just the opposite of *Ladder for Booker T. Washington*.

MP: Yes, exactly. The Saint-Louis Salpêtrière piece started out with very massive steps at the base, massive steps made out of solid chunks of wood and increasing in lightness and levity as it went up so that when it was at the very top it was made from very thin pieces of wood. And the steps were made out of very thin translucent fabric—muslin—so it looked kind of like a Japanese lantern at the very top. By the time it reached the full height, it was extremely light and airy and almost translucent. It was suspended from wires, from cables that were suspended near the roof of the cathedral. I thought it was kind of spectacular the way it was finally realized. The title—*This Mortal Coil*—suggests some emotion of transcendence or possibly a reference to death or what happens after death. Like I said, I'm not that comfortable analyzing the titles. I put them out there and if they're ambiguous enough, people will find their own connection between what they're looking at visually and what the words are.

MA: In *Ladder* and *This Mortal Coil*, there seems to be a gesture towards an opening-up of space, where a lot of your other pieces seem to be about containment, an enclosing of space. Do you find that when you go between these pieces, when you make a piece like *Ladder for Booker T. Washington*, which seems to be about openness and breaking out and getting off the plane of the earth, that you then go back to a more contained piece? Do you do that consciously?

MP: I tend to work between the two polarities of closed volume on the one hand, and describing space with linear elements on the other. Sometimes I do pieces that are completely enclosed and as impenetrable as can be as far as knowing what's inside the skin. In other words, the skin is completely continuous and they're closed. There's no opening. Sometimes I make work that has openings, but then again the skin is usually a continuous skin, closed in volume.

MA: It seems to me you have an almost architectural sensibility that takes itself to a point and then subverts it, which can help show some of the creative limits of architecture.

MP: Well, that's interesting. Let me think about that. [*chuckles*] I am very interested in architecture. I think a lot of sculptors probably are. And with a certain amount of envy because architects actually—the best ones—can see their works realized in space and in real social space, where their works not only get realized, but the public negotiates their space in ways that often sculpture is just walked past. It's a very different enterprise. It's not every sculptor that gets a chance to work on that scale and with that kind of support. I think there occasionally can be a bit of an envy factor involved in that, but I'm happy doing what I do. I wouldn't want to be an architect. I wouldn't want to be always making enclosures for people. I need sometimes to gravitate to the other pole of opening the container and stretching out the forms, like in *Ladder*. It's like breathing to me, the need to work between these different ways of negotiating space. I wouldn't call it as regular a rhythm as breathing, but for me it's like inhaling and exhaling.

SUSAN ROTHENBERG

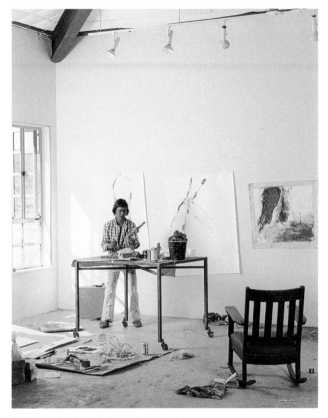

Susan Rothenberg in her studio, Galisteo, New Mexico,
January 3, 1992. Photograph by Todd Eberle.

DRAWN AND QUARTERED

July 24–26, 1991
Galisteo, New Mexico

Michael Auping: **There are periods when you do a lot of drawing and periods when you don't. When you first moved to New York in 1969, do you remember what role drawing played then? Were you making sketches? Were you doodling? Were you doing finished drawings?**

Susan Rothenberg: The first horses generally involved some drawing on the canvas with pencil; first with pencil, then with paint, and then the form. I always place my materials out, get the canvas gessoed, stick a brush in any old colored dirty turpentine, and start to draw.

MA: You draw with the brush?

SR: Yeah. It often starts with pencil and then the light brush drawing and then it gets a little more solid and eventually areas of paint come. Even though I might change it one hundred times, it begins with a drawing action. I don't go in there and paint a shape, or a head. I've drawn it first and changed it ten times, in pencil or drawn brushstrokes, before I pick up a full brush of paint and scrub an area in.

MA: **I've noticed that around your studio and all over your house you have a lot of casual drawing pads.**

SR: Yellow pads. All the horses started out on the backs of envelopes, or any scrap of paper laying around. The first paper that came to hand was usually in the mail pile. Rather than getting a sheet of paper and putting it on the wall and developing a drawing, I'd just sit in my chair and say, "What if it was like this?" Little doodles, on and on: on a torn envelope, on the back of a Con Ed bill. It seemed like a lot of work to get a piece of paper, staple it to the wall, and make a drawing. I'd rather just sit in a chair and say, "I know what I want to do, but I don't know, should it be square, should it be long, should it have a perimeter, double image, or triple image, or should it be an X or a side bar?" All of those horse paintings developed out of drawings in which I asked myself, "What if it was like this? What if I did this? What would happen?"

One of the things that drawing added to the horse paintings was a sense of geometry. I remember I made a number of small drawings in which I drew

straight lines through the horse. I probably threw them out because they were experimental ideas. They were not "finished." But the lines in those drawings added geometry, which added a needed tension to the paintings. It was a way of making this big, soft animal tougher and a bit more abstract, and also a way of unifying figure/ground spatially.

MA: How does a drawing function for you? What does it mean in the larger scheme of your work?

SR: A drawing is about thinking. It's a record of your thinking, which means it can be just a mere note to your thinking made visible. Then if you're really interested, you can develop it so that it's much more than a notation. To me, there is a large range of what a drawing can be, from the smallest indication of a direction that you want to go, that you can make visible to yourself, to staying with it for a couple of hours, a couple of days, or a couple of weeks and make it into a much fuller realization. You can get very interested in its problems and solutions, the erasures and the gessoing out of certain sections. Then it becomes very similar to making a painting, if you engage with it. If you don't engage with it, it stays in the simpler state, just telling yourself what you can't visualize inside, or maybe the opposite—visualizing what you can't tell yourself inside? Drawing is an activity that I do when I either don't have an interesting painting going, or I don't have the energy to dip into a full painting session, but I want to be in the studio. Many drawings happen after paintings, as afterthoughts. With the horse images I drew a lot between series, to try and figure out where I was going next.

MA: Did you once tell me that you took figure drawing classes?

SR: Yes, at one period with Elizabeth Murray for about a month or two in her studio. I also did a whole summer's worth of it with John Duff. Both of us took a course just a few years ago, at the School of Visual Arts. The instructor thought I was terrible. He didn't know I was an artist. He said, "What are you making all these hairy lines for? I want you to look and observe and use a nice simple, clean, clear line." I had told him I was a housewife. Duff said he was a construction worker.

MA: What is your favorite drawing instrument? Do you like a pencil with very sharp lead?

SR: No! But I love graphite, the softest, smeariest graphite I can find, and this one charcoal that I had for a short period of time. You can't find it anywhere, and it was the best drawing material I ever had. It was a stick of black powder called Noire Velour. But I'm happiest with a very soft lead, and I like a really black pencil, soft, so that if you rub it, it smears, and it's semi-erasable. You're always leaving some trace no matter how hard you scrub.

MA: Do you think there is such a thing as "women's painting" or maybe, more accurately, a female sensibility as opposed to a male sensibility? Do you think such a thing exists?

SR: I never know what to do with these questions. I know men and women are different. I would imagine that a lot of the problem-solving is dealt with differently. But I would hate to think that you could walk into a room and identify the sex of the painter. Because we all know that we have male and female in each one of us. You shouldn't really be concerned with the sex of a painter when you look at a piece of art. On the other hand, what grabs you, say your color sensibility, is a personal matter, an individual matter, and all that's partially informed by your sex, I suppose. Most of the art that I saw as a young woman was made by a man, of course, and if there is one factor that I think women artists allow for better than men, it is rendering the world, truly I think, as more various. Men often try to impose coherency on that condition.

STEPHEN SHORE

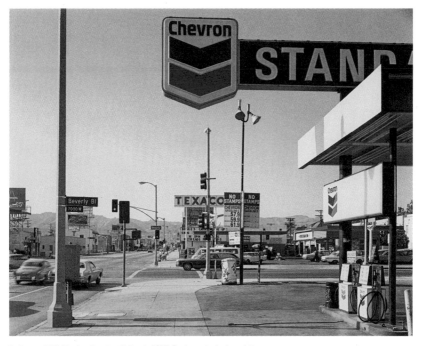

La Brea and Wilshire, Los Angeles, California, 1975. Resin-coated color print.
14 × 17 inches (35.6 × 43.2 cm). Private collection.

AMERICAN
PHOTOGRAPHER

1981
New York, New York

Michael Auping: **How do you decide what to photograph?**

Stephen Shore: That was the question I'd hoped you would not ask. That's the hardest one to answer . . . almost impossible to answer. I can answer it very vaguely and say . . . I look around and then I recognize something in me that says, "This is a photograph."

MA: **Then, you're not looking for subject matter, per se, but for photographs.**

SS: In a way, yes . . . but that doesn't diminish the subject matter. There are times when I might be particularly interested in a kind of subject matter and so that's going to keep cropping up. There are times that my attention is shifted a little bit to a formal problem and so that's going to keep cropping up.

MA: **Why I'm asking this is because a lot of people who see your photographs for the first time, myself included, often ask, "Why did he photograph that?"**

SS: Do you mind if I ask you what you think my subject matter is—why do you think I choose to photograph what I do?

MA: **Well, what I see in the photographs . . . they're like in-between images. It's the kind of thing that you see only peripherally, on your way to looking at something else.**

SS: I'd agree that that is a part of the subject matter of my work. But the larger issue here, why people might ask why I photograph what I do, is because they're conditioned to expect something different from photographs, a different kind of subject matter. I'm really interested in showing people what they're not seeing. And I'm trying to do it with as little prejudice as I can. Now, of course, there still is some. I'm curious as to why people don't tend to ask that about Walker Evans' photographs, which mine are often compared to.

MA: **I think there was a more obvious political intent, depending on which of Walker Evans' photographs we're talking about. But your photographs don't**

seem to me to demonstrate a single obvious intent. They're very individual in their vision, but it's a vision that's very eclectic, involving a kind of Kodachrome amateur outlook, a photojournalistic outlook, and then a fine art outlook, all in one thing without letting either one be so totally dominant that it tells you, "Aha, that's how I should look at that photograph."

SS: I'd say that's pretty true. I'm not sure I agree with you about the Kodachrome outlook. Because the pictures are in some ways so formal and traditional, there's very little of the snapshot look, to me at least. I guess it's that problem of expectation of subject matter. Disregarding the technical skill and sense of composition, someone might think it was taken by mistake if they're expecting a different subject matter. . . . It might help if I read a quote that I like very much, and that I used in a portfolio of my work published by the Metropolitan Museum. It comes close to explaining my attitude about taking photographs. It's an intro-duction to a book on Chinese poetry written by Witter Bynner in 1929: "Chinese poetry rarely trespasses beyond the bounds of actuality. Whereas Western poets will take actuality as points of departure of exaggeration of fantasy, or else as shadows of contrast against dreams of unreality, the great Chinese poets accept the world exactly as they find it in all its terms, and with profound simplicity find therein sufficient solace. Even in phraseology they seldom talk about one thing in terms of another, but are able enough and sure enough as artists to make the ultimately exact terms become the beautiful terms." That's how I can see my pictures as being poetic.

MA: Do you see your work as having an emotional content?

SS: I know people don't think of my work as particularly emotional. I think there is a lot of emotion in my pictures. It just isn't dramatic emotion. . . . I think we're conditioned to expect a certain kind of obvious sentimentality in photographs, and if we don't see emotion presented this way, we assume it's not there. If you photograph a person feeling emotion—supposedly feeling emotion—the photograph doesn't necessarily have anything to do with the emotional range of the photographer, or of the person feeling the emotion. There's no way to know from looking at photographs whether that person is acting or posing. Look at

the emotion we see in movies and on television. I'm trying not to pander to those kinds of blatant emotional responses. And yet I still hope my piece of art will have strong emotional content. It's just a different kind. I've taken quite a few sentimental photographs. I remember when I was twelve, photographing an old man with his head buried in his hands. I would read *Popular Photography* and see that kind of picture and assumed that was how a picture should look. Then I went out and did it. But that has nothing to do with expressing emotion.

MA: There was a period when you were hanging out at Warhol's Factory. Do you feel the time you spent there changed your outlook on taking pictures?

SS: I can't see how it didn't. I can't imagine spending as much time there as I did, around him, and not being affected. All I can really say is that my aesthetic appreciation broadened.

MA: Are there any photographers whose work you feel has had a direct effect on yours?

SS: The ones that immediately come to mind: Evans, Atget, Carlton Watkins.

MA: I can see Evans and Atget . . .

SS: There are some pictures of mine that formally look more like a Carlton Watkins, particularly in the way he uses foreground. I think my pictures are very different than Atget's in choice of subject matter. He was photographing things that were more picturesque. The Paris that he photographed toward the end of his life was Paris at the height of Art Moderne, but he didn't photograph that Paris, at least in the photographs I'm familiar with. He was photographing an older Paris. I can't see myself doing that. However, I think Atget is probably my favorite photographer. I've learned more from him about how to see things than from anyone else.

In regard to Evans, I'd say that my work is more directly related to his than to the other two; in terms of both of us photographing the same country at different times, both using the same type of camera, both having an interest in architecture, etc. Obviously, I've been influenced by his work.

I want to add one thing that relates to the question of people asking, "Why did he take that picture?" It has to do with impact. I've told the story before of going to a symposium at the International Center of Photography with Jay Maisel and Jay telling me that the problem with my pictures is that they don't have impact. He then proceeded to show slides to the group gathered there. He put on a tray of slides and had them changed at five-second intervals. Each time a new photograph appeared, the audience went, "Ah!" And before they could finish their "Ah!" or their "Ooh!" the next picture was there. Evidently, he was interested in the first five seconds of a person's reaction to a photograph. My hunch is that the people who ask, "Why did Stephen Shore take that picture?" are people used to seeing photographs that are high in initial impact. And my view is very different. The first five seconds aren't as important to me.

RICHARD TUTTLE

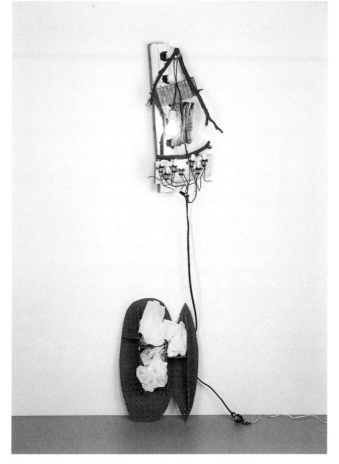

Relative in Our Society, 1990. Wood, wire, mesh, cedar branch, electrical wire,
light bulbs, paper, and Masonite. 73 × 23 × 10 inches (185.4 × 58.4 × 25.4 cm).
Collection of the Modern Art Museum of Fort Worth. Museum purchase, 2000.

TENDER

July 17, 1997
Abiquiu, New Mexico

Michael Auping: What attracted you initially to Agnes Martin's work?

Richard Tuttle: Well, I had seen her work in Sam Wagstaff's exhibition *Black, White, Gray* in the early sixties. I remember that her work posed a lot of questions. I went to her studio eventually and bought a drawing. I remember asking myself what the difference was between graph paper and Agnes's grids. Eventually I decided it had to do with the difference between the loved line and the unloved line. Agnes's line is extremely sensitive to the actual event of making the line. Agnes's work is sensitive to an ideal sense of humanness. She's saying what a human being is, is something that is free of nature.

MA: Do you see her work, as well as yours, as being abstract and beyond nature?

RT: I guess you could say that's a point of contact with her. Then we seem to diverge; she moves to the abstract and I to the concrete. Ironically, as personalities, Agnes is concrete and I am abstract.

MA: That is an irony. I sometimes think your work is very funny. I can't help but smile or laugh when I first see your work. It's an entryway for me. And after the laugh, I begin to look.

RT: If you compare what is really important in life to the things we call important, the only thing you can do is give up a huge belly laugh. That kind of freedom can be a beginning.

MA: Do you think there is humor in Agnes's work?

RT: Agnes has a wonderful sense of humor in her person. The depths from which she can laugh at human folly is like Erasmus. Humor is a subject people have written books about, and what's funny to one person is not to another.

MA: Is it true that you were Agnes Martin's studio assistant in the sixties?

RT: No. Agnes is the last artist I can imagine who would have a studio assistant. She concentrates when she is working in a way that if anyone were there or even nearby, they would be a distraction.

MA: **What did you learn from Agnes?**

RT: Well, that's difficult. It wasn't so much about learning *what* to think as *how* to think. Agnes doesn't try to tell you who she is, but allows you a space to contemplate who you are.

MA: **Did you work for other artists besides Agnes—odd jobs, stretching, framing?**

RT: I worked for Tony Smith. He would divide space, make it seem very solid. I think our response to any image is a response to the space it inhabits.

MA: **Does this have anything to do with how Agnes uses color?**

RT: Her color seems ethereal, but it's very specific. It's pre-verbal.

MA: **Did you ever talk to Agnes about how she used color?**

RT: No.

MA: **You are a different generation. I don't expect that you would have the same concerns.**

RT: My means are very modest. You used the word *intimate* to describe our work earlier. I think that is correct, but I would like to think of it as a very large intimacy.

MA: **And you and Agnes talked a lot?**

RT: Yes, stories about New Mexico and camping and hiking, the outdoors, both here and in Canada, and jobs that she'd had. She has the quality that a story is never told in the same way. There's always a twist to it, a light that you've never seen before.

MA: If you could describe Agnes's sense of color in one word or one sentence, how would you do it?

RT: Tender.

BILL VIOLA

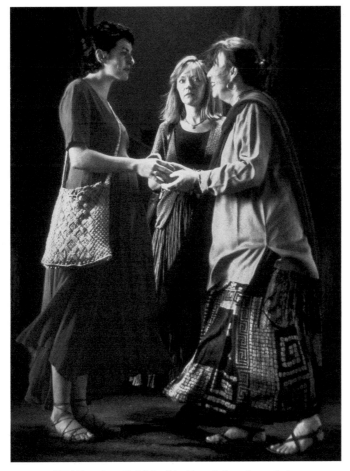

The Greeting, 1995. Video and sound installation: Color video projection on large vertical screen mounted on wall in darkened space, amplified stereo sound. 168 × 258 × 306 inches (426.7 × 655.3 × 777.2 cm). Collection of the Modern Art Museum of Fort Worth. Museum purchase, 1995.

THE VISITATION

October 1995
London

Michael Auping: **What attracted you to this image by Pontormo?**[1]

Bill Viola: I guess it was the moment of mystery that is contained in that event of *The Visitation* when Mary speaks to Elizabeth. I'm fascinated by the whole tradition of sacred conversation in painting. There is a certain exclusionary aspect to conversations that take place in paintings, particularly when you're viewing them hundreds of years later. . . .

Anyway, I looked at the image and these women, and I just became entranced. I remember, I photocopied it and put it up on my wall, and I don't do that a lot. I'd look at it from time to time, notice the colors, and the strange figures. They're elongated in a funny way. I began to break it down optically. Eventually, I got interested in it as social observation. I saw it simply as a social situation; something that happens on street corners all the time, where two people are talking and someone else comes into the meeting. I'm fascinated by the subsurface or subtextual machinations that go on when you're in those situations. There's the polite hellos, how do you do's, and everybody's trying to figure out where everybody stands in this group.

MA: **In the original Pontormo painting there are four individuals. Would it be correct to say that the fourth person in your *Greeting* is in fact the person watching the tape?**

BV: Yes, absolutely. You are part of a series of stages of psychological engagement within the whole group. You could be a bystander on the street corner nearby. They know your presence is there but because of their involvement with each other they can't acknowledge you into their social sphere. Except at that one point when the woman in the middle looks out in your direction. At that point, you're halfway in and still halfway out of their social triad. A piece of her psychological energy reaches out. It's like coming out this way. That's a key point. In a funny way, you've been tagged. You're no longer just a voyeur.

MA: **They're intruding on my space in the same way I'm intruding on theirs.**

BV: Right. She was most important for me, the woman in the back who stares out. In a way, she's the point of the whole piece. I worked on her the longest. She is the quiet outsider, engaged with everyone, but on the edge of everyone's circle. I put myself in her position. The way I structured the piece was that I imagined I was waiting with a friend (the woman on the viewer's right) and someone else comes up. They know each other, in fact better than I know the one I'm waiting with. The irony is that the one in the middle eventually becomes peripheral and therein lies the tension. She begins by being very cheerful and outgoing, and then when this other woman comes in she subtly pulls away— her energy is pulled back—she becomes more withdrawn. She looks down at one point like she doesn't know what to do. The other two women seem to share a secret, as if they have been meaning to talk for some time. It's just a simple chance meeting, but under a magnifying glass.

MA: The magnifier being the element of time.

BV: Yes. By slowing everything down, every breath, gesture, or eye movement has the effect of an earthquake. They were out just talking and by chance she happened to come by.

MA: The woman on the right whispers something to the woman who arrives, but the audio is not distinct. What is she saying? What is the secret?

BV: What do you think it is? One of the reasons I don't like to get too specific with a narrative is that I want the image to cycle through the viewer and let the viewer take the narrative where they will. Unlike Pontormo's Christian image —we know what they said—I want a fluid meaning. It's important that the secret is never really clear.

MA: The figures in this video seem way too big for the space they inhabit. They're giants.

BV: Yeah, they are. We worked hard for that effect. It took a very elaborate set-up.

MA: What was the reasoning?

BV: It takes it out of the domain of the document. Video is a documentary medium. That's its power. It's the power of the "objective eye." But it can be so much more than that—a subjective, speculative medium. Leave the "truth" to CNN. Magnification and subtle distortions allow me to get at a more subjective truth.

MA: Was this filmed on a stage set?

BV: Yes. Completely constructed from scratch. What I'm trying to do is integrate the two worlds of painting and video installation, and if I pull it off, and I think I have here, it will open up a whole new area in my work. At the same time, I think it's consistent with my other work in terms of its coming out of interests and developments over a number of years—almost ten years. The other thing is that I think it also can be misinterpreted in the sense that it, in fact, *is* an installation. It may not be as total and involving physically as others, but it is a room, and there are restrictions on how it can be installed. It's a strange and slightly odd space between video and painting, which theoretically is not supposed to work. But I think it can. It's a physical screen on the wall, it's not a projection on the wall. It has a profile. It's coming off the wall maybe four inches.

MA: Like a painting, and it's framed.

BV: Yes. But the room is dark, so you're not so much confronted by a thing on the wall as you are by life-size, moving people. What brings the experience into the room and puts the viewer *in* the piece is the sound. It would be a very different work without the sound.

MA: What are the other sounds we hear? They're difficult to make out.

BV: The sound is a combination of recordings of traffic on the freeway, wind noise in the desert, people at lunch break in a large lobby in a downtown office building recorded from a distance, and a recording of a woman whispering.

MA: I'm curious about the two men in the extreme background. What is going on there?

BV: That's the male complement to what's going on with the women. It's another kind of "greeting," recapitulating the whole thing of what's happening in the foreground.

MA: I couldn't tell whether they were male or female.

BV: No, you can't. Also, you can't read their actions as well as the women in the foreground because they're slowed down so much and they're so small. Basically, what happens is, there's a guy who's crouching when the piece starts. He stands up and is standing there, then turns and lights a match, and there's a little flare, and you see the waft of smoke coming up. Then another man comes in and they exchange greetings. Then the visitor leaves to get something for the other one and he comes back in with something, which is a book, and he hands it to him. You can barely see it as it catches a little bit of light when he hands it over. And then that other guy receives it, and they just sort of stand there. It's a little more complicated than that, but that's the basic action.

MA: Why did you feel you needed those? Were they part of the idea the whole time?

BV: Yes. There has to be another element drawn out, not just compositionally, but psychologically. There had to be a counterpoint to the massive intensity of the three women. It adds mystery while reinforcing the theme of a secret.

1 This discussion refers to Viola's work The Greeting, 1995, which is a translation—physically and psychologically—of a sixteenth-century painting, The Visitation, 1528, by the Florentine Mannerist Pontormo. Pontormo's Visitation depicts the biblical story of the visit by Mary to her older cousin Elizabeth shortly after both women miraculously became pregnant, Mary with Jesus and Elizabeth with John the Baptist.

CHRISTOPHER WILMARTH

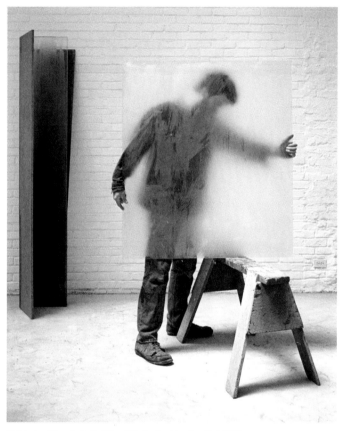

Christopher Wilmarth, Sackett Street Studio, Brooklyn, New York, 1986.
Photograph by Jerry L. Thompson.

NINE CLEARINGS FOR A STANDING MAN

1979
Brooklyn, New York

Michael Auping: How did *Nine Clearings for a Standing Man* come about?

Christopher Wilmarth: That's hard to put into words, other than what the title suggests. They are the words that I would use. Beyond that, I'm not sure what to say.

MA: Maybe if we talk about what these works are made of—glass, steel, thin wire cables that are sort of like drawing over or behind the glass. What brought you to those materials?

CW: Contradiction. Materials are like the relationships between people. Sometimes when you see two married people together you say to yourself, "How did they get together?" They seem so completely different. But then you realize there's a friction that makes them work, that keeps that relationship alive; and there's also something that balances their darknesses and their light. I feel that way about glass and steel.

MA: Do you see the steel as an armature, or a vehicle that carries the light?

CW: I try not to see one material as subservient to the other. In some cases that may be so. Some people when they see my work just see the glass. They just want to see the light, pun intended. The problem is they see light just as lightness, a lightness of feeling. The steel gives weight to the light. I'm more interested in how to get darkness into light than light into darkness.

MA: Like Rothko's paintings? Is that worth talking about?

CW: I would take that as a great compliment to have my work compared to Rothko's, but that will sound like the struggling artist trying to justify his worth by publicly identifying with someone of unquestioned importance. You could say that the connection is appropriate in terms of giving weight to light. On the other hand, I am not a painter. I'm a sculptor, and sculpture suggests different problems and different ways of handling those problems. My materials have a weight that is intrinsic and generally understood. There is much less a history of illusion in sculpture than in painting. So when Rothko creates a space in his paintings, he is amplifying a space that is assumed to be there. He does it

brilliantly, creating different stages of space in different paintings. To create these stages of space in sculpture is a very different proposition. It's difficult to verbalize. If you're not careful, in sculpture the materials can get in the way of the space, and building a space is not the solution, unless you fancy yourself an architect, who constructs a big room and calls that a space, which in fact may only be an empty room. I think in sculpture you need to look into the materials themselves. Glass, for example, is essentially stone. It's transparent stone.

MA: Well, in your case, it actually isn't transparent. It's translucent, because you etch the glass.

CW: That's true. The glass is etched with hydrofluoric acid. In very simple terms, this is a way of giving the space a texture. There are these great Egyptian sculptures at the Brooklyn Museum made of alabaster, like stones glowing with light but with no apparent light source. For me, the presence of that material, regardless of the importance of the figure being depicted, is emotional. Like alabaster, glass can have different emotion densities. If you then layer it with steel, you give it more weight and more emotional complexity.

MA: This technique of treating the glass with hydrofluoric acid has an almost painterly quality. I go back to that cloudy light of Rothko.

CW: I see the acid as a very gentle form of carving, the way breath from your body carves out a space in front of your head. When we breathe, we don't apply the breath to the space; we breathe into it. The work I'm doing now, which is an homage to Mallarmé, addresses this idea very directly. . . . You mentioned Rothko. I would cite Newman as equally, if not more, important to me at a certain point. This series is titled *Nine Clearings for a Standing Man* because it is about locating a sense of place. Newman talked about this. I see his paintings as being about creating the gravity of place, aligning sheets of color of various densities to establish the weight of a space.

MA: So you see it as a phenomenological or formal issue rather than a spiritual one.

CW: No. It's all spiritual.

We are grateful to the artists or their estates for granting permission to publish these interviews. Thanks are due to Tadao Ando; Georg Baselitz; Robert Bechtle; Jonathan Borofsky; Louise Bourgeois; the Estate of Joan Brown / Mike Hebel, Noel Neri, courtesy of Paule Anglim Gallery, San Francisco; the Estate of Ian Burn; the Scott Burton Estate / The Museum of Modern Art, New York; the Estate of James Lee Byars and Michael Werner Gallery; Cai Guo-Qiang; John Chamberlain; Francesco Clemente; the Estate of Robert Creeley; the Estate of Robert Duncan; the co-Trustees of the Morton Feldman Estate; Vernon Fisher; Jenny Holzer; the Estate of Douglas Huebler / Artists Rights Society (ARS), New York; the Estate of Jess Collins; Ellsworth Kelly; Anselm Kiefer; Richard Long; the Estate of Agnes Martin, courtesy of PaceWildenstein Gallery; Bruce Nauman; Philip Pearlstein; Michelangelo Pistoletto; Martin Puryear; Susan Rothenberg; Stephen Shore; Richard Tuttle; Bill Viola; and the Estate of Christopher Wilmarth, courtesy of Betty Cuningham Gallery, New York. The image on page 163 is © 2007 Estate of Douglas Huebler / Artists Rights Society (ARS), New York.

First published in 2007 by the Modern Art Museum of Fort Worth in association with Prestel

Modern Art Museum of Fort Worth
3200 Darnell Street
Fort Worth, Texas 76107
www.themodern.org

Prestel Verlag
Königinstrasse 9, 80539 Munich
Tel. +49(89)381709-0
Fax +49(89)381709-35

Prestel Publishing Ltd.
4 Bloomsbury Place
London WC1A 2QA
Tel. +44(020)7323-5004
Fax +44(020)7636-8004

Prestel Publishing
900 Broadway, Suite 603
New York, NY 10003
Tel. +1(212)995-2720
Fax +1(212)995-2733

Museum ISBN 978-0-929865-27-0
Prestel ISBN 978-3-7913-3885-9

Copyright © 2007 The Board of Trustees, Fort Worth Art Association The illustrations of works of art in this volume are reproduced with the permission of the artists and are © the artist.

All rights reserved. No part of the contents of this book may be reproduced in any manner without written permission.

All measurements are in inches and centimeters.

Edited by Pam Hatley, Modern Art Museum of Fort Worth
Design and layout by Peter B. Willberg
Origination by Repro Ludwig, Austria
Printing and binding by Passavia Druckservice, Germany
Produced by Prestel Verlag
Printed and bound in Germany on acid-free paper

Library of Congress Cataloging-in-Publication Data

Auping, Michael.
 30 years : interviews and outtakes / Michael Auping.
 p. cm.
 ISBN 978-0-929865-27-0 (alk. paper)
 1. Artists—Interviews. 2. Arts, Modern—20th century. 3. Arts, Modern—21st century. I. Modern Art Museum of Fort Worth. II. Title. III. Title: Thirty years.
 NX456.A873 2007
 700.9'04—dc22
 2007018059

 LIBRARY
WESTERN WYOMING COMMUNITY COLLEGE